Your Everyday Art World

YOUR EVERYDAY ART WORLD

Lane Relyea

THE MIT PRESS CAMBRIDGE, MASSACHUSETTS LONDON, ENGLAND

MIT Press books may be purchased at special quantity
discounts for business or sales promotional use. For
information, please email special_sales@mitpress.mit.edu
or write to Special Sales Department, The MIT Press,
55 Hayward Street, Cambridge, MA 02142.

This book was set in Chaparral by the MIT Press.
Printed and bound in Canada.

Library of Congress Cataloging-in-Publication Data
Relyea, Lane, 1960–
Your everyday art world / Lane Relyea.
pages cm
Includes bibliographical references and index.
ISBN 978-0-262-01923-1 (hardcover : alk. paper) 1. Art
and society—History—20th century. 2. Art and
society—History—21st century. 3. Art—Social
aspects. I. Title.
N72.S6R45 2013
709.05′1—dc23
2012048019

10 9 8 7 6 5 4 3 2 1

Contents

Preface

This book looks at the changes that have swept the art world over the past twenty years, using as a framing device the rise to dominance of network structures and behaviors and their enabling manifestations: the database, the platform, the project, and the free agent or do-it-yourselfer. These are all terms the art world has come to rely on heavily, favored metaphors for describing the kind of dynamic landscape it envisions in its turn toward an art of performativity, sociality, and eventfulness: networks extending communications and connecting communities, platforms facilitating myriad activities, and so on. More than just slogans, I believe these keywords reveal more than their champions likely intend. The figure of the network plays a significant and complex role in plotting the emergent potentialities of our historical moment; it responds to new materialities and helps produce in turn new logics, new sets of practices, and new norms; it brings with it an ensemble of corresponding figures which together diagram or model the emergence and exercising of power and privilege today. Thus, despite all the references to information and networking in what follows, my argument has less to do with specific technologies than with general forms of organization. I try to describe an organizational shift in the art world, a whole new managerial imaginary, the effects of which are affecting not only material infrastructures and relations among people, objects, and institutions, but also conceptual categories and conventions, and ultimately the construction of meaning.

Such a transformation, of course, has not been inherent solely to art. It has unfolded in relation to—has paralleled, intersected, and resisted, been shaped by and helped shape in turn—developments

in political, economic, cultural, and social life, changes that have often been analyzed under the general headings of globalization, postcolonialism, and neoliberalism. Particularly important has been the shift in focus from the national and even international toward the transnational, the global, and the diasporic, as well as the rejection among theorists in anthropology, ethnography, and postcolonial studies of essentializing models of culture in favor of stressing the specificities of material practices. Also influential has been the interest among political theorists in nongovernmental organizations (NGOs) and the subsequent shift in emphasis away from big ideological struggles toward micropolitics and more local forms of agency, and of course the parallel transition within political economy from a Fordist to a post-Fordist paradigm, away from the production of large inventories to just-in-time manufacture and the providing of services and information. I'm not alone in wanting to understand the relationship of art to all these things.

At the same time, there are risks involved in deploying within an art context nonart models developed within different disciplinary histories and contexts and often dealing with empirical data specific to those disciplines. Cultural changes don't by necessity follow changes in other realms, and even in the fine arts themselves, change is often inconsistent. For example, at the very moment when many encyclopedic museums are attracting ever larger crowds by embracing contemporary art with its plurality of styles, mediums, and interests as well as its motley barrage of readymade and everyday materials, most venues for "serious" music like symphonies and operas grow increasingly conservative, limiting their repertoires to a relatively small number of "timeless" classics. Often changes in culture that appear obviously to parallel changes elsewhere will turn out to be more contradictory when examined in finer detail. Alas, it's a primary aim of this book to complicate analogies between, on the one hand, the recent turn in art toward agency, practice, sociality, and the performative, and, on the other hand, the transition from mass consumerism to mass customization, or what gets called today DIY culture, where an uptick in personal consumer choice can be read in different ways, by some as evidence of further penetration

by the market into every aspect of life, by others as facilitating do-it-yourself empowerment and the expansion of authentic cultural undergrounds.

At the same time, parallels between art and other spheres may be indicative of only very superficial alignments. Hence, while I use a lot of techno-sounding terms and figures in what follows, I nevertheless don't feel that what gets called digital or net art has any prior or particularly urgent claim on the subjects I address, and so I ignore such examples almost completely. Finally, what might at first appear an obvious antagonism between values in the culture and those in, say, the economy may in fact conceal a very deep level of abiding agreement and mutual reinforcement. One example, which I elaborate on in chapter 3, is the misconception that current cultural fetishizing of the handmade stands in strict opposition to technological trends toward digitization and virtuality, a view that ignores how the handmade, as a conspicuous celebration of freelance performance and of practice—that is, of the pragmatics of doing elevated over the semantics of meaning, of the syntagmatic over the paradigmatic—is very much complimentary to the new priorities of a network paradigm.

This applies in particular to recent bricolaged sculpture, a major trend in art for the last decade or more, and especially the thrift store pickings that constitute the bulk of it, which, while aggressively low-tech on a literal level, would be impossible to adequately analyze and contextualize without bringing up the eclipse of spectacular culture by database culture and the practices and values encouraged by the latter's more DIY modes of handling.

An additional benefit of the particular analytical approach I take is that it attempts to make sense of exactly what many critics simply shrug their shoulders over—namely, today's profuse pluralism, the collapsing of structures that formerly organized collective practice and experience, the decay of canons and critical criteria, the inability to convincingly circumscribe what is most significant about contemporary art within deep historical logics or determinations. Placing blame on crass commercialization and the chaos of an insatiable market, while not entirely incorrect, at this point sounds more like a broken record than a historically specific

explanation. My argument is that it's precisely by falling into disarray that structures like the museum or the canon become not obsolete but updated, it's how the spaces of art and culture are modernized. Such a collapse is only one side of a simultaneously integrative process, which is the replacement of hierarchical, restrictive, and summarizing models of culture, whether spectacular or canonical, with new, more horizontal and networked models based on ever-extending databases and platforms enhanced by better connectivity, a change that has brought with it a new subject, no longer the individual as distilled essence of a centered culture, whether high culture's elitist snob or mass culture's brainwashed couch potato, but rather a more spread-out and decentered actor, what sociologists studying this new normative type like to call the "omnivore."[1] Indeed, it's the rise of the omnivore that might help explain why contemporary art museums boast healthier attendance figures than symphonies, which can't promise arrays of pick-and-choose attractions but are limited in their presentational options to linear, take-it-or-leave-it programs.

The artists who appear in the upcoming pages—including Andrea Fraser, Douglas Gordon, Rachel Harrison, Dave Muller, Jorge Pardo, Stephen Prina, and Rirkrit Tiravanija—in no way compose a coherent group, but they do crisscross one another's paths in representative ways, in their interests and working methods (including a preoccupation most share in the fate of site-specific art and institutional critique) as well as in their personal histories and career trajectories. Many of these artists established contact with one another in a couple of select art schools (the California Institute of the Arts and Art Center College of Design in Los Angeles, the School of Visual Arts and Whitney Independent Study Program in New York) and went on to show in the same galleries (Galerie Christian Nagel in Cologne, American Fine Arts and Friedrich Petzel in New York), some even joining in collaborative projects with one another. Many were also curated together into important shows, such as Peter Weibel's 1993 exhibition "Kontext Kunst: The Art of the '90s," Nicolas Bourriaud's "Traffic" in 1996, and Bennett Simpson's "Make Your Own Life: Artists In and Out of Cologne" in 2003.

Most of these artists began their careers in the late 1980s and early 1990s, launching performance-based and/or temporary projects about nomadic existence and prosaic daily life (documenting travels, temporarily intervening in various sites, creating way stations and environments for passing conversation). Over the years such work came to be credited with throwing off the limitations of art and reembedding itself in the everyday. As Miwon Kwon remarked in 1996, such art "drives toward the real world, privileging it over the art world, which is thought beside the point, detached and separate from the 'real.'"[2] And yet the validation of these practices has remained highly dependent on a narrative about neo-avant-garde aims and ambitions, a narrative fully institutionalized within the specialized field of art (i.e., one emphasized in art schools, in art magazines and books, in art museums) and whose moment of initial articulation in the 1960s makes it historically anterior to the neoliberal paradigm that gained ascendance beginning in the 1970s. From this myriad contradictions arise, whereby new value hierarchies, or inverted old ones, are entrenched while also being bracketed from social, economic, and political perspectives that would problematize the attribution of progressivity to them.

The main task of this book, then, is an engagement with and transvaluation of this discursive situation. In recent theorizing about art there are at least three themes that I believe have gained prominence because of their involvement—sometimes critical, most times not—with the new priorities of an ascendant network paradigm. First is the theme of the dialogical or relational as taken up, for example, by Bourriaud in his books *Relational Aesthetics* and *Postproduction*. Second, the theme of flexibility with regard to categorical affiliations and identity, articulated early on and forcefully by James Meyer among others. And third, the theme of mobility and nomadism, especially as these have been examined by Kwon and Meyer in their writings on the site-specific art of Fraser, Mark Dion, Renée Green, Christian Philipp Müller, and others. Questions I ask include whether today's stress on DIY—and, beyond that, "practice" more generally—continues the devaluing of theory ongoing since the late 1980s. I also ask whether celebrating dialogical over monological approaches to art and exhibition

masks the degree to which economic and social control today relies on feedback mechanisms that extinguish every space of privacy in favor of increased just-in-time responsiveness and flexibility. In addition, I inquire whether delusions of agency obscure underlying systematic determinants, including the inequalities that increasingly structure the field underlying the seeming formal equality of networks. In some cases—especially Bourriaud and Meyer—I question the ascribing of oppositionality to what are really central aspects of a new status quo; and in other cases, where these aspects are already problematized—especially in the writings of Kwon and Fraser—I outline how such arguments can be advanced and enriched by my framework.

A lot has been published lately about the art world as a functional system—about how museums, art fairs, and international exhibitions operate, about the workings of studios, art schools, and archives, etc.—and this book no doubt falls into that trend. The difference is that I try to push back against the all-too-common belief that these interlocking functions, this entwining of connection, distribution, and circulation, are somehow purely practical or technological, as if without political content. The institution of art is too often made out to no longer represent a politics because both the institution and representation have themselves been eclipsed—precisely by communication, by the metonymy of the nonreferencing connection, by things getting done, by getting things done yourself. Each act of communicating, of connecting, of practice, gets treated as what Bill Readings calls "a non-referential unit of value entirely internal to the system . . . the moment of technology's self-reflection [which] refers to nothing other than the optimal input/output ratio in matters of information."[3] Paradoxically, then, the move beyond the autonomous art object made in the name of critique and politicization would now grant cover for a depoliticization. In relation to such an innocent view of art's recent turn to services and socializing as simply human nature or right-thinking, I agree with Paolo Virno when he argues, "The putting to work (and to profit) of language is the material ground, hidden and distorted, on which postmodern ideology rests . . . [an] ideology [that] underlines the unlimited and virtual proliferation

of 'linguistic games.'"[4] Indeed, such a depoliticization may be one consequence of seeing the art world as no longer a "system," as it was so often described in the 1960s. Instead we talk about "networks," in which behaviors and dynamics are easily and often portrayed as spontaneous, natural, organic. I offer a critique of precisely this characterization of the network.

Acknowledgments

There are many folks who deserve thanks for their help with this project. First, I express gratitude to Roger Conover at the MIT Press for taking interest in this book early on and then continuing to show encouragement despite all the missed deadlines. I am particularly obliged to Thomas Lawson, Andrea Fraser, Alex Slade, Ross Sinclair, and Richard Wright for going out of their way to provide me with valuable and hard-to-find information. Many people took time out to answer my questions; I'm particularly grateful to Lincoln Tobier and Helen Maria Nugent in this regard. I received a generous project grant from the Department of Art Theory & Practice at Northwestern University, where I've taught and had my work supported since 2002. My students there have patiently endured hours of me struggling through these ideas and responded with valuable insights and feedback, never once complaining about getting the short end of the bargain. Some also assisted in the book's research, including Curt Bozif, John Henderson, Jessie Mott, and Angela Wang; in particular I'm indebted to Morgan Krehbiel and Tyler Myers for their help. In the fall of 2009, just I was this getting this project under way in earnest, I was lucky enough to be awarded a Critical Studies Teaching Fellowship from the Cranbrook Academy of Art. My thanks to Sarah Turner and all the amazing students there who made that such a memorable and rewarding experience. Here in Chicago it's been my good fortune to partake in challenging conversations with Gregg Bordowitz, Huey Copeland, Kevin Henry, Brian Holmes, Laurie Palmer, Claire Pentecost, and many others, members of the city's very amazing and welcoming cultural and intellectual

community and the main reasons why I've managed to get over my homesickness for L.A.

Many of the ideas explored in these pages originated in earlier writing I did for magazines and catalogs, and I'm appreciative of my editors who solicited and helped shape my thoughts. They include Howard Singerman, editor of *Public Offerings* (Los Angeles Museum of Contemporary Art, 2000); Ellen Birrell and Brian Tucker at *X-tra*; Thomas Lawson and Pablo Lafuente at *Afterall*; Claire Barliant and Domenick Ammirati at *Modern Painters*; and Judith Rodenbeck at *Art Journal*. I also thank the editors of two recent anthologies in which I published brief mash-ups pulled from the manuscript: Michelle Grabner and Mary Jane Jacob of *The Studio Reader* (University of Chicago Press, 2010); and Alexander Dumbadze and Suzanne Hudson of *Contemporary Art: 1989 to the Present* (Wiley-Blackwell, 2013).

Rough drafts of this material were delivered in numerous lectures and I benefited greatly from the thoughtful responses and criticisms of the organizers and attendees. In particular, my thanks to Doug Ashford and Walid Raad at Cooper Union; David Bunn at the California Institute of the Arts; Robert Hariman at Northwestern University's Department of Communication Studies; Mary LeClère at the Core Program in Houston; Terence Hannum and Debra Parr at Columbia College, Chicago; Sharon Lockhart, Frances Stark, and Charlie White at the University of California's Roski School of Fine Arts; Kevin Murphy at the Graduate Center in New York; Laurie Palmer and Stephen Reber at the School of the Art Institute of Chicago's Sculpture Department; Renee Petropoulos at the Otis College of Art and Design; Craig Cree Stone at California State University Long Beach; and last but not least Philip Von Zweck and his Much More Lecture Series (run out of his Chicago apartment, more on that later). In terms of this kind of scholarly exchange, there are two events that stand out in particular: the "Poetics of Materiality and Waste" panel that Maura Coughlin and Jaimey Hamilton organized for the Association of Art Historians 2010 Conference in Glasgow; and the roundtable on relational aesthetics with Ute Meta Bauer, Jose Luis Falconi, Carrie Lambert-Beatty, Linda Norden, Nicolau Sevcenko, and Doris Sommer that Gabriela

Rangel organized at Harvard's David Rockefeller Center for Latin American Studies in 2007. I'm deeply grateful to all involved.

What you're about to read is at bottom me trying really hard to keep pace with a few people, my debt to whom there's no way I'm about to try to summarize here, so instead I'll just end these acknowledgments with a brief but very heartfelt, touch-your-toes bow to them. For their constant grounding, educating, encouragement, generosity, camaraderie, and inspiration, my deepest gratitude goes to Paul Mattick and Katy Siegel in Brooklyn; to my longtime friend and mentor Howard Singerman, who bears the horrible responsibility for me becoming an art critic in the first place and whose own work remains the lodestar for my sense of what criticism can achieve; and most of all to Annika Marie, who has patiently talked me through all of the following material, and by way of much tender mulling, questioning, head-shaking, correcting, and suggesting has helped give my argument what little sense and depth it might now have. Together these people make up my immediate intellectual community. There's much I dedicate to them, including this book.

1 Welcome to Yourspace

Grand Tour 2007 is under way. Seemingly the entire art world is here, hopscotching the EU. The occasion: a rare calendric alignment bringing together in one long summer several periodic international mega-exhibitions of differing temporal orbits, most notably the annual fair in Basel, the Biennale in Venice, the quinquennial mounting of Documenta in Kassel, and the septennial Skulptur Projekte in Münster. People wave in passing. Some slow for a moment to exchange recommendations, update information. The conversation, always cratering, gets further diverted by incoming calls and texts. Plans shift, backup plans are readied, just in case, just in time. More people arrive—from the immediate

present and distant past and all points between. Time and space collapse accordion-like and people's attention drifts elsewhere. Then everybody just as quickly moves on.

The theme of mobility pervades the artworks on display, including the exhibition halls made into artworks. Isa Genzken transformed the entire German pavilion in Venice into an in-progress construction site by shrouding the building's exterior with scaffolding, while inside she hoarded orphaned travel bags and luggage. Information is stockpiled, collaged, circulated, as in Rainer Ganahl's screen-shot-cum-wall-mural of Google search results or Ignasi Aballí's relentless clippings of newspaper headlines reporting numbers (of money spent, units sold, lives lost). At Kassel Christian Marclay's automated guitars constantly warm up for a concert never performed. Everywhere there are travelogue films and documentary videos. Skulptur Projekte is nothing less than a citywide treasure hunt. The only way to watch Guy Ben-Ner's latest videos in Münster is to pedal a stationary bicycle. Or was that in Venice?

Traipsing the multiply braided pathways of the Grand Tour makes abundantly clear how, like other major business sectors undergoing globalization, the art world too has grown increasingly decentered and far-flung while at the same time achieving ever greater organizational and professional coherence. To borrow David Harvey's general thesis about capitalism in *The Condition of Postmodernity*, the art world "is becoming ever more tightly organized *through* dispersal, geographical mobility and flexible responses . . . all accompanied by hefty doses of institutional, product and technological innovation."[1] Objects, events, and locations that just recently were considered singular or isolated now thoroughly bleed into and out of an expansive international circuitry that itself has little sense of set borders. Take the 2007 Documenta: 109 artists from forty-three countries exhibiting over five hundred works, visited by roughly three-quarters of a million people, including twenty thousand journalists and VIPs from fifty-two countries. Also, consider the expansion of the contemporary art map since the early 1990s, with the rise of the London and Los Angeles art scenes; with Berlin emerging as a pivotal center, and

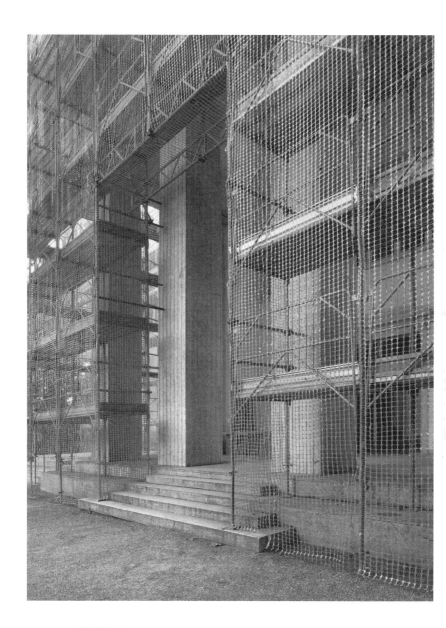

FIGURE 1.1

Isa Genzken, *Oil*, installation view at the German Pavilion,
Venice Biennale, 2007. Photo: Jan Bitter.

Eastern European artists suddenly gaining wide recognition after the fall of the Iron Curtain; with the explosion in the market for Chinese contemporary art; and with close to fifty different cities throughout not just Europe but Africa, Asia, South America, and the Middle East establishing new international bi- and triennials.

Today the art world no longer resembles a pyramid with one city at its apex. It is a horizontal matrix. Prestige now accrues not to any single city, exhibition, or art event, but to the lines between, the routes of connection, distribution, and circulation that interlace the various centers and gatherings. The ability to shuttle along these pathways, to partake in the network's scaffolding of spokes and nodes, is what keeps competition heated.

Put simply, to go where the action is means to be always on the go. How to best describe and analyze such movement is one of the main preoccupations of this book. Over the following pages I talk a lot about network structures and the elements they rely on, like databases, platforms, projects, and free agents or networkers. All are crucial to the recent reorganization of the art world away from static enclosures toward connectivity and circulation. But importantly, despite such technological-sounding terms and figures, the reshaping of the contemporary art landscape can't be reduced to just a matter of particular technologies, which would risk losing sight of other forces, especially neoliberal economic policies whose formulation and implementation are relatively, but significantly, independent of developments in the various technologies they draw on. Hence, while characterizations of today's proliferating connectivity typically suggest a world made increasingly sublime in scale and digital in nature, the rise of networked organizational forms in fact places greater emphasis on individual "human capital" and its embodied, improvised performances. As the economy shifts from commodity production and exchange toward information-oriented services and short-term contracts, participating parties are drawn into more intricate social collaboration, and subjectivity itself gets inducted more completely into productive and economic processes. Pitted against the mechanical, quantitative tasks of Fordism, post-Fordism boasts decision making, data filtering, and the management of affect—not passive workers,

shoppers, or entertainment audiences but information managers, DJs, prosumers (marketer-speak for professional or "producerly" consumers), all of whom adopt a supposedly active relation toward pliant databases. Instead of being suppressed for the sake of getting work done, now the communicating and performing of subjectivity is itself put to work.

Thus this book's other preoccupation: how today's network paradigm lends itself to a neoentrepreneurial mythology about volunteerism and "do it yourself" (DIY) agency. "In a world regarded as extremely uncertain and fluctuating," Luc Boltanski and Eve Chiapello write in *The New Spirit of Capitalism*, their 1999 study of networked and flexible business and labor practices, "the *self* is the only element worth the effort of identifying and developing, since it is the only thing that presents itself as even minimally *enduring*."[2]

DIY serves as the honorific term for the kind of subject required by the constant just-in-time turmoil of our networked world. It has come to stand for a potent mix of entrepreneurial agency and networked sociality, proclaiming itself heir to both punk autonomy, the notion of living by your wits and as an outsider, and to a subcultural basis for authentic artistic production, the assumption that truly creative individuals exist in spontaneously formed social undergrounds. Most artists tend to be DIY today—I know this from experience. When I first started teaching college art courses in the early 1980s, it would often be in painting departments, and I, like everyone else, would assign articles from the 1960s addressing topics like the difference between modernist medium specificity and conceptualism's art in general. I would ask the painting students how they would identify themselves if someone asked them—in a bar, in court—"What do you do?" Would they call themselves painters or artists? Most back then answered, "I'm a painter." I've continued to ask this question, at schools where I work full time and also at schools where I'm invited to conduct one-day seminars, group critiques, or individual studio visits. Today the painting students, all of them, across the board, don't say they're painters. But they also don't call themselves artists. "I do stuff" is the most frequent response. Or, "I make stuff." All verb, no predicate. All open-ended adaptability and responsiveness, no set vocation.

Ergo, free agents, action-oriented individuals liberated from the confines of labels and titles—"a growing population of people," as Frances Stark describes the budding art scene in early-1990s L.A., "trying to eke out an existence in any number of vaguely defined layers of a so-called art world."[3] (Later I'll talk about a diametrically opposite identifying statement, Andrea Fraser's declaration, "I am the institution," also from the early 1990s.)

Of course, doing it yourself and being in a network are not identical—on a desert island you can be self-reliant and yet lack social connections—but today the two do closely overlap. That's because the subject of DIY is not an autonomous individual; rather it's a "free agent" or networker who, by being so thoroughly defined in her or his predisposition to "doing" and making connections, is always situated and contextualized, externalized and performative. And yet this agent remains "free," despite being context-dependent, because the new context is not thought to be the all-determining social structure or the rigid bureaucratic institution or the brainwashing ideological apparatus. It's the temporary project.

This dual emphasis on networked connectivity and DIY agency helps account for the unique spatial template of today's art: extremely local performances staged against a backdrop of seemingly unimpeded international travel. Both are equally crucial to the art world now that prestige is measured in communicational terms, according to which the only thing more valuable than extensive reach is complex, intimate feedback. Providing the pivot between the two is the short-term contract or informal work agreement, which allows for both engagement in specific productive situations and quick disengagement so that productive units will return constantly to the circulatory movement of the worldwide market. Because the contract facilitates embeddedness-for-hire or employment agreements heavy with subjective performance and investment, it is both the means by which artists enter into socially and contextually embedded projects and at the same time the means by which they just as easily become disembedded from context, free of social ties.

But this is also where myriad problems arise. In charting the world in this way, with focus shifted onto individual actors and their immediate and intimate connections and, at the same time,

the indeterminate and immeasurable space of international mobility in which those contexts and connections unfold, how do mid-range issues of modern social organization not get displaced and obscured? Don't constantly fluctuating networks threaten certain conditions necessary for bringing about social justice, such as the stability and enclosure required for determining collectivities, or "wholes," that can be measured by, and held accountable to, the yardstick of across-the-board fairness? Doesn't the ideal of equal distribution of resources prohibit the asymmetry of connections and access that is the a priori assumption of network models? (This asymmetry often goes unremarked in all the hoopla about networks, about how, in their supposed horizontality, they are non-hierarchical and egalitarian, even though the period of their rise has been marked by dramatic increases in all sorts of inequality.)

By the same token, how does the art world, in privileging the temporary and performative and turning attention to the spatial extremes of the very near and very far, continue to address those formerly dominant, more enduring institutional contexts such as the studio and museum, with their entrenched, repeatable practices, those rituals that instill belief within subjects and thus produce embodied ideology? What about other such civic institutions or "ideological apparatuses," such middle-ground entities like specific traditions and canons, mythologies, even "the public sphere" or "dominant culture" or "shared ways of life"—how do these things not fall out of focus, lose some of their function and relevance?

The results of this process are what I grapple with here. Namely, what happens to art once metalinguistic and paradigmatic structures, language's "metaphoric pole" as Roman Jakobson called it, recede in importance, while more practical or functional enunciations, the syntagms and metonymic effects of specific agents within specific contexts, leap to the fore.

Within the art world, as in other fields, what metaphors remain popular today are those that figure precisely this transition away from sturdy isomorphic attachments and extensions toward more loose metonymic glancings and proximities—that is, a rhetorical shift away from architectonics toward flows and atmosphere. It's said, for example, that the museum, like many institutions, is now

in ruins; disciplinary walls that once striated space are collaps-
ing, leaving in their wake a smooth surface of dispersal—"clouds
of narrative language elements," as Jean-François Lyotard put it
in *The Postmodern Condition*, rolling across a landscape strewn
with "institutions in patches" (or as Michel de Certeau reworks
the scenography, "a dark sea from which successive institutions
emerge").[4] Michael Hardt and Antonio Negri also choreograph
this figural repertoire. "As the walls of these institutions break
down," they write, "the logics of subjectification that previously
operated within their limited spaces now spread out, generalized
across the social field."[5] Among examples to which they and others
point: fewer and fewer people actually live in traditional nuclear
families, and yet the rhetoric of family values seems everywhere;
retail malls go bankrupt, but everything takes on the structure of
a marketplace; factories close and jobs are outsourced, and yet the
work discipline seeps into every space, every activity and every
hour of the day. The canon of fine art is in shambles, and yet every-
day life becomes aestheticized, with connoisseurship and tasteful
discrimination dominating the discourses of mass marketed food,
clothing, furniture, and more (signaling not the end of art so much
as the more dispersed instrumentalization of its distinction as a
means to add value to a greatly expanded field of practices and ob-
jects). If the modernist regime of sharply demarcated disciplines,
categories, and discourses has given way to a postmodern condi-
tion characterized by, in Lyotard's words, a more scattershot "prag-
matics of language particles," then it would no longer be metaphor
but metonymy that the culture shows a bias toward—dialogue fa-
vored over monologue, context over autonomy.

Perhaps, then, the demise of lexical storehouses like museums
foreshadows an end to ideology itself? Especially since, as Benja-
min Buchloh puts it, museums "transform the primary language of
art into the secondary language of culture," and thus represent an
important resource for legitimation, social reproduction, and "col-
lective storytelling" (narratives about nation and culture that take
the form of, say, themed shows and historical or geographic sur-
veys).[6] On the other hand, how can the promise of ideological lib-
eration not itself be deeply ideological? What's more likely is that

a new ideology has risen to dominance. And this would be an ideology of the absence of a social and cultural middle ground. Only free agents, specific projects, boundless mobility. The risk, then, as Susan Buck-Morss observes, is that "members of the same society become aware that they 'no longer inhabit the same economy' [and] reconsider what they owe each other. This process raises the danger not only of a legitimation crisis of the welfare state but also of a deeper crisis in the social polity because it challenges the very definition of the collective itself."[7]

My argument here is not that DIY is inherently bad. On the contrary, it can indeed provide relief from the many alienations and social divisions of large-scale industry, technology, professionalization, and bureaucracy, and also allow one to duck the official decrees, censorship, and other forms of state and institutional overpresence. Apartment galleries, for example, operate without government grants, which can be rescinded. But DIY is not so oppositional when placed within the kinds of contexts one encounters more and more these days, especially government underpresence resulting from neoliberal attacks on state redistribution mechanisms and security assurances as compensation for social inequality and injustice. Likewise, networks sound heroically resistant when pitted against the restrictive, one-size-fits-all enclosures and norms imposed by modern forms of organization—the army barracks, the school house, the factory and union, the housing project, and so on. But again, as all these enclosures grow increasingly fragmented and porous today, the figure of the network begins to appear less like defiance and more like the latest answer to capitalism's constant need to overcome and reinvent itself.

This is what interests me about recent poststudio practices in art: not how they resist the reproduction of a formerly dominant system—not how they oppose a Fordist production process that results in discrete objects made and stockpiled in studios and distributed through a market system regulated by galleries and museums—but rather how they align with and articulate new social and organizational norms and positions, especially the post-Fordist free agent and entrepreneur and new on-demand, just-in-time modes of production and distribution.

In particular, I follow the lead of Boltanski and Chiapello, whose book describes the appropriation of networked forms of co-ordination as mainstream business policy beginning in the 1980s. This was the period when neoentrepreneurialism took shape, when corporations downsized, dismantling their former static hierarchical structures by eliminating middle management positions and outsourcing tasks to external spot-labor markets, all the while quickening the pace of their megamergers and acquisitions. In the new paradigm that emerges, the do-it-yourselfer—the networker, entrepreneur, free agent, and outside consultant—eclipses the company man as a labor ideal, and rank-and-file solidarity is structurally dispersed as across-the-board pay scales are replaced by individual, short-term contracts. (Even the more lucrative long-term contracts grow personalized and differentiated, often laden with incentive clauses and bonuses based on individual performance expectations, so that individuals end up competing against themselves—that is, against the performance criteria and production levels each person sets by her or his past labor record.)

With the increasing adoption by artists of itinerant and post-studio approaches, and by museums of commissions and residencies, this shift from production to project now characterizes the art world—and many other areas of social and cultural life as well. Already by the end of the 1970s Lyotard was writing about how "the temporary contract [which] is in practice supplanting permanent institutions in the professional, emotional, sexual, cultural, family, and international domains, as well as in political affairs . . . is favored by the system due to its greater flexibility, lower cost, and the creative turmoil of its accompanying motivations—all of these factors contribute to increased operativity."[8]

But the point is not just that formal homologies exist between the way the spheres of art and business are organized. Boltanski and Chiapello go further, arguing that neoliberalism, in its crusade to shift risk onto individuals and privatize social life through aggressive assaults on unions and state assistance programs, has sold itself as basically an "artistic" revolution, promising an end to Fordist conformity and standardization via a more fulfilling life of individual autonomy, personal initiative, creative spontaneity and

self-realization. It is precisely the euphemism of a "creative life," or the metonymic association of artistic creativity with Joseph Schumpeter's theory of entrepreneurial capitalism as a process of "creative destruction," that provides ideological cover for the shift in labor conditions to more chronically intermittent employment with longer work hours and no benefits. Artists and designers are made into role models for the highly motivated, underpaid, short-term and subcontracted creative types who neoliberals imagine will staff their fantasy of a fully freelance economy—what ex–Al Gore speechwriter Daniel Pink has titled "Free Agent Nation" and the Tony Blair government pithily christened "The Talent Economy." As Andrea Fraser sums up, artists "have become the poster children for the joys of insecurity, flexibility, deferred economic rewards, so-cial alienation, cultural uprooting and geographical displacement."[9]

Given all this, the cultural left's continued parroting of a for-merly radical battle cry about defending open over closed form, the temporal over the static, the flexible and transient over the stable, the communicational and performative over the repre-sentational, doesn't just ignore but indeed risks glamorizing the harsh realities of today's more networked status quo. Too much criticism continues to reduce the art world to a choice between marketplace commodities and bureaucratic institutions, despite the rise to dominance of networks, which, as sociologists and management experts insist, are structured neither institution-ally nor like a market. Miwon Kwon, who along with Fraser has forcefully articulated aspects of this problem, wrote in 2003 about how "the presumption that dematerialization = anticommodity still persists in structuring the contemporary art discourse," this despite the fact that "services, information and 'experience' are now quantifiable units of measure to gauge economic productivity, growth and profit. Ideas and actions do not debilitate or escape the market system because they are dematerialized; they drive it precisely because so."[10]

So why wouldn't criticism, just as it had formerly challenged the autonomous, studio-made object in its ideological appropria-tion as authoritatively timeless, transcendent, and self-sufficient, now seek to interrogate claims made by and for performative

projects and artists' services in response to mainstream appropriation of those claims? Among the myriad reasons art discourse hasn't adapted more aggressively, the most damning would be that hypocrisy—i.e., basing assertions about the superiority of relational, dialogical, and flexible artistic forms on a static, ahistorical, and reified caricature of their conditions—while undermining real critical force, doesn't render written criticism entirely inoperable. That is, by leaving unwitting complicities intact, even romanticizing them in the guise of criticism, much art writing today functions as an ideological asset. To take one particular example, Chrissie Iles and Philippe Vergne, curators of the 2006 Whitney Biennial, tried to credit such coy artist collectives as John Kelsey's Bernadette Corporation and Reena Spaulings as having escaped the art system into a zone of freedom, "creating a space outside the market . . . so that the artist isn't directly accessible."[11] Remarkably, their comments appeared the very week that the *Wall Street Journal* ran an article on the Spaulings Gallery's part in the pseudonyms fad, quoting Kelsey's comment that "in part because of 'this mystique around the collective,' at a recent show, works sold quickly."[12]

Today's DIY culture portrays our neoliberal world in an all-too-enchanting light. Being a DIY artist, uncategorizable and nomadic, a hacker of culture and a poet of the everyday—all this is romantic. Its template is the romantic hero's transcendent quest of leaving behind common social definitions and roles in search of unique paths and triumphs, fuller truths and a more authentic and rich existence. But given current circumstances, with official policy advancing risk and short-term profit-taking over the social contract's promises of security, and with the penetration of market turnovers and rhythms further and further into the everyday, it's hard to see how the values of networking and DIY—loose and numerous affiliations, hypermobility, opportunistic interventions in any situation or ensemble anywhere, the recombining of "data" indefinitely—can be taken as challenges to the system when these are the very attributes today's dominant system so loudly promotes.

On the contrary, today's claims of romantic defiance too often look past the fact that our sense of expanded agency has been

purchased largely through an aggressive shattering and collapse of the larger social structure. Falling progressively into ruin, this is a scene that belongs not to romance but to tragedy.

Networks, Databases, Platforms, and Projects

It's not for nothing that the art world treats untrammeled mobility and tightly situated performance as leading tropes of artistic agency today. What I stress here, though, is that the two need to be understood in tandem, rather than each being treated separately as an abstract value in its own right.

On the one side, mobility—nothing signals success quite like it. And this goes for collectors, directors, critics, everybody. Including artists—showing only in town is no longer enough; one needs to always show elsewhere. Hierarchies have been realigned, and those without the time, money, and institutional backing to travel constantly are finding it next to impossible to join the elite who can experience the development of today's most important careers and bodies of work firsthand and in the flesh, and thereby talk about it comprehensively, with authority. The hierarchy is not between this city and others, between New Yorkers and the rest. It's between those who can entrust their gallery or other business to a well-enough-paid staff while they're on the road all the time, or who can jump from one gallery to another, or from one job to another, who can travel or freelance without fear of offers drying up, and those who can't.

Which is to say that, contrary to the common claim that mobility per se stands as inherently progressive in opposition to the statuesque rigidity of hierarchies, in fact mobility serves as the very medium through which particularly oppressive forms of hierarchy now exert themselves. To take one glaring example, the accumulation of prestige, contacts, and information by those who are "international" and jet around constantly is routinely won off the backs of those left behind, the assistants, adjuncts, and other lower-ranking and less well-known professionals—often recently graduated MFA students, but also older practitioners and scholars—who man the phones, shuffle the paperwork, and take care of the other daily chores in the artist's studio, in the art school's classrooms and

administrative cubicles, in the gallery and museum back offices, and so on. "The immobile are exploited in relation to the mobile," argue Boltanski and Chiapello. "The role they play as a factor in production does not receive the acknowledgement it merits . . . their contribution to the creation of value added is not remunerated at the requisite level for its distribution to be deemed fair."[13]

But while constant movement grows all the more crucial to the production of surplus value today, it can't be just pell-mell and far-flung. It must instead be connective and structuring. It must constantly produce and reproduce networks. Thus, while enhanced mobility is a defining characteristic of contemporary neoliberal agency, individual agents can't themselves be granted anything like autonomy in deciding where and when they travel. Such units instead need to be compliantly modular, always oriented toward higher levels of aggregation and fragmentation, capable of being moved, dropped indefinitely and retrieved on demand. That is, today mobility is itself an offshoot of network forces. Which means that networks articulate a further level of hierarchy, as they gain definition in relation to their own dominated other, to the immobile version of the network itself, to the database.

Networks stand at one end of an active-passive spectrum, at the opposite end of which are databases. Somewhat like the marketplace for retail commodities, databases are the result of often unnoticed labor, the collecting together of things (objects, information, people) all made to appear as if passively and innocently awaiting activation, like a reserve army of supposedly dormant units each amenable to being isolated from or arranged with every other. Art schools, for example, are often portrayed as protean networking scenes. And yet schools are also the places where artists usually confront their first set of jurors, as they are compiled as a database for application reviews. After passing through this first filter, the resulting data (students) form networks that spread after graduation through postgraduate residencies or adjunct teaching jobs, and also as some students get picked up by galleries or included in museum group shows. These are all opportunities for the network to make connections with other networks, but also

for the data within networks to get picked through, refined, and thinned down. Thus a graduating class of art students can appear, from one angle, like a bunch of action-oriented networkers, from another like one big submissive database. The same can be said of a museum's collection of art objects, or a biennial's menu of events and exhibitions, and so on.

Databases are compiled like inventories under the logic of equivalence and sameness, and therefore seem to lack the prior ordering of, say, a library or a TV network's prime-time lineup—or a show of the museum's permanent collection. But unlike inventories, which are associated with supplies of interchangeable entities stocked in quantity—and, by extension, with the Fordist assembly line (inventories of lumber at the hardware store, tires at the automotive shop, cornflakes at the supermarket)—the items in databases are not so denotative and basic, not so ruled by consistency and sameness within generalized categories. With inventories, the question is less likely to be about differences between, say, sixty-watt light bulbs and one-inch screws, but rather about how many. Databases, on the other hand, have more search options, and in this way they begin to resemble libraries and museum collections; both make available items in their singularity; they are organized qualitatively, by *difference* within category, and can be searched connotatively, by genre, author, historical period, geography, etc. (Today much of material culture is arrayed and made available in ways that resemble libraries rather than inventories—whereas the old Sears & Roebuck catalog looked like a phone book, today's Restoration Hardware catalog looks like a museum publication.) Items in databases and libraries, though they remain available simultaneously, are not broadcast and consumed simultaneously (as with TV and other broadcast media, at least before home recording devices), but are instead activated by individual moments of search and consumption. And yet, unlike libraries, databases feign to be ideology-free, since they seem less rigidly and exclusively ordered, and don't assume to constitute a "whole"; they supposedly don't systematize and synthesize all knowledge as the realm of the sayable which, when performed by individuals, leads to ideological subjectification. That is, databases are usually not identified as institutions.

In this way, the rise of databases supports an ideology of the end of ideology, the end of institutions—databases are promoted as enabling individuals to perform rituals of supposedly original combination and unique ordering. The difference is captured by Allan Sekula when he compares Edward Steichen's amassing of photographs for his 1955 "Family of Man" survey at New York's Museum of Modern Art and Bill Gates trying to corner the market on image rights to license through his Corbis Corporation:

> [Gates] is no Steichen, since he refuses the role of the grand paternalistic editor, preferring in a more veiled manner to manage the global archive and retrieval system from which any number of pictorial statements might be constructed. In effect, he allows his clients to play in the privacy of their homes the role of mini-Steichen, perusing vast quantities of images from around the world, culling freely—but for a price—with meaning in mind.[14]

Databases, in other words, don't presume to unify (except, perhaps, profits); they privilege the syntagms of individual language games or speech acts over the paradigms of discursive disciplines or institutionalized knowledge. Lev Manovich, following the art historian Erwin Panofsky on Renaissance perspective as an ur-symbol of past ideals about wholeness and unity, calls the database our "new symbolic form of the computer age," according to which "the world appears to us as an endless and unstructured collection of images, texts, and other data records."[15]

Networks, on the other hand, are the form that action gives to data, the result of agents using particular projects and platforms as occasions for searching, retrieving, gathering, organizing, filtering, interfacing, communicating—occasions for instancing selections of data in their dynamic connection with one another. Networks and databases share many of the same characteristics—both are open-ended, horizontal, aggregative, and extensive, and constantly recalibrating without any a priori bounding limit or sense of completion. In fact, they're often the very same entity glimpsed in two different modes, passive and active. As cultural

offerings increasingly assume the form of databases, the more the reception and consumption of that culture will seem active rather than passive or conformist—goodbye, brainwashing mass spectacle; hello, heroic DJs and culture hackers. Networking becomes both a means and an object of construction, unfolding within and drawing upon the resources of databases, projects, and platforms. To exist in a *network* (a noun), one *networks* (a verb). A database, on the other hand, is always a passive object, never a verb. Mobility, flexibility, and feedback characterize the resulting ensemble: everything that actively networks is itself networked in turn; every technology—like mounting an exhibition, say—can be at once a unit of data (in corporate PR budgets, among tourist destinations), a platform (for artists, curators, dealers, critics), and a networking agent in its own right that helps spur the art world in its constant churning. The same goes for making an artwork, convening an art school, or publishing an art magazine—all actively network; all are networked in turn.

Projects and platforms are the fulcrums between this supposedly passive data and its mobilization in networks by agents. They supply the provisional spatial and temporal pockets needed to allow for accumulation amid all the turbulence. According to Boltanski and Chiapello:

> *The* project *is the occasion and reason for the connection. It temporarily assembles a very disparate group of people, and presents itself as a* highly activated section of network *for a period of time that is relatively short, but allows for the construction of more enduring links that will be put on hold while remaining available. Projects make production and accumulation possible in a world which, were it to be purely connexionist, would simply contain flows, where nothing could be stabilized, accumulated or crystallized.*[16]

Projects and platforms can be thought to complement each other in a sort of effervescent figure-ground relationship, like a work force and its skill set and factory (if, that is, there were industrial sectors that appeared for only one fiscal quarter at a time—which

is indeed how short-term speculators eyeing the latest corporate reports would have it). Projects are crucial for the temporary conjunctions characteristic of mobile networks, while platforms provide the proper conditions and infrastructure for such projects to congeal, for them to draw together a multitude of resources and participants and just as quickly let those resources and participants go their separate ways.

In the art world, the term *project* became a buzzword toward the end of the 1960s, increasingly used as the name by which artists described their work and museums labeled new programs of small, just-in-time exhibitions of contemporary art. New York's Museum of Modern Art initiated its "Projects" program in 1971, "a series of small exhibitions presented to inform the public about current researches and explorations in the visual arts."[17] "A part of the museum," one critic responded, "becomes at once a studio for the artist and a gallery for the viewer, generating a kind of immediate vitality within the museum."[18] About the increasing use of the word *projects* in relation to art, Edit deAk and Walter Robinson wrote in 1978, "Artists do not want to exclude anyone, especially themselves, from anything, so to have noncompetitive cross-pluralism everybody now makes 'projects.' When you have your project you have finally given a structure, a transient goal, to your gooey perpetual artmaking. You can do projects in any style, any medium; the concept of projects covers the entire spectrum of art activities, from artmaking to curating to fundraising. It is, in short, whatever you do anyway."[19] Among those who embraced the word early on was the important conceptual-art dealer Seth Siegelaub. "I like the term project," he remarked in 1969, "because it is never clear what exactly is meant by it . . . it covers lots of different things; it is more open and full of possibilities."[20]

Widespread use of the word *platform* is a more recent phenomenon. It became a mainstay in post-Wall European art circles and gained increased currency when Okwui Enwezor split his acclaimed 2002 Documenta into five separate "platforms," only one of which, the last, was the exhibition in Kassel; the others were realized as conferences held earlier in the year in different countries around the globe. Indeed, a number of the exhibitions included

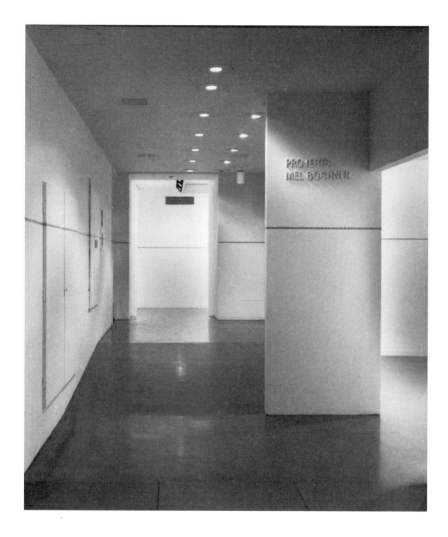

FIGURE 1.2

Installation view of the exhibition "Projects: Mel Bochner,"
August 9–September 20, 1971. The Museum of Modern
Art, New York. Photo: Eric Pollitzer. Digital image
© The Museum of Modern Art/Licensed by SCALA/Art
Resource, New York.

in the 2007 Grand Tour promoted themselves as platforms. The Sharjah Biennial, for instance, proclaimed itself "the most comprehensive platform for artistic practices in the Middle East," while the Istanbul Biennial was conceived by its curator Hou Hanru to "not be a thematic exhibition in the traditional manner . . . instead of imposing any definite concept on the event via fixed exhibition format, we decided to open up the Biennial as a platform of imagination, dialogue and production."[21]

What exactly does it mean for an exhibition to become a platform? There are, of course, political connotations to the word, derived from its use in naming the listed positions publicly adopted by an organized political group (i.e., a party platform). Think *Communist Manifesto*, for instance. Within an art context, a hint of this kind of political engagement and activism is often meant to peek through. But where the word really comes from is the discourses on engineering, design, and business management, all of which widely embraced the term in the 1990s to describe increasingly decentralized forms of coordination, whether in computer systems, product design, or interactions between different industrial manufacturers, suppliers, and work teams. According to them, a platform denotes a basic, underlying architecture or system, a common workbench that, while itself stable and enduring, is open and flexible enough to allow for a high variety of interfaces, a range of inputs and outputs. A few minimal parameters should allow for compatibility between a potentially diverse and shifting array of contents and actors. Modifications are all the more numerous because none are permanently locked in. Unlike the sense of principled commitment conveyed by a political platform, this kind of platform avoids lasting commitments as much as possible. The fewer the requirements a platform imposes, the more factors it can leave unconstrained, thus making it easier to adapt to unforeseen changes in the external environment. Computers, of course, are a favorite example: "It is unnecessary to design various new machines to do various computing processes," as Alan Turing explained their significance back in 1950. "They can all be done with one digital computer, suitably programmed for each case."[22] With the introduction of the participatory architectures of Web 2.0, the Internet was transformed

from mainly providing static sheets of information to establishing the network as platform.

Platforms are distinguished by their looseness. Rather than bounded and fixed, they are traversable, permeable, and responsive, constituted by dialogue with an outside. Whatever profile or boundary they do possess is only the one their interfaces actively conjure. In this sense they can be considered performative; only through and within acts of coordination with peripherals and externalities does their existence as entities come into focus. A periodic international exhibition like Documenta or the Venice Biennale will include a curator position, but it's only the position that's part of the platform, not the particular person appointed to it. That person is part of the project and not the platform, and thus changes with each new iteration of the event. Exhibitions are platforms for curators as well as for art.

Platforms and projects dominate the new organizational forms of the art world, replacing more closed, nonhorizontal forms. This has put tremendous pressure on museums (traditionally very opposite sorts of structures, hierarchical and exclusive) and most are racing to adjust, as more of their curators leave for posts at other institutions and the power and role of temporary, independent curators-for-hire expands. A growing tendency at exhibition venues, whether museums, *Kunsthallen*, or international festivals, is to extend exhibitions communicationally, to transform static object display and monologue into ongoing semiotic interaction and dialogue. There is increasing reliance on artist residencies and commissions, on more flexible approaches to display (peripatetic curator Hans Ulrich Obrist has advanced the notion of the "evolutionary exhibition") and greater emphasis placed on information and discussion (again Documenta leads the way here, not just with Enwezor's yearlong conference series in 2002, but also with the 2007 outing, a main component of which was a collaboration between ninety different magazines and journals from over fifty countries).

Commercial galleries, too, are finding it necessary to adapt, and not just by moving operations from one neighborhood to another more frequently. The transactions they conduct at the growing number of art fairs and other on-the-road events are now

surpassing home storefront business.[23] Furthermore, what used to be called a gallery's "stable" of artists is undergoing faster turnover. A decade ago dealer Randy Sommers of ACME gallery in Los Angeles was already complaining publicly that "there are more dealers now terrified the people they discovered are going to leave them because it's a stepping stone, and a lot of it's not coming from the older artists, it's coming from the kids tumbling out of graduate school."[24] Similar worries have been reported on the opposite coast. "Artists get itchy," the *New York Times* explains, "and think about moving up the gallery food chain. Even the friendliest, most mutually beneficial artist-dealer relationships can prove finite."[25]

Such trends have encouraged and been encouraged by what artists are doing, as many of them now offer up their projects or shows as participatory architectures for other artists to operate within. Single artworks can serve as platforms. For example, Philippe Parreno and Pierre Huyghe's *No Ghost Just a Shell,* begun in 1999 when the two artists bought the copyright to a Manga animation character for their artist-friends to develop new works around, was described in *Artforum* as "the creation of a platform for artistic community."[26] Other examples might include Three Day Weekend, the project Dave Muller debuted in 1993 when he began inviting friends to use his Los Angeles loft to show their work or curate exhibitions whenever a federal holiday fell on a Monday; or the Wrong Gallery, a locked glass doorway in New York's Chelsea district that Maurizio Cattelan, Ali Subotnick, and Massimiliano Gioni used as an outsized vitrine in which to stage over forty different solo shows between 2002 and 2005; or "Utopia Station," a sprawling 150-artist get-together that Obrist curated along with Rirkrit Tiravanija and Molly Nesbit for the 2003 Venice Biennale. The curator Nicolas Bourriaud, who has worked extensively with many of these artists, writes in his influential book *Relational Aesthetics* that the most distinctive feature to emerge in the art of the 1990s is how it

> *strives to achieve modest connections, open up (one or two) obstructed passages, connect levels of reality kept apart. . . . The contemporary artwork's form is spreading out from its material form: it is a linking element,*

a principle of dynamic agglutination. An artwork is a dot on a line. . . . In observing contemporary artistic practices, we ought to talk of "formations" rather than "forms." Unlike an object that is closed in on itself by the intervention of a style and a signature, present-day art shows that form only exists in the encounter and in the dynamic relationship enjoyed by an artistic proposition with other formations, artistic or otherwise.[27]

Indeed, even the figure of the artist has been treated as a type of platform. Shadowy artist collectives and pseudo-identities were described by the curators of the 2006 Whitney Biennial as existing in "a space where things can't be pinned down so easily."[28] The Bernadette Corporation, a star of the show, is famed for its widely exhibited videos and installations as well as the 2005 novel *Reena Spaulings*, the introduction to which claims that "150 writers, professional and amateur . . . contributed to" its writing.[29] Who exactly belongs to the collective is unclear, beyond its cofounder, the aforementioned John Kelsey, a contributing editor at *Artforum* and also codirector of the New York gallery Reena Spaulings—the novel's namesake and itself a widely exhibited fake artist identity. By also including Spaulings in its biennial, the Whitney made Kelsey a participant twice over. So widespread is such use of platforms by artists that, as Roberta Smith recently sighed in the *New York Times*, "solo shows that resemble group shows are becoming generic."[30]

Even when considering objects produced by comparatively studio-bound practices, there is the prevalence today of collaged or "bricolaged" everyday materials that, though personalized through hands-on artistic intervention, still remain opened out and available to larger systems of cultural circulation and exchange. Whether studio or poststudio, increasingly the aim of much art is to "repurpose" already existing objects, sites, practices, and discourses, to make platforms that network with other platforms, to access and link various databases (not just those in the art world but beyond, from social acquaintances to research archives to personal libraries to pop-culture inventories like thrift stores and used-record collections). Just as no single TV show or pop song is as hot today as

the TiVo boxes and iPods that manage their organization, so too with art it is the ease and agility of access and navigation through and across data fields that takes precedence over any singular, lone *objet*.

Signs of a shift toward more networked structures range, then, from interactions among art professionals and how art is institutionally handled to how artworks themselves are conceived and configured. But again, this new system's flexibility and accommodation have their limits—movement is not unrestricted. There remains within the platform's more modular, responsive structure something akin to the interchangeability of parts that was characteristic of earlier Taylorist regimes. Only across-the-board compatibility, the uniformity of markets through exchange, the universal applicability across databases of common search terms, the filtering, disciplining, and credentialing performed by the highly codified system of professionalization that graduate programs in studio art and contemporary art history comprise, and the resulting homogenization of spaces, things, and operations can make possible the increased availability of one area or domain or object or function by another, allowing everything to communicate and hybridize with everything else, to grow more dispersed and decentered while also growing more organized and coherent. Rather than the older continuities of medium or canon, today continuity is found in operational space and professional conformity, in ease of coding and recoding, in the technical basis of point-to-point communication, in the input and output of interfunctionality. That's what makes Münster and Documenta and Basel so exemplary (and art schools, too)—the extent to which they can be reprogrammed with each new group and new outing, each new crop of artists and artworks, the way they're able to maintain a minimal continuity of identity and infrastructural specifications and at the same time accommodate a maximum of product turnover, thus remaining as responsive as possible to shifts in outside tastes, trends, and conditions. That is what makes them the emergent forms today, why they are emulated by other, formerly dominant apparatuses like traditional museums and commercial galleries, which look more and more vestigial. As the business managers especially like

to advise, flexibility is crucial to survival in this quickening, ever-expanding, ever more tightly intertwined and violently fluctuating world—whether it's the art world or the world at large.

Let me cite one last example of a recent art platform, a particularly inventive and efficient one, which I ran into toward the end of my summer on the Grand Tour, while en route from Münster to my final destination, Paris, when I stopped in Einhoven to visit the Van Abbemuseum. "Welcome to 'yourspace' . . ." read the first of the Van Abbe's wall signs I encountered. "As a multi-disciplinary platform, 'yourspace' is interested in generating an exchange of knowledge and opinions, a space for open discussions. All in all this room is a 'comfortable activation zone' that aims to provide discussions, lectures, performances and presentations that function on a self-organizing principle."

Why would the simple christening of one of its galleries as "yourspace" make the Van Abbemuseum more like a platform? To put it briefly: By employing the adjective "your," the museum keeps the designation of the gallery as open as possible, since the word "you," as Rosalind Krauss informed the art world of the mid-1970s, is what linguists call a "shifter," a type of sign that is essentially empty, has no fixed content, its signifying capacity gained only through the ephemeral particularities of each different instant and situation in which it is used.[31] Which means that what the Van Abbe is referring to with the word "yourspace" is left radically contingent, changing from moment to moment depending on the person or persons who occupy the gallery and read the sign, when they occupy it and for what purpose. As with adopting the model of the platform, so too does the designation "yourspace" make the museum more flexible and responsive, a locus of the performative. It marks a shift toward constant turnover and just-in-time adaptation, and away from static display, the permanent collection, the notion of art as autonomous, aloof, self-centered and unresponsive, as not communicating. The Van Abbemuseum, like a lot of other museums, project spaces, and *Kunsthallen* these days, is trying to move beyond the traditional limitations of art exhibition.

But this only raises a host of further questions. Why now? What encourages exhibition venues to change in this way? Why is

exhibition so widely seen as limited, and in what ways is it limited? What new advantages are exhibition venues trying to obtain? And so the longer answer, which might begin: It is by being remade into a platform, becoming a "yourspace," that the space of exhibition now serves the databases and networks to which it has surrendered primacy.

Reading Neo-avant-garde History in Terms of Networks and DIY

It was the exhibition itself that, back in the 1960s, was said to have replaced the single work as the primary unit of meaning in art. "The object has not become less important," Robert Morris put it in 1966. "It has merely become less self-important."[32] Thierry de Duve points to the 1959 debut of Frank Stella's all-black paintings at the Museum of Modern Art, New York (MoMA) as granting permission for artists "to think of work in terms of a 'show' and not of individual objects."[33] For most, though, it was the one-two punch of minimalist objects and conceptual and process art, their prioritizing of the artwork's exteriority, including not just the actual space it shares with viewers but the legal and administrative strictures of exhibition as well as forms of art distribution and publicity, that definitively undermined the barriers that had kept art within an idealist and contemplative universe all too separate from the world of the here and now.

But exhibitions are no longer the primary unit in art. At least not if the kind of exhibition one has in mind is still a self-contained, closed entity. And the context for exhibitions has changed. When the single art work was primary, its context was often described diachronically—as moving from previous work toward future work, the whole forming a narrative succession or *Bildungsroman* that gained value by mirroring or internalizing the supposedly autonomous progression of art in general. But when focus turned toward exhibitions, the context became more synchronic. At least for many artists of the 1960s, exhibitions were related to institutions and systems. For example, among those who inventoried the new sense of limits greeting their work as it both emphasized exhibition and challenged illusionistic convention, Daniel Buren

counted a number of institutions—not just the exhibition but also the studio and the museum—and analyzed their "functions," finding them all sharing a role as "frames, envelopes and limits," with these frames locking together to comprise one cohesive albeit complex organizational unity. "The museum and gallery on the one hand and the studio on the other are linked to form the foundation of the same edifice and the same system," Buren writes.[34]

A number of things are accomplished by calling the art world a system. First, it not only signals a turn from diachrony to synchrony but also assumes the growth of a milieu beyond the studio and the immediate peer community to something larger, more anonymous, more technically integrated, self-modifying, and self-regulating. Moreover, "system" stresses a new sense of homogeneity, a generic identity—an *art world*—over and above any of its particular instances or manifestations. Whatever lies within a system will have its function narrowly limited by its place and moment within the whole; constraint is exerted horizontally by other parts and downward by the system's total architecture. "Systems are characterized by regularity, thoroughness, and repetition in execution," Mel Bochner wrote in 1968. "They are methodical."[35]

Thinking in terms of systems pervaded the art world of the 1960s. Among the articles Bochner wrote that chronicled manifestations of "serial or systematic thinking" was a review of the show "Systemic Painting" that Lawrence Alloway curated for the Guggenheim Museum in 1966.[36] Jack Burnham published essays in *Artforum* about Hans Haacke and other artists working with "Real Time Systems" and "Systems Esthetics," arguing that "we are now in transition from an *object-oriented* to a *systems-oriented culture*."[37] Such an interest complemented developments at the time like new math and structuralism that fed the younger generation's rejection of 1950s existentialism and humanist values in art in favor of a more cool and rigorous aesthetic. But branding the whole art world a system also carried with it a confrontational edge, especially in its explicit appeal to the period's antiauthoritarian politics. "The real content of the night was the airing of general complaints about The System," Lucy Lippard reported about the discussion that took place among nearly three hundred respondents to the

April 1969 call by the newly formed Art Workers' Coalition for an "Open Public Hearing on the Subject: What Should Be the Program of The Art Workers Regarding Museum Reform, and to Establish the Program of an Open Art Workers' Coalition."[38] The word "system" emphasizes the monological and authoritarian character of any closed structure, its intolerance of anything not serving the single overriding goal governing the components and their interactions. As Germano Celant opened his Arte Povera manifesto of 1967, "Anyone can propose reform, criticize, violate and demystify, but always with the obligation to remain within the system. . . . To exist from outside the system amounts to revolution."[39]

Geared toward the exchange of discrete, supposedly enduring objects, the components of the art system like the studio and gallery were routinely listed as among the ways art betrayed its ideological complicities, its pretensions to timelessness and autonomy. But they could also be seen as typifying the system's high level of technical conformity—that is, the idea of a "system" not only pointed to an ideology of social hierarchy but also to the expanding art world's need for standardization. The system stood for a set of both conceptual and practical arrangements. Buren, for example, as well as Seth Siegelaub, described the generic white cube of studio and exhibition spaces as both connoting purity and spirituality as well as serving as an industrial norm that helped streamline ever-increasing volumes of anonymous production, distribution, and consumption. This "predictable cubic space," Buren frowned, "uniformly lit, neutralized to the extreme . . . consciously or unconsciously compels the artist to banalize his own work in order to make it conform to the banality of the space that receives it."[40]

The word *system* was thus used to name the art world's overall business model, its general specifications before the onset of platforms—that is, staticness and inflexibility, growing internal consistency and standardization, rigid division of labor and linear chains of command, the advancing of a specialized terminology and an internal set of issues and methodologies, and the fact that within it all there were no specific origins or destinations for the work of art, no place it needed to respond to or account for, outside the generic

resources and requirements of the system itself. The system was, Buren said, "an enclosure where art is born and buried."[41]

But historical contradictions and tensions also inhabited the system—indeed, inhabited modernism's very zeal for systems in general—and by the end of the 1960s the structure of art production and reception, like a lot of political, economic, and social structures at the time, began to fall into crisis. Much would need to be dismantled and reconstructed anew. Among the targets, for art as for other sectors, was this sense of inflexibility, that too many processes were overly isolated in unresponsive enclosures, trapped in a "Fordist model" with its "relatively 'mute' relationship between production and consumption."[42] The art system would have to be made less static, its institutions less rigidly structured, less closed around one monolithic function, a function personified in the self-contained glory of the autonomous art object. Connections would now be emphasized over divisions.

By the end of the decade a new art world begins to emerge that foregrounds feedback, circulation, and mobility. "New York is beginning to break down as a center," Siegelaub announced. But he also saw no other city replacing it; instead he envisioned a much more explicitly peripatetic art system, with emphasis shifted away from such brick-and-mortar housings as the studio and museum toward individual practitioners themselves, resulting in a map of constantly shifting arrangements, with pockets of density forming here and there only to quickly disappear and reform elsewhere. "Where any artist is will be the center," he continued. "Art centers arise because artists go there. They go there because of . . . access to other artists, information and power channels and money . . . [which] are now becoming balanced throughout the world."[43]

Also celebrated during the 1960s was a general decentering of the art object as well as of the site of its production. "A division of labor was considered correct when art was assumed to be an entirely private matter," Allan Kaprow noted wryly in 1964. Such private, studio-oriented art required the intervention of a public relations staff, "middle men . . . to tell audiences in words what the artist was doing in shapes." But with growing opportunities for presentation and distribution, "today's artist is sharing this job at the

very urging of his representatives."[44] As artworks began to spread out, to take the form of elaborate projects or whole exhibitions (minisystems in their own right), they also grew more flattened, losing a formerly cherished sense of depth and interiority (an interiority to the object in which the artist safely locked away his or her autonomous expression and labor). "Individual units possess no intrinsic significance beyond their concrete utility," Dan Flavin noted about the fluorescent lights he employed. "It is difficult either to project into them extraneous qualities, a spurious insight, or for them to be appropriated for fulfillment or personal inner needs."[45] Instead stress fell on what lay outside the work, i.e., its systemic affinities, which categories, discourses, and sites it could access and activate, which routes of circulation it could travel, how it provided information about the art system, indeed became more like information itself. As Sol LeWitt put it, the artist "functions merely as a clerk cataloguing the results of his premise."[46]

Amid all this growing circuitry, it became increasingly unclear if, and how, the work of art—rather than, say, the artist or exhibition—still stood at the system's center. If it did, it often wasn't in the form of a single object—or, for that matter, even a single gallery or museum show. "For many years it has been well known that more people are aware of an artist's work through the printed media or conversation than by direct confrontation with the art itself," Siegelaub remarked. (Two years earlier, in 1967, Michael Fried had famously identified minimalism as not only promoting a more public viewing experience but, more so, making itself more accommodating to communication and conversation by "seek[ing] to declare and occupy a position . . . that can be formulated in words and in fact has been so formulated by some of its leading practitioners.")[47]

Art was not just simply made and then exhibited; it was disseminated via the surge in media, information, and money devoted to it—promoted and advertised, reported on and gossiped about, sold and resold, reviewed, analyzed, interpreted, appropriated, historicized, cataloged, categorized, contextualized, and recontextualized in collections, books, and magazine articles, in one group show after another. Siegelaub's famous response to the

situation was to draw up with lawyer Bob Projansky *The Artist's Reserved Rights Transfer and Sale Agreement*, a legal contract that addressed "artists' lack of control over the use of their work and participation in its economics after they no longer own it." Contracts as a form of art had been proliferating over the course of the decade, with artists producing documents stipulating terms and conditions (among the more famous examples: Robert Rauschenberg's *Portrait of Iris Clert*, 1961; Robert Morris's *Statement of Aesthetic Withdrawal*, 1963; the N.E. Thing Co.'s issuance, beginning in 1967, of certificates identifying ACTs [Aesthetically Claimed Things]; Lawrence Weiner's *Declaration of Intent*, 1968; Dan Graham's *DanGrahamInc*, 1969; Douglas Huebler's various works beginning in 1970 that specify terms and conditions involving price, resale, distribution, and so on). Even Buren, despite all his rhetoric of static enclosures, admitted that the artwork "must be seen, therefore, as an object subject to infinite manipulation."[48]

Looked at in this context, in terms of the rising importance of communication, the move from object to exhibition appears to foreshadow something other than making art more public and materialist and less private and idealist. It's also about making a more itinerant and flexible art world. And yet what mobility means within such a communications apparatus is different from the kind of dispersion suggested by the market's anonymous and isolated moments of exchange (the market as a scene of social disconnection masked and compensated for by commodity fetishism and advertising's abstract contextualizings and framings). When subordinated to a general communicational demand of commensurability, interface, and retrievability, individual entities, whether artist or artwork, studio or institution, must contend with both decentralization and integration at once. "Art is spread in an exploded and non-hierarchic world," was how the Guggenheim's Alloway described it in 1966. Exploded, yes, but also more tightly integrated, as communication fused former divisions and gaps, increasing relative proximity, like a map growing bigger but also more compactly folding in on itself. "There is almost no time lag," Alloway continued, "as exhibitions and the mass media familiarize everybody with the latest work. Once a museum worked at a fixed

distance from the art it exhibited . . . [but] museums now show not only new works but new talent. . . . Curators can be in happenings or write art criticism. . . . We are all looped together in a new and unsettled connectivity." Such a fluid, dialogical structure would seem to call for a different label than *system*. "Art today is distributed in a network of communications," Alloway proposed.[49]

Instead of enclosures, networks are characterized by what Gilles Deleuze has called "*modulation*, like a self-deforming cast that will continuously change from one moment to the other, or like a sieve whose mesh will transmute from point to point."[50] Networks can't be figured in the same way as, for instance, a nation or region is indicated by its borders or a category by its definitional limits, or the way an institution is equated with its architectural edifice. A network doesn't possess a limiting contour marked out in advance, since unlike closed systems networks don't assume the existence of pathways, sequences, and directions prior to their articulation by agents. A network is also not a branching structure, which still implies a hierarchy since each projecting line is considered an offshoot of a more main line, as twig is to branch and branch is to trunk. What the figures of main trunk and bounding profile reveal is the degree to which the centralized and linear organizations that they so often are used to describe are bound up in an ultimately abstracting, representational, and essentialist logic; they suggest that such political and social constructs as nations and regions, categories, and institutions possess a source of growth at their heart and a shielding skin at their perimeter, as if they generated themselves organically and necessarily from an internal core as well as protected themselves at their edges from an external, surrounding otherness.

This is organization on the model of a living organism. Within such a representational epistemology, foundational categories and definitions operate as bounding frames, each projecting onto all actions and objects existing within it an importance beyond themselves, some shared, a priori motivation and rationale as well as some final, ultimate significance, some idealistic order or "metanarrative" that subsumes as a demonstration of itself any and all singularities existing within it. The network, on the other hand,

follows not a representational but a performative logic, according to which the basis of identity and meaning shift from territorial shapes to specific, temporal situations. Unlike a representational act, which has little reality of its own but instead effaces itself in figuration and essentialist metaphorics, the acts that animate networks are pragmatic and defined by performance; their importance lies not in what they reveal about their source actors but in how they establish relationships and communication. (What Fried said about Jackson Pollock's use of line could also apply to network transactions, which are also "freed at last from the job of describing contours and bounding shapes.")[51] Networks can be contrasted not only to hierarchical structures but to any system that follows a chain of command, where the call and response of communication is proscribed to a unilateral and sequential schema, with messages passed from conceptualizers to implementers, from headquarters to local branches, from before to after and from above to below. Networks instead are characterized by decentralized and simultaneous access and exchange.

If up to the 1970s the dominant view still divided society between relatively sovereign, centrally governed organizations or units on the one hand and atomized actors enacting buying-and-selling choices and exchanges on the other, or "islands of planned co-ordination in a sea of market relations," networks introduce an alternative.[52] In networks, people are seen as linked more tightly than in the marketplace, with its anonymity and its cash sales and title transfers punctually marking when and how one is or isn't involved with things or other people. At the same time, people are also more loosely linked than in hierarchical bureaucracies or rigidly structured social systems, which strictly prescribe and coordinate duties and relations, who's higher or lower and who dictates to whom. Networks are often equated with a third sector beyond the personal and the public; here subjects are viewed as neither under- nor oversocialized, neither autonomous nor entirely indoctrinated, neither bracketed from nor reducible to institutional determinants. This again demonstrates how networks show relative disregard for isolating boundaries; they are not built around a sovereign Cartesian individual who exercises free rational choice, nor

around the commodity as the discrete object or vehicle of market exchange, nor around rigidly defined offices, roles, and duties as in structuralist and functionalist accounts of social organization. The network approach places too much stress on the importance of relations, interaction, and feedback to overly isolate individuals from each other or overly circumscribe their interdependence within predetermined rules. Thus such an approach offers as little support for the myth of the lone studio artist naturally endowed with innate genius as it does for the view of the institutionally empowered museum that indiscriminately and thoroughly imposes its brainwashing ideology on all who step through its doors.

Indeed, when transposed from a system to a network, the work of art itself will tend to appear less aloof, less like a disembedded, autonomous commodity on the market or a disembedded, autonomous representative of transcendent aesthetic achievement in the museum's canon. Instead it grows more situated, anchored in relationships and relatively loose and temporally drawn-out contracts and agreements between artists and others. Specifically, the artwork becomes less a function of a studio-gallery-museum system—a system based on discrete objects and the discrete transfer of ownership of those objects—and instead becomes embedded in projects and their multiple actors.

Again, conceptual art plays a crucial role in this transition. The task-oriented logic of much conceptual work, the sense of guidelines being followed, hews closely to the legal contract's sense of binding promise. (As Daniel McLean points out, "Legal promises are special instances of what J. L. Austin describes as the 'performative' [speech acts which act upon the world rather than describe it]. . . . [T]he contract conditions future action, prescribing, like many earlier Conceptual instruction-based works [think of Vito Acconci or On Kawara], the actions the parties must perform.")[53] Along with conceptualism, the site-specific or architectural ambitions of minimalism often led to the challenging or appropriation of the standardized white cube and other established conventions of exhibition, thus forcing museums and galleries to adapt, to be more cooperative with artists' initiatives and ideas, resulting in more give and take between the work and its presentational site

or channel. Galleries and museums in turn instigated projects in which invited artists had to respond and adapt more directly to the institution's existing parameters and resources. For example, less than a year before inaugurating its "Projects" program, MoMA opened the exhibition "Spaces," the first show of its kind, in which several artists, including Michael Asher as well as Morris and Flavin, were commissioned to produce site-specific, museum-facilitated installations. "I decided to ask for proposals that would make unaccustomed demands on our staff and resources," explained curator Jennifer Licht. "So, in effect, we became responsible not only for exhibiting the artists' works but for executing them."[54] And MoMA's subsequent "Projects" program was itself followed by look-alike ventures at other institutions, such as "MATRIX," launched by the Wadsworth Atheneum to "supplement the larger-scaled exhibitions with a more informal and flexible approach to exhibiting the work of contemporary artists." "Spontaneity is basic to the concept," explained museum director James Elliott. "Because of the reduced lead time, MATRIX should give the Atheneum a new degree of responsiveness."[55]

Such artist projects and commissions knitted the spheres of production and institutional reception into a more intimate, responsive collaboration; artists would write proposals, itemize the materials and schedule the production process in coordination with exhibitors. But this embedding is only half of the story, the other half being a simultaneous tendency toward dispersal, as the constant turnover inherent in such a collaborative model promoted a temporality in conflict with the priority formerly given to permanent collections, static display, and aesthetically self-contained or closed art objects. If typically museums would use their white-cube gallery spaces as the architectural counterpart to their overall classifying approach to art, homogenizing together under some abstract heading the disparate objects cordoned off by any set of four walls, exceptions now appeared: a gallery space might instead manifest little more than the host institution's beneficence and discrimination in choosing to negotiate a specific arrangement or contract with a particular artist regarding the temporary use of one of its rooms. ("Artists shown together in MATRIX at any particular point,"

continues the Wadsworth's director, "are not intended to be viewed as a group show but as discrete units in a cumulative and ongoing statement reflective of the multiplicity of contemporary art.")[56] And the artwork itself, while more embedded, was still eclipsed in importance by its temporary display and exhibition context, by the feedback between site and its intervention.

By becoming "less *self*-important," by growing more exteriorized and context-dependent, artworks also became less reducible to a logic of ownership or title transfer. Instead there emerges a relatively open-ended idea of "subsidizing activity" rather than buying product—collectors were being replaced by patrons, or, as Lucy Lippard put it, people "less interested in possession."[57] Compared to ownership, patronage more fully acknowledges that the assets being acquired are not just material but also immaterial and social. Beyond gaining title over property, the relationship between patron and client is about gaining connections, being taken into confidence, trading endorsements, becoming part of a circle. Indeed, institutions were adopting a more personal approach; or at least it came as a surprise to many that curators now regularly wrote in their catalog introductions about working "closely" with artists, even thanking them for agreeing to let the museum champion their art.

But these relationships, insofar as they facilitated networks, couldn't be either as strongly tied or as hierarchical as those characterizing early-modern courtly patronage. Rather, the social milieu in which art was growing more firmly embedded was typically characterized as loose and horizontal, as befitting the increased professionalization of the art world and its corresponding etiquette of collegiality. The museum or moneyed collector, rather than hoarding selfishly, now posed as an underwriter of research. The catalog for the 1966 "Primary Structures" exhibition, for example, depicted artists as credential specialists. "Most of the sculptors," curator Kynaston McShine wrote, "are university trained, have read philosophy, are quite familiar with other disciplines, have a keen sense of history, express themselves articulately and are often involved in dialectic."[58] The discourse that collectors, museum personnel, and artists circulated among themselves was not just about reputation,

as in a patronage system, but about credible advances in the field, with credibility hinging on what fellow "objectively" accredited members of the profession agreed was legitimate or important. (This abstract egalitarianism encouraged by professional collegiality itself became the object of protest—as when the white male bias of the Art Workers' Coalition was exposed by the splinter groups Women Artists in Revolution [WAR] and Women Students and Artists for Black Art Liberation [WSABAL].)

The intensifying of these simultaneously decentralizing and integrative forces, the preference for itinerancy and circulation over fixity, the diminishing of hierarchies and boundaries in favor of mobility and flexibility across a more open, extensive environment, signals the transition of the art system into a more expanded geography as well as a more networked organizational structure. Andrea Fraser, who identifies herself as a present-day practitioner of institutional critique and successor to Buren, Asher, Haacke, et al., has succinctly summarized this history. "The material arrangements that artists of the past twenty-five years have endeavored to put into place . . . are not only conceptual systems. They are also practical systems. . . . Far from functioning only as ideology critique, they aimed to construct a less ideological form of autonomy, conditioned not by the abstraction of relations of consumption in the commodity form, but by the conscious and critical determination, in each particular and immediate instance, of the uses to which artistic activity is put and the interests it serves."[59]

As a result of this "substitution of literally heteronomous service relations for ideologically autonomous relations of commodity production and consumption," the studio and the museum begin to recede as emblems of a former static binary division between the work's birthplace and its entombment, between the autonomous, inward-turned chamber housing the artist's unique, individual creativity and the museum's equally impervious permanent collection representing a transcendent "official"—national, canonical—culture. What supersede them are more temporal, elapsing events, spaces of fluid interchange between objects, activities, and people. Today, rather than the object or even the exhibition, the primary unit of meaning in art is something much

closer to the Van Abbe's "yourspace," more like an open-ended platform or set of interlinked databases. It is now the communicational network.

How to Start Your Own Country

Thinking in terms of networks itself isn't that new—it's long existed, but until recently has lain somewhat dormant and fragmented across various fields. Traceable back to Europe in the 1930s, where it first appeared in work on math and social psychology, its present-day usage made it into the OED's list of citations by the 1940s (networking as "an interconnected group of people"). While a network approach continued to advance through the 1950s and 1960s, especially in sociology and anthropology, it wasn't until the 1970s that it began to divert serious attention away from the study of gray-flanneled Weberian bureaucracies and Parsonian functionalist social systems and developed an independent scholarly following of its own, replete with associations, journals, and conferences devoted exclusively to network analysis.

Then in the 1980s both the theory and practice of organization and business management underwent what was widely heralded as a postmodern or "post-bureaucratic" turn, away from rationalist systems of control toward decentralization, indeterminacy, and heterogeneity. By the beginning of the 1990s a new image of the corporation was installed in popular culture, the once large and vertically hierarchical firm now fragmented (as in *Fortune*'s 1991 cover story on "Bureaucracy Busters") and scattered across the globe (as in *Business Week*'s 1990 cover story on "The Stateless Corporation").[60]

Beyond sociology and organizational theory, though, the emergence of a network paradigm took longer still. Shifts in the study of contemporary culture that could be thought to foreshadow a network approach include the Birmingham School's work in the 1970s on youth and subculture, especially in the way such work challenged the view of modern culture industries as a historical outgrowth of an overstretched monopoly capitalism and posited instead the idea of a hegemonic cultural code or *langue* that subjects turned into *parole* by not just passively reading and reproducing it but rather

"negotiating" its significations. Such an approach meant that dis-
crepancies within consumerist practices would need to be paid
their proper due, as would the role that reception played in the
production of meaning in general. At the same time, though, me-
dia and discourse in the 1980s were also saturated with an oppo-
site set of metaphors, not networks and decentralization but the
nationalistic drum-beating, military adventurism, and authori-
tarian social policies advanced by the new conservative regimes
of Thatcher, Reagan, and Kohl in the West, and their parallel in
art with the famous return to painting, to figuration, and to his-
toricism. With the launch in 1982 of the *New Criterion*, a conserva-
tive art criticism arose that advocated for traditional values in art
and defended the continued preeminence of the Western cultural
canon against challenges from multiculturalists. These develop-
ments would continue to engulf the second half of the 1980s as the
Reagan administration responded to the AIDS crisis with deadly
inaction and the kind of polarizing censorship and obstructionism
it was also mobilizing against women's reproductive rights. The
Republican Party's strenuous efforts to abolish the tiny National
Endowment for the Arts can be seen to represent some of the
different sides of the 1980s, embodying both government over-
presence and underpresence, at once social authoritarianism and
financial deregulation, on the one hand an act of strong-armed
censorship and on the other hand an example of the pro-market
dismantling of social programs, subsidies, and other forms of gov-
ernment "interference."

Throughout the 1980s a totalizing Frankfurt School por-
trayal of culture as monolithic, dictatorial, and pacifying would
vie with the more sociologically grounded, Gramscian arguments
advanced by the Birmingham School's Stuart Hall and Dick Heb-
dige, et al., whose talk of resistant signifying practices promised
a more capacious response to the growing popularity of hip-hop,
punk, and new wave, to the sudden surge in activist politics like
ACT-UP, and to the proliferation of fanzines and other media
empowerments of the corner copy shop. Media came to mean as
much the xeroxed flyers of protesters and punk bands as it did
the multimillion-dollar ad campaigns of Madison Avenue. Just

as blockbuster culture reached its zenith with Michael Jackson's *Thriller* and the *Star Wars* trilogy, with music seemingly limited to hit radio and the industry's six corporate giants, and television centered around three hours of prime time on only three major networks, a new world was simultaneously dawning of cable and home video, of Walkmans and twin-deck boom boxes and mix cassette tapes.[61] By 1987 VHS rentals and sales were already topping total movie theater receipts in terms of annual gross, anticipating a slew of more recent technological advances that further allowed products to bypass any moment of public debut and debate and instead be delivered directly to isolated moments of private consumption. Young artists coming of age at the time no longer felt part of the same media generation. They belonged to a video generation—they watched movies at home, by themselves, at all hours. "I just started to play with the freeze frame and the slow motion," recalls Douglas Gordon, who turned twenty-one in 1987. "You can watch things over and over again and see things that you're not supposed to see."[62]

As they extended into the 1990s, such changes began to snowball. In 1991, freshly appointed *Artforum* editor Jack Bankowsky introduced a new normative cultural type, the slacker, whom he described as nudging aside the preceding decade's concerns with commodification, spectacle, and corporate power. Bankowsky wrote that "where the art of the '80s intoned 'plug in or expire,' slack art tunes out. . . . Jeff Koons, Meyer Vaisman, Ashley Bickerton, et al. celebrated the penetration of art by the rhythms of capital, fueled by the electronic circulation of information; the slacker has a nose for the fissures in this dream of surface."[63] A new sales pitch greeted visitors to galleries: instead of being fluent in theory, art of the 1990s took up various forms of practice (practical design, folksy sculptural craft, painting conceived as a daily studio practice). Instead of dwelling on analysis of the sign, the 1990s ushered in a new common denominator of information, which asked to be handled and circulated rather than looked at from a distance and deciphered. Instead of mass media, artists took an interest in narrowcasting, in transmitting personalized communication, creating conversation nooks and serving hot meals to chitchat over. In place

of Richard Prince's haunting media appropriations, there were Elizabeth Peyton's glowing fangirl paintings of celebrities; rather than Barbara Kruger's hectoring advertisements, there were the handwritten pedestrian communiqués facilitated by Gillian Wearing. Seemingly forgotten were Adorno and Horkheimer's idea of culture industry, or the death of the author and of the original, or Guy Debord's opening line from *Society of the Spectacle*—how "everything that was directly lived has moved away into a representation." Instead, there were the editors of *Fast Company* magazine asking, "What's one thing that all free agents need? Copies!"[64]

Instead of exhibitions and images, there were connections. Peter Halley went from quoting Jean Baudrillard in 1983 to publishing *Index* magazine in 1996. The artist team of Clegg and Guttmann, who went from producing intimidatingly large and officious portraits of the wealthy and powerful to setting up small, freely accessible outdoor libraries, declared that "we feel a necessity to shift from a preoccupation with content—Art as Critique—to experimentation with new modes of communication and reception."[65] In the work of Mike Kelley and Jim Shaw, shopping segued into thrifting; with Wolfgang Tillmans, thrifting turned fashion into street fashion. And so on. What seemed at the beginning of the 1990s to be an opposition between the apparitions of spectacle and the opacities of abject art's embodiment and trauma soon disappeared, as artists instead embraced a new "middle ground" between the two—the realm of everyday life and common cultural exchange, of casual existence and informality. Not superstar celebrities or abject flesh but people wearing clothes, eating food, and hanging out with friends.

I myself got caught up in these trends. I spent the second half of the 1980s editing a small art magazine in Minneapolis called *Artpaper*, where I began my tenure writing and publishing essays that critiqued the institutional art world centered in New York (we were the first, for instance, to publish one of Andrea Fraser's performance scripts, her piece "Gallery Tour Starts Here" for the 1986 show "Damaged Goods" at the New Museum). My inaugural year ended with a summer issue devoted to haranguing prime time network TV. But we also advocated for DIY culture, running articles

FIGURE 1.3

Clegg & Guttmann, *The Financiers*, 1986. Cibachrome
photograph laminated behind Plexiglas with MDF
support frame. 270 × 91 cm. Courtesy Georg Kargl
Fine Arts, Vienna.

FIGURE 1.4

Clegg & Guttmann, *Open Public Library*, 1991, Graz.
Courtesy Georg Kargl Fine Arts, Vienna.

about cassette tapes, xeroxed zines, role-playing communities, pirate radio, postal art, and so on. On the one hand we ran editorials and articles urging readers to petition their members of Congress to defend the NEA; on the other, we published anarchist screeds by the likes of Peter Lamborn Wilson (a.k.a. Hakim Bey) and Bob Black. This culminated in 1989 with a special issue titled "Decentralization, Self-Reliance and Garage-Band Culture." As I wrote in the editorial,

> *The idea behind this issue emerged from a discussion among the staff about how some day we were going to start a part-time rock band together. Since then our plans have widened, thanks mainly to a potent mix of books floating around the office: among them, P.M.'s* bolo'bolo, *Greil Marcus's* Lipstick Traces, *Eunice Shuster's* Native American Anarchy, *and a book called* How to Start Your Own Country *by Erwin Strauss. For those who are curious, the proper term for Mr. Strauss's field of expertise is micropatrology—the study of very small countries. What we're now thinking is that this future band of ours will serve as the basis for a new country. We're semi-serious: we'd pass out a few homemade stamps, maybe re-write our budgets (under defense would go taxes, parking tickets, etc.) and send off lots of letters protesting actions taken by other heads of state. We wouldn't be seeking official recognition, though: any attention would do. Most importantly, we'd be putting into practice one of our most cherished beliefs: that the only reason people should form a union is because they play well together.*[66]

In the cloying, candybox romanticism of just those few lines I managed to commit glaring examples of the kind of rhetorical and ideological sins for which I now offer this book as a belated mea culpa. But if only it were me alone. Instead, given the art world's state of mind back then, this work on DIY culture is what helped me find gainful employment as a young art critic. It's what landed me a teaching job at CalArts the very next year, where I worked with

students like Dave Muller and taught a class called "How to Secede as an Artist," in which we read fringe literature, organized postal-art exchanges and produced and distributed zines (my name can be found in the list of participants in figure 2.4). Soon after that I was invited to write regularly for *Artforum*, where Bankowsky was looking for critics who, as he would later recall, "held in common a healthy disregard for the dutiful dreariness of institutionalized intellection."[67] Among other things I further elaborated on and glamorized his notion of the slacker, writing in 1993 that "these rebels opt neither to rehabilitate the society they've inherited nor to plot its demolition. What they do is only what the mainstream regards as close to nothing." I went on to align slacker culture within the legacy of May 1968, associating it with "the poignant mix of hypertrophic alienation and unbridled creativity that characterizes life in the netherworld the Situationists described as 'the catacombs of visible culture.'"[68] Thus did I contribute in my own small way to transforming the slacker into a more heroic neoliberal figure, the DIY free agent.

And if only it were limited to the "indie" craze of those years. Instead, I continue to run into it everywhere, in more and more inflated forms and loftier locales, including during my 2007 Grand Tour jaunt through Europe, when I stopped at the Van Abbemuseum and was startled to find on display several of the titles I mentioned in that special issue of *Artpaper* back in 1989. On exhibit in the "yourspace" gallery was a project by the collaborative art team Bik van der Pol, something the museum had just purchased for its collection. Titled *Loompanics*, it turned "yourspace" into a clearinghouse of fringe publishing, an extensive, hodgepodge catalog of stuff not likely to be found in the museum bookstore, not even on Amazon.com. The walls of the gallery were lined with shelves displaying over one hundred titles from the recently defunct publisher/bookseller Loompanics, a purveyor of extreme literature that was particularly hip (along with Amok Books) during the 1980s DIY fad. Available on the wall was, for instance, Erwin Strauss's book *How to Start Your Own Country*. Also in the gallery was a self-service copy machine for visitors to use if they wanted to make copies from the books. The piece possessed some of the flavor of early conceptual art, except

FIGURE 1.5

Bik van der Pol, *Loompanics* (part of the installation
Pay Attention Van Abbe Museum, Eindhoven), 2008.
Books, mixed media. Photo: Bik van der Pol. Courtesy
Van Abbemuseum, The Netherlands.

that it replaced bureaucratic grayness with diverse and deviant missives from far-flung and overbaked micronetworks. Also, by taking a cue from Felix Gonzalez-Torres and including the copy machine, Bik van der Pol added a participatory element and imbued the project with a gregariousness and conviviality that offset—or perhaps punkified—the usual association of xeroxing with the institutional anonymity and bureaucracy of the white-collar office.

The fact that *How to Start Your Own Country* had now become part of a museum collection is perhaps telling, but not in the familiar sense of recuperation, not as another cautionary tale of the challenges of art being pacified through the authoritarian museum's embrace of it. Not if, as I've been trying to argue, the museum and canon have already been superseded by the platform and database, by spaces and operations of availability and access rather than exclusion and prohibition. The dissemination of remote information is a gesture—but of privilege, not defiance. A museum exhibition of "underground" literature seems appropriate given how, as Lev Manovich points out, "culture industries have started to systematically turn every subculture (particularly every youth subculture) into products. In short, the cultural tactics evolved by people [are] turned into strategies now sold to them."[69]

Something has been co-opted, all right, but it dates further back than Bik van der Pol and belongs to a deep and wide though historically specific process. It is, to borrow Boltanski and Chiapello's phrase, the "artistic critique" that has itself been assimilated—the condemnation, that is, of modern rationalization, standardization, and systemization, of corporate and state paternalisms, of routine and bureaucracy, of what Adorno called the "totally administered life" and the Situationists abbreviated as "boredom." Everything standing in the way of a life of creativity and authenticity, a life without constraints—this is the artist's battle cry that now serves as official policy. According to Boltanski and Chiapello, "It was by opposing a social capitalism planned and supervised by the state—treated as obsolete, cramped and constraining—and leaning on the artistic critique (autonomy and creativity) that the new spirit of capitalism gradually took shape at the end of the crisis of the 1960s and 1970s, and undertook to restore the prestige of

capitalism."[70] Or as Chiapello has argued elsewhere, "Management literature has gone out of its way to explain that while wage laborers may have lost job security in the latest transformation of the world of work, they have gained more creative, more varied, more autonomous labor, closer to an artistic lifestyle. . . . Neo-management has adopted practices that are similar to those found in the art world . . . it has listened to the complaints that emanated from 'artist critique'. . . . 'Artist critique' has lost much of [its] poignancy precisely because it has been successful."[71]

The end of Fordism hasn't left us with a less turbulent, shattering, and dispersive version of capitalism, only one offering much fewer remedies to such things. And today DIY serves as one of its campaign slogans. It's the new punk, after capitalism itself has gone punk—has gone liquid, disorganized, and flexible. No longer about condemning the system, DIY is exemplary of how to endlessly bargain and negotiate with it, how to battle for a modicum of romantic glamor and self-worth within it, a sense of worth measured by the system's values and achieved through its laws and norms. Louis Althusser's insight into the necessity for labor power to reproduce itself is no less true today, only now laborers are constructed in conformity with dominant conditions by being flexible rather than rigidly disciplined, and by acting out in their daily material practices the society's reigning belief in flexibility, flux, and the short-term as undeniably enduring and timeless values. And while Althusser also certainly focused on institutions in his analysis, they weren't fundamental for him; as if anticipating the shift today toward a more mobile and atomized unit of measure, he distilled the existence of ideology into two things: what he called "the practical telecommunication of hailings" and the "destination" of such communication, "concrete individuals as subjects." "This destination for ideology," he writes in "Ideology and Ideological State Apparatuses," "is only made possible by the subject: meaning, *by the category of the subject* and its functioning . . . *all ideology hails or interpellates concrete individuals as concrete subjects*."[72]

Indeed, it would be hard to concoct a better motto or hail for our neoentrepreneurial age than "do it yourself," an ingrown, chest-thumping form of self-hailing in which the steely sense of

role and identity enforced by former institutional and disciplinary apparatuses of the Fordist "society of discipline" are superseded by the improvised adaptations and temporary projects of free agents in the "society of control." The syntax of "do it yourself" favors not the spatial matching and mirroring of subject and stable framing predicate but the temporal drumbeat of a verb-centered practice—do, do, do—a practice that is both open-ended (do what?) and oddly autistic (*what* isn't important, *you* are), whose second-person subject is posited as the responsive and responsible addressee of an unattributed, generalized grammatical imperative (the address of language per se as the basis of access to social existence), although now the imperative implores not just ongoing, intransitive action but the taking of ownership over that action, commanding that the commanded feel themselves in command. The empty index here—an update of the cop's "Hey, you" in the Althusserian account—is substantiated from one moment of doing to the next, in context after context, by means of a practice with seemingly no other goal than that subject's own perpetual reproduction as self-assertive. You publish your own blog, run your own gallery, knit your own sweaters. You motivate yourself, apply yourself, manage yourself—now congratulate yourself! Beyond this claustrophobic autism and treadmill repetition-compulsion, the *you* in DIY is troubled by a founding or ontological contradiction; overly eager to recognize itself in the open pronoun, the subject so designated is both authoritative and obedient, its triumph attained only upon submission. And this tension between simultaneous action and reaction continues to mount as the hailing grows louder and more frequent, the phrase becoming a general cultural value, a socially recognized virtue, a political ideal, a normative subject type. And of course a marketing fad: "'Our,' 'my' and 'your' are consumer empowerment words," notes Manning Field, senior vice president for brand management at Chase Card Services, when explaining the retail trend ignited by the popularity of websites such as MySpace and YouTube.[73]

In the wake of collapsing disciplinary arenas—school, family, factory, shopping mall, but also art studio and museum, all frames or "apparatuses" with prescribed, discrete, and repeatable

practices, the enactment of which leads to their being identified with, as if spontaneously, by subjects—doing it yourself is today's generalized, all-purpose call to action, a far more flexible ritual that etches subjects into, carves them out of, neoliberal ideology. Under such conditions—in which, following Jakobson, a strong metonymic bias means that "words with an inherent reference to the context, such as pronouns and pronominal adverbs, and words serving merely to construct the context, such as connectives and auxiliaries, are particularly prone to survive"—it would only make sense that the museum be replaced by "yourspace."[74]

It seems long overdue, then, for a reconsideration of the possible avenues left open to ideology critique, to see if any relevance can still be found in the now overly sober and deterministic-sounding arguments of yore—in Althusser's notion of interpellation, for example, or Adorno and Horkheimer's indictment of culture industry. It was precisely this kind of reconsideration that Fredric Jameson called for back in 1990, when he expressed reservations about the glorifying of the everyday and of resistant signifying practices by DIY prosumers, complaining in *Late Marxism* that "today, where the triumph of more utopian theories of mass culture seems complete and virtually hegemonic, we need the corrective of some new theory of manipulation, and of a properly postmodern commodification, which couldn't in any case be the same as Adorno and Horkheimer's now historical one."[75] Simply put, that's what I'm trying to do here.

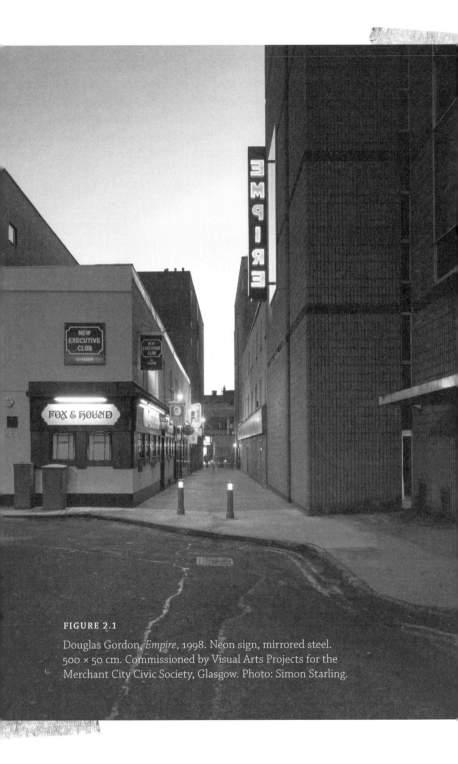

FIGURE 2.1

Douglas Gordon, *Empire*, 1998. Neon sign, mirrored steel.
500 × 50 cm. Commissioned by Visual Arts Projects for the
Merchant City Civic Society, Glasgow. Photo: Simon Starling.

2 **Glasgow, Los Angeles, New York, Cologne**

> *Mysteriously but dramatically, Glasgow has become*
> *the kind of place that people now want to visit, to see*
> *and be seen in.*
>
> —John Urry, *The Tourist Gaze*, 2002

It seems impossible to flip open an art magazine or catalog these days without running into photographs of artists socializing. Not formal portraits of artists isolated each in her or his studio, posed statuesquely behind professional-grade cameras and studio lights. These are handheld snapshots taken with automatic flash, seemingly private tokens not suspecting they would someday end up as glossy art world publicity. Just as the single artwork has been replaced by the exhibition, such photographs attest to how the artist as lone individual has been replaced by a more social, extroverted figure, by a milieu. Sometimes the artists are shown circled in seminar-like debate, either speaking or listening, looking deep

in thought, equipped with writing pads, marked-up Xeroxes, and Styrofoam coffee cups. More often than not, though, they're laughing and relaxing, mugging and toasting the camera, convened at tables strewn with half-eaten plates of food, overflowing ashtrays and empty bottles of beer. The setting is everyday—meals, casual conversation, sometimes in modest neighborhood haunts or pedestrian-filled streets or common tourist or vacation spots. The scale is intimate, face to face, a few friends, some effervescent moments and a handy digital point-and-shoot—or, more recently, a cell phone camera—to capture it all. And the camera itself, rather than looking in from an anonymous position outside, is instead entirely immersed in the situation, one more spontaneous element in the give-and-take of the group's overall collaborative play.

Pictures "of informal and spontaneous sociability"—to borrow Meyer Schapiro's description of early impressionism—have returned as a dominant genre in art since the early 1990s.[1] But here a question arises. If the exhibition that replaced the single work has itself been superseded, replaced by a more open type of exhibition, by the platform, then what likewise replaces the artists' group today? It would perhaps be a more open type of group, a more porous, connective, constantly shifting assembly, a highly flexible social network, what sociologists call a network of weak ties.

According to Mark Granovetter, who first theorized the phenomenon in the early 1970s, weak-tied social networks exhibit crucial advantages over their strong-tied counterparts.[2] Weakly tied networks are enjoyed by professionals who actually need social undercommitment to better access and exchange far-flung information. Casual acquaintances end up being more beneficial than close friends and relatives when it comes to acquiring useful information (about job openings, investment tips, potential professional contacts, project ideas and resources, hip new restaurants or other networking spots). In comparison, strongly tied networks are utilized by underprivileged communities in which survival often depends on direct mutual aid and tighter material obligations—i.e., someone to watch the kids when you're working the late shift, or who has a spare twenty to loan till payday.

FIGURE 2.2

Armin Linke, *6th Caribbean Biennial, St. Kitts, Caribbean*, 2001. Digital scan. Courtesy of Armin Linke.

This weak-strong distinction further maps onto other hierarchical divisions. Saskia Sassen, for example, distinguishes between, on the one hand, global actors whose travels follow and profit from, and are sustained and legitimized by, the flow of products, information, and value between global cities and, on the other hand, lower-level labor whose search for info-economy employment might necessitate migration but whose job itself, once "secured," means staying put.[3] Limits on mobility translate into communicational limits; when restricted to the immobile, to a small and closed group and/or locality, face-to-face interaction will tend to distribute information of little value beyond that immediate circle, while the same group's interactions with others across greater distances will often be confined to anonymous, electronic means without much nuance or capacity to convey the intimacy and personality necessary for the development of profitable relationships based on a sense of reliability, likeability, and trust. According to Nitin Nohria, dean of Harvard Business School, this limited form of communication is characteristic of more anonymous and rote laborers, in contrast to whom the powerful conduct their up-close transactions beyond the local, participating in the "electronically mediated exchange [that] can increase the range, amount and velocity of information flow in a network organization" but whose "viability and effectiveness . . . will depend critically on an underlying network of social relationships based on face-to-face interaction."[4]

Richard Florida has also taken up the weak-tie theory in his influential arguments about the new "creative class," claiming that young artistic types show a "preference for weak ties and quasi-anonymity" and thus gravitate to dense urban neighborhoods with high residential turnover, shying away from "stable communities characterized by strong ties and commitments."[5] (This again echoes Meyer Schapiro's comments on impressionism's initial popularity: "In enjoying realistic pictures of his surroundings as a spectacle of traffic and changing atmospheres, the cultivated rentier was experiencing in its phenomenal aspects that mobility of the environment, the market and of industry to which he owes his income and his freedom.") Members of the creative class are leery of the invasiveness of close, cohesive communities, seeking

instead the flexibility and freedom to pursue and shape their lives independently, and thus express their creativity and individuality. "What they look for in communities," Florida claims, "are abundant high-quality experiences, an openness to diversity of all kinds, and, above all else, the opportunity to validate their identities as creative people."

As described by these theorists and others, one way in which networks profit from heightened mobility is by favoring casual, weak ties over tight, long-term commitments, so as to increase the prospects of fortuitous, happenstance encounters that lead outward from any one communicational nexus or group, enabling communication to expand by incorporating new connections while maintaining old ones as latent and reactivatable. Under such conditions individuals are obliged to shed not only pretenses to sovereignty but also long-term loyalties and identifications, and become instead more mobile, promiscuous operators who mesh seamlessly with the system's mobile, promiscuous operations. Much like the postmodern object or artwork, so too does the networking subject forego claims to autonomy in favor of dependence on context—or rather, many contexts, one context after another, as these themselves become increasingly mobile, short-lived and ever-changing. Granovetter calls this "the *strength* of weak ties"—meaning that power accrues to those who do not succumb to either too much solitude or too much solidarity, too much individualism or too much group commitment, but instead depend on and utilize others via loose chains of informal yet intimate links and contacts.

In this chapter I want to reconsider some examples of art's recent social turn and see if the standard account of them can be problematized and complicated precisely by importing such concepts from sociology, the academic field charged with studying all things social. If today the lone, autonomous actor and the rigid, hierarchical institution no longer dominate as they once did, then perhaps it's the weak-tied network that has taken their place. Indeed, I want to argue, along with Miwon Kwon and James Meyer, that art's recent social turn can be thought of as a specific moment in the history of that vein or methodology in post-1960s art known as institutional critique, the current moment of that history being

characterized by the progressive loosening and dispersing of the institution's formerly rigid structure.

A close identification between the social world and institutions is a distinguishing feature of modernism; Émile Durkheim described sociology as the "science of institutions, their genesis and their functioning."[6] But today institutions typically get pitted against what we identify as the main characteristics of social life: its presumed casualness, effervescence, flexibility and localness. Furthermore, social life gets tacitly imagined or explicitly portrayed as organic and spontaneous, or as practical in a mostly immediate, functionalist sense, but either way as oddly devoid of ideology. It's as if the social could be cleanly divided between immediate experience and practice and a more abstract level of organization, with the former escaping any part in the reproduction of institutions and domination, as if social and ideological practices could be strictly segregated, or as if ideology itself existed without a basis in material practice and daily life, as if it didn't rely on sets of everyday rituals aligned with and crucial to the existence of institutions. Instead social life gets equated with, and alas helps to naturalize, the flexible and mobile, while institutions are regarded as static and long-term, founded upon the authoritarian imposition of societal injunctions and proscriptions that transcend the lives and intentions of particular individuals and groups. Institutions are ascribed the same level of abstractness and permanence as the social contract itself: they are "the humanly devised constraints that shape human interaction."[7] But what happens when the social contract is increasingly replaced by the short-term contract?

A Context of One's Own

Four photographs hang on a wall at the Irish Museum of Modern Art in Dublin (IMMA), part of the 1992 show "Guilt by Association," organized by and featuring the work of five young Scottish artists: Christine Borland, Roderick Buchanan, Douglas Gordon, Kevin Henderson, and Craig Richardson. The photographs are Buchanan's, and each depicts the show's five participants standing or sitting around in the artists' different apartments, in each case embroiled

in the early planning stages of the IMMA project. The five artists have done this once before, initiated an exhibition showcasing themselves ("Self-Conscious State" at Glasgow's Third Eye Centre in 1990). All of them except Henderson are recent graduates of the Environmental Art department at the Glasgow School of Art (GSA), a department founded in 1984 and headed by David Harding, Scotland's first official Town Artist, who was employed from 1968 to 1978 by the department of architecture and planning in Glenrothes. The first students to enroll in the GSA's new department, according to Harding, "had already, at the age of 18 or so, rejected the other traditional disciplines of the School of Fine Art; Painting, Photography, Printmaking and Sculpture."[8] At the same time, he remembers that "the student group"—which also included Claire Barclay, Martin Boyce, Nathan Coley, Jonathan Monk, and Ross Sinclair, among others—"was a remarkably enfolded community."

"In all our conversations you stress the importance of the way in which you reach decisions as a group; the meetings, discussions, reading, eating and drinking."[9] So reads the IMMA show's accompanying catalog, written by Thomas Lawson, himself a native of Glasgow who attended college in Edinburgh before making his reputation as a painter and critic in New York in the 1980s, and who in 1991 moved to Los Angeles to become Dean of the Art School at the California Institute of the Arts (CalArts). For the catalog Lawson decided against a standard single-author essay, instead building a collage from conversations held, and emails and statements exchanged, between himself and the show's five artists. About the fragmentary format choice, Lawson explains, "All of us seem to be traveling constantly." Some of the text was obviously generated on a computer, with deliberate manipulation of letter case and font, while other passages exhibit the immediacy of spoken conversation. Yet any tight question-and-answer causality is ultimately broken up, dispersed, and rearranged in the published version. It's an apt analogy for the show itself, which, as documented in Buchanan's photos, began in dialogue and collaboration and yet ends in discretely individual works and projects, with no shared medium or theme to tie them together, not even a common concern with the particularities of the exhibition site. Shattered syntagms, "clouds of narrative

FIGURE 2.3

Roderick Buchanan, *Untitled*, 1992. Photograph.
Courtesy of the artist.

language elements," as Lyotard describes the remains of collapsed metadiscourses, put forth by a loosely tied group of creative individuals.[10] ("The artists consider themselves 'an arrangement' as opposed to a group," clarifies an IMMA press release.) Lawson gestures for the reader to join in. "You may start reading what follows wherever you wish, and create the narrative you need to negotiate an understanding of the work presented here."[11]

One semi-response floats in from Craig Richardson. "All the competing ideas offered up by the artists," he tells Lawson, "supply a context as dynamic as place or site."[12] Dialogue between the artists is as constitutive of a work's context as is its physical destination, which in this case is pretty remarkable, given that it had been less than a year since IMMA opened in what was the Royal Hospital Kilmainham, a majestic seventeenth-century home for retired Irish soldiers modeled on Les Invalides in Paris. Douglas Gordon reports that what attracted the artists wasn't the Kilmainham building and its dense history so much as IMMA's Declan McGonagle, who, before being appointed the museum's inaugural director, had formerly headed the Orchard Gallery in Derry, where he developed a reputation for, as Gordon puts it, "bringing international artists into a context in which they and their audience felt capable of engaging at a critical level." Indeed, McGonagle's work in Derry landed him on the shortlist for the 1987 Turner Prize, making him the first curator so recognized. "We all wanted to be a part of such a discourse," Gordon states.

A comment by Borland appears. The difference, she notes, between her generation of Scottish artists and the previous one is that the "new ex-students . . . talked more loudly and traveled, which was new . . . travel was perceived as one of the most important things to do." A line from Gordon serves as an elaboration. "In the mid/late '80s the issue of ART in relation to PLACE in relation to INTERNATIONAL art practice was an engaging focus for any young artist who wanted to shift his/her practice from a provincial forum to an international dialogue." Given their mutual rejection of Glasgow's touted tradition of painting, this inaugural group of Environmental Art students was predisposed to the peripatetic conception of art practice the department encouraged, the general

assignment being not to set up individual studios like in the other departments—spaces that, for reasons both practical and ideological, could accommodate routine, be returned to and remain familiar from one day to the next, and thus institute a kind of *ritual*—but rather to go out and do things beyond the parameters of traditional art sites and materials. And so the students wandered. Jonathan Monk, for example, executed a work in which he affixed stickers reading "cancelled" in all capital letters to wheat-pasted posters advertising concerts and other upcoming cultural events. "The department bred confidence in working without a studio, but with writing letters, talking to people, negotiating," recalls classmate Nathan Coley.[13] Introduced here were the fundamentals for a new set of rituals.

But while nomadic, the students remained tightly knit. Dialogue and collaboration were also mainstays of the curriculum. Deemphasizing the studio meant less solitary activity. Housed in a decaying girls' high school far from the main campus, the department foregrounded more temporal modes of expression, performance and video as well as conversation in general. One of the only things it did share with the rest of the school was the Thatcher-era mandates of staff cuts and enrollment increases. Students and teachers didn't have much in the way of resources—and given the student numbers and work load, Harding adds, not even much of a life outside school. But they had each other, and so they made that their life. Without exception, everyone's recollections of the department at the time emphasize the drinking, the parties, and the abiding camaraderie.

And so they bonded, but that didn't mean the group was overly hermetic. Along with their practice having an outwardly, prospector-like orientation, they were professionally ambitious and well informed about recent art world goings-on. They and others used the term "neoconceptual" to position not only their work's operations and properties but also themselves more generally within a canonical history and an international art map. ("Conceptual Art," John Perreault remarked back in 1971, "is a symptom of globalism and it is the first—Surrealism almost was—really international art style.")[14] Harding would invite representatives of Glasgow's most innovative

exhibition space, the artist-run Transmission, to speak to the department each year about the gallery and how it operated. Quickly after graduating, Borland, Gordon, and Richardson all became members of Transmission's governing committee, and showed there as well, along with many of their former classmates. As one local curator remembers their impact, "In the early '90s Transmission became, not mainstream, but certainly more allied to the international art scene. . . . The gallery became increasingly recognized outside Scotland, and increasingly reviewed in the art press."[15] Among the other artists who showed at the space between 1991 and 1993 were Stan Douglas, Wolf Vostell, and (in a show arranged by Gordon) Lawrence Weiner. Transmission also organized exchange exhibitions with similar artist-run spaces in Europe and the US, and as a result committee members quickly built up international exhibition records and established crucial international contacts.

Ambitious wasn't usually how these artists chose to describe themselves. A preferable term was "self-determination." That it still amounted to ambition they also wouldn't deny. For example, in 1991 Ross Sinclair, while still enrolled in Glasgow's MA course (after completing his Environmental Art degree), described his generation in tones that were equal parts confession and manifesto, admitting that "art schools have become ever more intensive and frenetic. . . . Students come careering out like a fast train, fuelled up in a speed frenzy where you've *fuckin' had it* if you're not famous by the time you're twenty five."[16] Sinclair expressed a similar self-critique earlier that year in his artwork *Irascibles*, a takeoff on the famous photograph that forty years earlier and a continent away *Life* magazine ran in response to New York School artists protesting negligence of their work by local museums. Sinclair's remake, in which he and thirteen other recent and current GSA students are shown encased in an ornate gold frame alongside a handy legend to help match names to faces, extinguishes any distance detectable in the original between staunch defiance and self-serving publicity. And yet, while thus demystified, Sinclair's group apotheosis still conveys naked self-assertion more than distancing parody, even (or especially) given the work's modest context—Sinclair made the piece for an exhibition called "The Living Room," in which twenty

artists shoehorned their work into a small Glasgow flat. It wasn't that these newcomers had any illusions about landing a prestigious gallery and selling to collectors (which Glasgow didn't have anyway), much less about trying to make an impression at the occasional regional juried show or during an out-of-town curator's halfhearted visit. "So what do you do?" Sinclair asked. "You get together with other artists and set up some shows . . . create a context for initiating and exhibiting work—*on your own terms*."[17]

"Artists' initiatives," as such DIY shows were called, were a prime example of the group's "self-determination," and ranged from small apartment affairs to much larger undertakings, like the "Windfall '91" exhibition, the last in a short run of self-organized group shows in unconventional, temporary spaces beginning in 1988 in London's Hyde Park and growing into ever-larger outings in Bremen in 1989 and then Glasgow two years later. It was for the handsome catalog accompanying the Glasgow installment that Sinclair wrote his manifesto, in which he touts artists' initiatives for "promot[ing] a sharing of information, skills and experience while also nurturing relationships between artists which can often become fertile breeding grounds for a horizontal and organically developing infrastructure of cultural activity."[18] The organizational force behind "Windfall '91" was again former GSA students who capitalized on their propensity to travel and pile up contacts to leverage twenty-five artists from eight different countries into exhibiting in a soon-to-be-redeveloped downtown building. The show paid off by garnering extensive attention and reviews. The recently established London-based magazine *Frieze* quoted one of the Glasgow organizers, who explained that "the artists were chosen not just on how much we liked their work, but on its suitability to the project and how much they would interact and network."[19]

"Windfall '91" made clear that if these artists were becoming international, that didn't necessarily mean they were about to move to London or New York. And while context or "place" was crucial for them, that context wasn't their hometown of Glasgow, just as it hadn't been the old Royal Hospital when "Guilt by Association" opened at IMMA. Young Glaswegians like Gordon did identify with the previous generation of local artists, but not with their

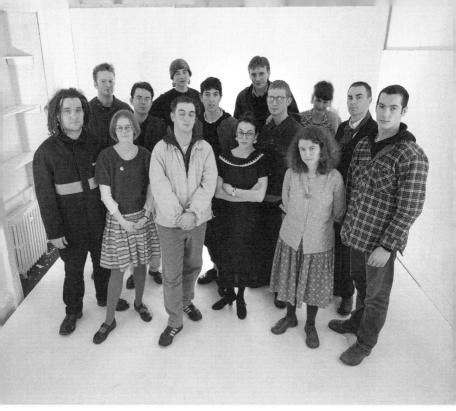

FIGURE 2.4

Ross Sinclair, *The Irascibles* (detail), 1991. Photograph. (1. Ross Sinclair;
2. Karen Vaughan; 3. Nathan Coley; 4. Craig Richardson; 5. Christine
Borland; 6. Douglas Gordon; 7. Roderick Buchanan; 8. Helen Maria Nugent;
9. Malcolm Dickson; 10. Martin Boyce; 11. Heather Allen; 12. Jacqueline
Donachie; 13. Dave Allen; 14. Kenneth MacKay.) Courtesy of the artist.

FIGURE 2.5

"Windfall '91," exhibition at the Seaman's Mission, Glasgow, 1991. Front wall photomural of the participating artists by Roderick Buchanan.

conception of art or of what it meant to be an artist, certainly not with some tradition or school they were deemed to represent, only with their international success—a few neoexpressionist paint- ers from Glasgow like Stephen Campbell and Adrian Wiszniewski achieved international visibility in the 1980s and yet surprisingly chose to remain in town rather than relocate, thus setting an im- portant precedent. The options that once faced artists—trying to make it as a standout in your home city or moving to a crowded center like London—no longer sufficed. The problem with being closely identified with a certain province was that it meant getting pinned down, having one's mobility constricted, while the prob- lem with the center was its overly congested movement, the risk of drowning in obscurity. The aim was fluid movement, passing as if effortlessly from one context or "place" to another within a "horizontal and organically developing infrastructure of cultural ac- tivity." That was the key to joining an "international dialogue" and attaining an "international practice," which Gordon named as the normative pursuit for young artists at the time.

And that's why Gordon writes the formula as he does: art re- lates to place relates to international practice and dialogue. Or talk plus travel, using Borland's more concise math. A few years later, Miwon Kwon would nod in agreement from across the Atlantic, writing in *October* that "if the artist is successful, he or she travels constantly as a freelancer."[20] Talk and travel become the gravita- tional poles that distinctively reorder the field of art for this rising generation, and within that field the studio and the lone creator are displaced, as is anything associated with isolation and fixity. As Boltanski and Chiapello describe the change, against an older as- sumption that "people are creative when they are separated from others," today "creativity is a function of the number and quality of links."[21] As in Buchanan's photographs, when artists are sitting around working and making decisions they aren't isolated; they're immersed in conversation, participating in group interaction, cir- culating ideas. Crucial for an artist is having connections to en- gage, to hear from and respond to, but also for oneself to "occupy a position" that can be communicated, "that can be formulated in words" (to borrow again from Fried on minimalism). At the same

time, no less crucial is the ability to move constantly, to change positions and connections, to disconnect and reconnect as if at will. "In a connexionist world," Boltanski and Chiapello continue, "mobility—the ability to move around autonomously not only in geographical space, but also between people, or in mental space, between ideas—is an essential quality of great men, such that the little people are characterized primarily by their fixity (their inflexibility)."[22] Or, as Kwon remarks in her 1997 essay, "The ability to deploy multiple, fluid identities in and of itself is a privilege of mobilization that has a specific relationship to power."[23]

Talk and travel, as two forms of communication, are both crucial to the rise of poststudio projects and the eclipse of the closed, static *objet*. But they exceed the isolations of the studio and the object in two seemingly opposite directions: talk, by stressing proximate connections to a particular surrounding, thus emphasizing context-dependence; and travel, by effecting a liberation from local context, thus privileging mobility between this context and that. In the 1990s both Kwon and James Meyer would detect the presence of this two-pronged communicational dynamic in the work of many of their contemporaries, and in their writings they traced its emergence back to the 1960s neo-avant-garde, specifically to conceptual art and its shift away from things to what Seth Siegelaub called "secondary information," and also the emphasis in minimalism and site-specific work on not objects but the places, rooms, and environments those objects activate and inflect. Combining investigations both into the contingencies of physical site and into the framing information of catalogs and captions was an important step in the development of 1970s and 1980s institutional critique. But even as institutions begin to wane in significance, interest in combining talk and travel continues to grow.

Indeed, as institutions are "dispersed in clouds of language elements" (Lyotard), what is left behind are talk (the intricate information attained from face-to-face, embedded feedback within a particular context) and travel (the ability to exchange that information with any other faraway niche or context that one chooses). This is the network logic that operates at the heart of much recent poststudio art, those temporary projects or service provisions

made specifically about whatever site they're commissioned for, but which also treat that site as "discursive"—as constituted by custom and historical narratives, by disciplinary or professional bodies of knowledge, by bureaucratic rules and legal parameters, and also by the particular readings given such sites by various constituencies, each according to its particular subject position. As Kwon points out, not only does the category of site "encompass a relay of several interrelated but different spaces and economies," it also becomes increasingly "inclusive of non-art spaces, non-art institutions, and non-art issues (blurring the division between art and non-art)."[24] While site-specific and context-dependent—therefore *embedded*—such work at the same time becomes more mobile and informational, and therefore *disembedded*. Artists "swap one social or project-related setting for the next," Meyer writes, and thereby "prepar[e] themselves for a nomadic practice of artistic critique."[25] Always in transaction with its site, always moving from one site to another. (This is very close to the age-old description of the trader, or more recently the networker or consultant, an unfamiliar face that comes out of nowhere looking for things to exchange, then just as quickly disappears.) Meyer has at times labeled this new conception of site-specificity alternately "the expanded site," "the mobile site," and "the flexible site."[26]

The rise of the flexible site and the concurrent marginalizing of the anchored studio and artwork perhaps marks the demise of a whole episteme based on fixed positions, a model of consciousness erected on a representational logic according to which subjects distance and capture objects through static visual spatializings and orderings. Such objectifications depend on the presumption of a detached viewer, and it's this detachment that the communicational episteme disallows. Instead viewer and viewed, text and context, self and other are all brought into perpetual conversation and feedback with one another. As observers are implicated in theirs and others' various constructions of place, place in turn sheds its supposed physical objectivity. Engaging in a place comes to mean being an active participant in discussions that are always ongoing and unstable, with each actor spurring, directing, but also limiting the others, the tightly woven give-and-take both nesting the group

together and keeping each participant jostled within the turbulent environment of their mutual dialogue. That even Buchanan's camera seems caught up in this communal whirlpool suggests the replacement of visual representation by performed speech.

On the other hand, even when artists are in fact isolated they often aren't standing still, they're moving. Travel inherits from the studio certain conditions for getting work done; as Gordon would later observe, "if you're traveling around then no-one knows where you are, right? . . . When I'm flying from Scotland to Germany or from Holland to France, or whatever, I get so many more hours to think than I would if I was home, spending the whole bloody day answering the telephone, paying bills and responding to letters or whatever."[27] Home is like a bureaucrat's cubicle, less a specific place than an endless repetition of gray administrative tasks, a static, abstract ritual.

The same applies to the studio. Not only is it too insular, too much of a closed space, cut off from outside communication; it's also not substantial enough, not enough of a "real," singular, and unrepeatable place or context. It's too abstract—and not only because, to quote Andrea Fraser again, it is "conditioned by the abstraction of relations of consumption in the commodity form." It is also too ruled by routine and generality, by repetitive rituals based on static categorical definitions about role and purposive action, by the enclosed and distinct institutions that have been built out of artistic mediums and their traditions. Its allegiance to a prior representational regime imposes as primary categories not only the visual and spatial but also the metaphoric and substitutional. No occupant of the studio—whether subject or object, painter or painting—exists in its own right; it's instead assumed to belong to some generic and summarizing identity, a fictional construct that comes already filled, from centering "essence" to policed border, with a prior interiority and unity, an intentionality and narrative coherence. The studio thus lacks the conditions for real exteriority and exactness, for the pinpointedness and timeliness of sited, performative instantiations and interventions—for *projects*. As Kwon writes of the concreteness of projects, "The guarantee of a specific relationship between an art work and its 'site' is not based

on a physical permanence of that relationship . . . but rather on the recognition of its unfixed impermanence, to be experienced as an unrepeatable and fleeting situation."[28] Or, in Fraser's words, the project brings about "the conscious and critical determination, in each particular and immediate instance, of the uses to which artistic activity is put and the interests it serves."

Like the home and the office, the studio is thus different from place or site: whether at the studio, at home, or in the office, you're known, exceedingly so, by name, status, function, role, whereas on the plane (like on the street, but also on the Internet) you're less encumbered by labels and more anonymous, part of a nameless mass, a molten flow. The group of friends who convene at a pub is surprisingly close to the group on the plane, at least in relation to structural determinations of identity and social position; while not anonymous, participants in the group shift roles and functions according to the temporal dynamics of the conversation. This is place: it's punctual and exact, it means involvement in one or more specific projects, it is specifically being with certain colleagues, throwing around ideas, being active. "Its model," Kwon writes, "is not a map but an itinerary, a fragmentary sequence of events and actions through spaces, that is, a nomadic narrative whose path is articulated by the passage of the artist."[29]

Everyday Life

The pub and the street are iconic of what today is celebrated as everyday life, itself increasingly taken to represent a kind of platform writ large, idealized as a flexible space of just-in-time improvisation that floats to the surface in the wake of institutional dispersion. Initially aligned with the Marxist concept of alienation in Henri Lefebvre's pioneering mid-twentieth-century work, the everyday has since been used within critical theory not only to distill the deep banality and emptiness that capitalist society imposes on modern experience but increasingly to marvel at the pedestrian possibilities for transgressing such impositions. Art in the 1990s came to rely heavily on this latter sense of everyday life, and especially the anti-institutional recodings it permits. Here art is imagined to reside not at some Platonic remove, cordoned off within a

separate, autonomous disciplinary realm, but on street level, in a space of modest, shared practices. Artists align themselves with the everyday as representing a culture more common and less elite than what's suggested by the category of "fine art." But not too common. Everyday life is also intimate enough in scale and supposedly authentic enough that it escapes associations with pop or mass culture and its standardizations, its markets and the evils of (Fordist) capitalism. As opposed to modernism's mass and abstract subjects—worker, citizen, and consumer—everyday culture is both too specific and too vaguely general to dally much with such meat-and-potatoes political economy; its focus is so zoomed-in as to privilege individual subjects and groups over the imposed generic regimens their peculiarities and preferences inflect, and yet its scope of reference is so capacious as to seemingly touch upon all forms of material life and practice. In this clandestine realm of everyday activity and transactions, average people are seen as bending rules and living by their wits. As Michel de Certeau romanticizes inhabitants of the everyday, these are "poets of their own affairs, trailblazers in the jungles of functionalist rationality" able to make "dwelling, moving about, speaking, reading, shopping and cooking . . . correspond to the characteristics of tactical ruses and surprises."[30]

The everyday actors whom de Certeau touts speak and act in such a way that doesn't rehearse the official script of institutions and ideology, or even contest it—they live as if in an undetectable series of aporias and non sequiturs, moments of practice so singular they register as only textual lacunae. As Kristin Ross remarks about de Certeau's portrayal, "The liberatory values and *frissons* of 'mobility,' detour and displacement associated in an earlier moment of literary criticism with the slippage of meaning in a text are now attributed to the pedestrian's wily ruses, his various escapes from the hygienic order of the panopticon."[31] Ross goes on to note what a far cry this is not only from those spaces thought to represent institutional state apparatuses—the home, classroom, church, and army barrack—but also from Louis Althusser's idea of the common street itself, where his paradigmatic operation of ideological hailing is staged, the place where the anonymous police

officer calls out as if to everyone and no one in particular, "Hey, you there!"

Everyday life, in other words, has come to represent a modest evasion of "the system" and therefore, significantly, allows art to achieve a new degree of reenchantment. What the everyday provides is a realm not reducible either to institutional codes on the one hand or to purely private experience on the other; the everyday is neither as oversocialized as proponents of institutional critique make the museum out to be nor as undersocialized as aesthetic theory describes encounters with artworks. Indeed, when it comes to the question of art's transcendence, the everyday context allows one to elude both the Scylla of too much belief and the Charybdis of too much skepticism. To take the example of the apartment galleries that flared up in the late 1980s and early 1990s in Glasgow (like the one that staged "The Living Room" show where Sinclair debuted *Irascibles*) but also in Los Angeles and other cities, these signified a backlash against not only art as an institution but also the critique of that institution by preceding generations of artists. (In L.A., for instance, Dave Muller of Three Day Weekend was Michael Asher's student at CalArts; at Art Center, Jorge Pardo, a cofounder of an earlier apartment gallery, Bliss, was a student of Asher's student Stephen Prina. Remember too that Rirkrit Tiravanija, after being immersed in an institutional critique–heavy curriculum as a student at the Whitney Museum's Independent Study Program, staged his first solo show, the famed "Untitled [Free]" at New York's 303 Gallery in 1992, as an overt homage to Michael Asher's first show at a commercial establishment, Los Angeles's Claire Copley Gallery, in 1974.)

In the 1990s, at a moment when metadiscourses were in the midst of collapse—when, in Lyotard's words, "identifying with the great names, the heroes of contemporary history, [was] becoming more and more difficult"[32]—the modest context of daily life helped deflect the expectations of official presentation. Unlike in a white-cube gallery, what characterizes someone's apartment are not stagelike focal points but a semiunconscious and informal ambience. Indeed, as with the turn in music clubs away from live bands performing on stage to DJing and the more ambient energy

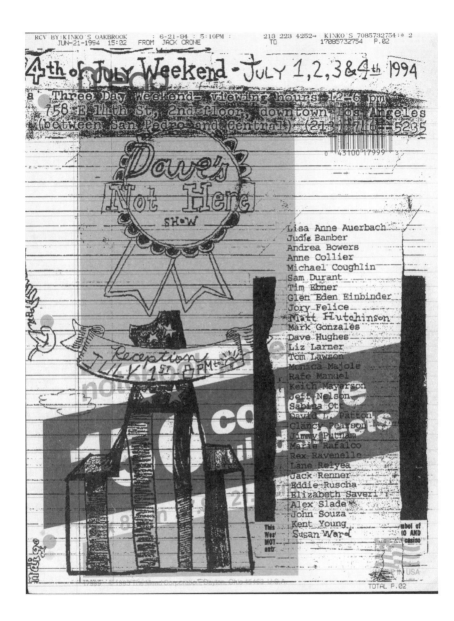

4th of July Weekend - July 1, 2, 3 & 4th 1994

a Three Day Weekend- viewing hours 12-6 pm
758 E 11th St, 2nd floor, downtown Los Angeles
(between San Pedro and Central) (213) 746-5235

Dave's Not Here SHoW

Reception JULY 1ST 8 PM to

Lisa Anne Auerbach
Judie Bamber
Andrea Bowers
Anne Collier
Michael Coughlin
Sam Durant
Tim Ebner
Glen Eden Einbinder
Jory Felice
Matt Hutchinson
Mark Gonzales
Dave Hughes
Liz Larner
Tom Lawson
Monica Majole
Rafe Mandel
Keith Mayerson
Jeff Nelson
Sabina Ott
David L. Patton
Clancі Pearson
Jimmy Putnam
Marie Rafalco
Rex Ravenelle
Lane Relyea
Jack Renner
Eddie Ruscha
Elizabeth Saveri
Alex Slade
John Souza
Kent Young
Susan Ward

FIGURE 2.6

Jory Felice and Dave Muller, *Three Day Weekend Flyer
(Dave's Not Here)*, 1994. Xerox on paper. Collection of Dave
Muller. Photo: Dave Muller. Courtesy of the artist and
Blum & Poe, Los Angeles.

FIGURE 2.7

Diana Thater, *Up the Lintel*, video installation at Bliss,
Pasadena, 1992. Photo: Diana Thater. Courtesy of the artist
and 1301PE, Los Angeles.

and "liveness" of the dance floor (and like karaoke bars, where separation between onstage singer and attentive crowd dissolves), so too at apartment gallery openings, where focus migrates away from what is behind glass, spotlit, and framed on the wall (a space of metaphor and projection) and toward the general mixing and atmosphere of the assembled throng. Attention is likewise dispersed and fugitive rather than centered in the lounges and conversation nooks that proliferated during the decade, as when Gordon and Tiravanija collaborated in the creation of *Cinéma Liberté Bar Lounge* in 1996, or when the latter cooked Thai curry three years earlier in the kitchen of dealer Brian Butler's Santa Monica apartment during the opening of a group show with Pardo, Sarah Seager, and Lincoln Tobier. (Pardo's contribution was also in Butler's kitchen, where he installed new cabinet doors, retiled the floor, and repainted the refrigerator door.) Artists cook and serve meals or re-create bars and lounges in galleries and museums in an effort to conjure an environment without marked-off frames or stages, only diffuse conviviality and atmosphere.

Like other privileged locales of the 1990s, such as the bar or hotel, the scene of the everyday is not only spatially diffused, but its time is too unmodulated to accommodate the dramatic turn of events of narrative form, and thus seems less subject to the historical clock-watching that was a prominent anxiety for many older artists—whether modernist, neo-avant-garde, or leftist generally. The exceedingly organized discourse of the art world could be imagined to not exist: shows at apartment galleries were perceived as if appearing not in a field of professional commentary, historical citation, and career tallying, but in the everyday's poetic antitext. It was as if a new state of innocence was being achieved, in which realist pragmatism and utopian (or microutopian) idealism could be magically reconciled. "I'm not sure that I am so interested in reacting against anything," was the answer Muller gave to the question of what motivated him to mount shows of his friends' art in his home. "I want to work in an organic manner, to maintain a direct relation between the desire to hold an exhibition and the exhibition itself."[33] Again, as in de Certeau's account, there is no contestation here, no ideological differences are at issue. The

FIGURE 2.8

Jorge Pardo, Sarah Seager, Rirkrit Tiravanija, and Lincoln Tobier, installation view of kitchen, group show (at 1301 Franklin, Santa Monica), July-August 1993. Photo: Fredrik Nilsen.

only concern is with maintaining authenticity, which is central to the quality and reputation of both Muller as an organizer and the events he puts his name on. "Certain institutional banalities threaten my spontaneity. . . . Three Day Weekend has always been about creating a sympathetic atmosphere within the confines of my means."

Apartment galleries could serve simultaneously as both home and office—but also as pub, gallery, etc.—and were thus credited with escaping the institutionality of not only the museum but also the traditional home and the traditional office. They were seen as too performative, their enactment of certain functions too punctual for such rigid, abstract labels as private domicile or public workplace. "An artist may be called on to play the role of curator, publisher or publicist, as circumstances dictate," was Hans Ulrich Obrist's reaction to the apartment galleries he saw revitalizing the UK art scene beginning in the 1990s.[34] Here one could be recognized as holding a certain position and its corresponding status and function based merely on casual arrangements made in conversation with friends, without the need for any fixed institutional titles and offices. "An institution differs from a conversation," Lyotard writes, "in that it always requires supplementary constraints"—having the right credentials and rank, knowing the proper professional terminology and behaviors—"for statements to be declared admissible within its bounds."[35]

Apartment galleries, in other words, are places. But this doesn't mean the reverse, that the traditional home or the traditional office represent place's dialectical opposite. Rather, the compliment to a specific place and project is precisely nowhere—being between places, hurtling at five hundred miles per hour nearly six miles above an empty countryside or ocean surface. With talk and travel brought to the fore under the general demand for greater connection and mobility, the opposition between stasis and movement, staying at home and hitting the road, gets superseded by relationships between kinds of communication, between those that are proximate versus distant, or those that have active versus passive components. Compared to project-making and place-activating talk, traveling is more passive, it means being pushed around

or transmitted between points, and because of this passivity it's more conducive to an outwardly disengaged mode, allowing one to turn inward and reflect privately, think to oneself. Travel provides sanctuary, a prolonged interval to collect one's thoughts, summarize, piece together an overview; the plane becomes, to use Buren's phrase, an "ivory tower," a space or—to slide the architectural metaphor toward temporality and process—a moment of autonomy and freedom, of free thinking and open imagination. In the move to a more connectionist world, certain of the studio's most important ideological functions are made possible by the nonplaces of plane and airport terminal. But either way, zooming through international space on a plane or leaning into a heated conversation with intimates at a pub or an art opening at someone's apartment, both beat being stuck in an officelike environment, trapped within a routine, repeating the same procedures day in and day out. That kind of work is left for others.

The Middle Drops Out

"Once the notion of the studio as a central locus of production from which art is dispatched toward other centers—galleries, museums, and the appropriately named 'art centers'—began to come unraveled, art no longer took its inspiration from geometry but literally from kinematics." So announced the critic Jean-Pierre Criqui in 1996. "In this context, the artist becomes an essentially mobile individual whose peregrinations form the basis of, or at least influence strongly, the work of art."[36] Described here is a kind of movement that newly articulates the field of art, resulting in a map that is no longer subtractive and compositional, dominated by predetermined perimeters and their center points. Instead art making now ranges beyond the dictates of medium specificity and generic role, and likewise artists travel to and show in cities other than the nearest art capital. In a field organized by connectivity rather than enclosures, the stasis of boxes, of boxing in, is replaced by the tensions and flows created by movements in all directions, with connections pulling in toward the close-up as well as pushing out toward the far-away. Value and status accrue to those who can bring the resources of the far, the far-flung, the disparate into

the close, tight working of a specific group and project; and vice versa, they go to those who can also bring the specificity, coherence, and concreteness of the tight group and project to places and others who are far away, far-flung, all over the map. (This goes for publicity in general today, as one must weigh the effectiveness of media that is broad in reach versus that which is more niched and narrowly targeted.) It's this tension between the centripetal pull of intimacy and the centrifugal push of global communication and travel that renders institutional enclosures obsolete and obstructive. The new map is both much bigger and much smaller. International mobility expands the terrain; context as interchange among a particular group contracts it.

But within this new landscape, with its sense of boundless extension providing a backdrop to small pockets of high-intensity group involvement, what happens to the middle ground? If what counts for context now is short-term projects, or just dialogue between friends—friends sitting directly across the table from one another, friends in different countries halfway around the world—what happens to such midlevel cultural institutions as museums? If at the macro end the art map now unfolds as if endlessly to chart a vast expanse of remote radar blips, while at the micro end it zooms in so closely as to register private, face-to-face performances, organic and immediate spaces stirred with breathy laughter and whispered talk, spaces of creaturely comforts, of touch and smell, of spontaneity and authenticity—between such densely compacted specificities and the far-flung trajectories of the art world's increasingly global reach, how do various mediating forms or paradigms in the middle not lose purchase, or just drop out of view entirely?

What troubles poststudio art making, then, is its inherent wariness when it comes to committing to a set place or position. How much repetition and routine can its interventions and operations take on while still warding off autonomy, disconnection, and abstraction—and hence institutionalization—in order to remain performance-based, pinpointed, and timely? How, or on what level, can it commit or subtend itself to, become statically identified with or stand for, one particular method or goal or principle?

If poststudio art is forever reliant on some further, next place and instance, one can think of it as additive rather than subtractive—instead of composing a painting or sculpture, or subdividing a box-like identity (abstract or figurative? romantic or classical?), such art must proceed from context to context. And yet if not generalizable, how then does such an art transcend the idiosyncratic and become socially recognizable?

Perhaps it's the artist her or himself—as "the only element worth the effort of identifying and developing ... the only thing that presents itself as even minimally enduring"—that becomes institutionalized. Or, to use the language of marketing, becomes branded. "Where any artist is will be the center," as Siegelaub put it. About poststudio's necessary itinerancy, Kwon remarks that "the artist approximates the 'work' . . . the presence of the artist has become an absolute prerequisite. . . . It is now the *performative* aspect of an artist's characteristic mode of operation (even when collaborative) that is repeated and circulated as a new art commodity."[37] As the art object dematerializes, value continues to be amassed, if not in the museum's collection then on the individual's CV. But the artist as brand can't come across as so statuesquely iconic as to appear aloof. Part of one's "characteristic mode" must be a knack for getting embedded in contexts and groups. Always having an institution to critique, a party to DJ, a crowded meal to prepare.

There's no question that for the young graduates of the Environmental Art department like Gordon it wasn't a matter of personal cliques on the one hand and international recognition on the other. They did identify with their home town and with Scotland, at least on some level. Upon accepting the Turner Prize in 1996, Gordon formally expressed his debt and allegiance to his fellow GSA classmates, ceremoniously referring to them in his speech as the "Scotia Nostra." As subjects they were all connectionist—dead set against the stereotype of the artist as lone genius or heroic individual, instead outward-going and context-dependent, embracing the intersubjective and performed determinations of the self. But they still exhibited a decided leeriness when it came to social institutions. Glasgow's storied past certainly didn't compel their devotion, or at least not that past as it had been distilled over time

into the art and writing collected in local museums and popular anthologies, and adopted as official imagery and narratives by the city and regional councils, or by the labor movement and other oppositional groups—stories about Glasgow's industrial-era glory as an international center of shipbuilding, about heroic strikes and other forms of resistance by workers against owners, of gritty survival in the face of severe economic and population decline starting as far back as the 1920s. Such representations assumed the stable existence of some collective subject—the City or the Proletariat or Scottish identity itself—bestowing narrative continuity and drama and a space of interior depth onto what were otherwise the institutional categories behind the modern organizing of large-scale social relations. To artists freshly trained in poetics and semiotic analysis and hungry for something to deconstruct, these official versions were like so many readymade constructs ripe for the picking. But on a deeper level the artists were expressing their feeling of disenchantment, their recognition that such master narratives, despite claiming enduring foundational status, now appeared hobbled, so contrived as to be beyond reform or overthrow. These metadiscourses lacked, to use Lyotard's word, credibility.

Compare, for example, Ken Currie, an artist from the previous generation, addressing Glasgow's long legacy of labor strife in his celebrated suite of murals commissioned in 1987, with Gordon, three years later, handling similar subject matter in a mural he executed just a few hundred yards away. Both works are situated in Glasgow Green, the old park known for hosting popular gatherings on the city's historically underprivileged east side. Currie's eight paintings adorn the ceiling of the People's Palace, a late-Victorian-era museum of social history set at the park's center, and were commissioned to celebrate the two hundredth anniversary of the Scottish labor movement. For *Proof*, 1990, Gordon chose not only a derelict site, the two adjacent walls that remained of the park's old railway station, but he also chose to paint his mural not on the building's front (facing the Palace) but rather on the inside of the walls facing back east. Currie's mural depicts eight turning points in labor history, each filled with allegorical figures striking theatrical poses, all rendered in a style crossing Neue Sachlichkeit with

Diego Rivera. By contrast, Gordon's precedents lean more toward Lawrence Weiner and On Kawara; his mural also starts with the date of the labor movement's birth, 1787, but then follows that with five other historical dates, each of the years simply listed in stenciled numbers, black on white, while on the adjacent wall is spelled out the single word *mute* in italics, followed by a slightly oversized comma.

How Gordon's mural operates is by treating its internal components and its external surroundings as one interrelated set of checkerboard-like functions and positions. There's a continuous play between west and south walls, text and number, italics and nonitalics, diachronic syntagm and synchronic grid, as well as between the work's generally open matrix and Currie's linear start-to-finish narrative. While Currie's dramaturgy of the lowly masses is enshrined, literally elevated on the ceiling of the nearby Palace, Gordon's loose collection of punctual facts inhabits a former transit hub, a site of intersections and constant motion (itself in transition, given over to the elements, to contingency and decay). The very word *mute* is filled with tension: big and italic, it loudly announces silence, emphatically calls for reserve. And if the conspicuous comma that punctuates it also signifies a break, it's a pause only, not a full stop, and thus also implies a pending continuation, more to say. So while literally signifying erasure and absence, here *mute* also brims with polyvalence thanks to its context. Reading the two walls left to right, the word ironically serves as a key for how to extrapolate meaning from the scene, and not only from the otherwise cryptic list of dates on the facing wall (especially since the last two dates correspond with the enactment and repeal of laws attacking public assembly and free speech in the city). *Mute* also opens a reading of the entropy to which the structure as a whole has succumbed, and the forms of nature now overtaking it.

Gordon's mural allows for, indeed depends on, a high degree of contingency and arbitrariness; not just a depiction of historical events, it is also an analytical breakdown of the basic mechanisms of such depiction. The resulting collection of fragmented and open-ended signifiers still allows meaning to be drawn from it, but only with an effort that betrays its undecidability, its negotiated and

FIGURE 2.9

Ken Currie, *Fight or Starve. . . Wandering through the Thirties* (panel six of the *Glasgow History Mural*), 1987. Oil on canvas. 86 × 150 in. People's Palace, Glasgow. © the artist and CSG CIC Glasgow Museums Collection.

FIGURE 2.10

Douglas Gordon, *Proof*, 1989, wall text, public artwork, Glasgow Green Station, London Road, Glasgow. Commissioned by the "Sites/Positions Project." Courtesy of Studio lost but found/Douglas Gordon.

inconclusive character. To use a distinction that had marked early twentieth-century Marxist debates on avant-garde aesthetics and was now being revived in the 1980s and early 1990s, whereas Currie aims to represent politics, to exalt and encourage tight identification with his story's protagonist, the working class, imagined as an essentialized collective identity, static, substantive, and inherent, Gordon seeks to make representation itself a political question, by emphasizing the story's constructed nature. In Currie's mural, representation is given the task of speaking on behalf of an already formed referent that precedes the relational and differential play of signification; for Gordon the referent is actively produced by and between vested positions and representational actions and practices, rather than existing prior to and outside of them.

But to suggest that cultural practice could remain politically engaged by approaching representation as something to critique rather than as a tool to awaken class consciousness was an especially fraught issue in a city like Glasgow, where the long-standing mix of Calvinist work ethic, commonsense philosophy, and proletarian identity led to a strong insistence on labor as a uniquely transcendent signified, the only basis of real action, real value, and real virtue. The issue was made even more volatile by the city's experience of deindustrialization. Not just factories closing and jobs disappearing: Glasgow was exemplary of the changes cities endured as newly globalized and decentralized businesses, liberated from the need to be physically near resources and markets, could instead approach location as a consumer choice, and governments in turn relented to the desires of this more unconstrained capital by advancing deregulation in place of former centralizing and protectionist industrial and urban policy. The resulting need to replace disappearing public money by attracting foreign investment led many metropolises, Glasgow among them, to turn outward, to exteriorize and aggressively brand themselves. Power was handed to public-private partnerships—in Glasgow's case a private-sector cabal called Glasgow Action—to improve "the business climate" and negotiate directly with companies, leading public policy to shift its focus from social equity to economic growth. Already by 1989 David Harvey was describing this trend as a move away from

managerial toward entrepreneurial city governance, away from "rational planning" toward more speculative and riskier investing (in new stadiums, outdoor waterfront developments, and the like).[38] That is, cities were undergoing transformations similar to that of business corporations, which Boltanski and Chiapello also characterize as a switch from managerial to entrepreneurial paradigms. Also typical was how Glasgow's "place marketing" relied heavily on leveraging the city's culture, its museums, monuments, and other distinctive features, as an asset that, while public or "common" enough to warrant using tax money on its upkeep (like roads and parks), could be manipulated as capital to generate private profits through higher rents, increased retail activity, tourism, etc.

Formed in 1985, Glasgow Action began to work closely with public agencies to heavily revise the city's image so as to better position it in the global economy. The efforts, which included a public works project to polish the stone facades of older buildings, paid off a year later, just before labor's two hundredth anniversary, when Glasgow won its bid to become European Capital of Culture for 1990. The announcement was a surprise since, unlike the first five cities to boast the title—Athens, Florence, Amsterdam, West Berlin, and Paris—Glasgow was known more for its joblessness and soccer violence than its arts scene. But the city threw itself, and its money, far more fully into the yearlong celebration than any of its predecessors, seeing it as a unique opportunity for its more long-term urban-renewal drive. So intense and unprecedented was the promotional effort that to this day city and regional leaders around the globe still talk about "doing a Glasgow." Saatchi and Saatchi handled the publicity, with print ads and posters rendered in turn-of-the-century Art Nouveau lettering suggestive of homegrown architect and designer Charles Rennie Mackintosh. Local art establishments both large and small saw funding increases over the year, but nothing like the money dangled to lure big-ticket acts like Frank Sinatra and the Bolshoi Ballet, or spent on the building of a new museum in the redeveloped part of downtown that would parade Glasgow's vibrant and unique history and identity.

Still, the Capital of Culture campaign met with plenty of local dissent, visually expressed by détourned versions of the Saatchi

posters (one featuring a layman with empty trouser pockets turned out, beneath him the simple tagline "1991"). Artists also joined in: Sinclair, for one, applied the situationist tactic of reversal in posters he plastered throughout the city advertising Glasgow's "Culture of Capital." The loudest opposition, though, was voiced by the some forty local writers, artists, and activists who joined to form the group Workers City. Along with waging numerous letter-writing campaigns and other protests, the group published two books, *Workers City: The Real Glasgow Stands Up* in 1988 and *Workers City: The Reckoning* in 1990, both collections of essays, poetry, and short fiction indicative, according to editor Farquhar McLay, of "the liberating power of working-class experience and consciousness in a long-standing tradition of struggle."[39] Workers City demanded accountability in the huge public outlays, and decried the transfer of materials from the free-to-the-public People's Palace to the new downtown museum, which not only charged admission but thoroughly sanitized Glasgow's past and present conditions to accord with development propaganda. "Glasgow—the working class city par excellence—is under attack," the first Workers City book warned. "Opportunistic politicians and entrepreneurial admen are concocting a lie," imposing a "wine-bar culture" that would transform the city "into the happy-land of yuppiedom."[40]

Capital of Culture or Workers City—which more accurately represented the *real* Glasgow? To many, the versions of both the Workers City group and the redevelopers were equally reductive. Especially in the arts scene, tension already existed between, on the one hand, those who privileged a politics of class and championed artists like Currie and, on the other, those who embraced the new social movements and conceived of progressive politics as advancing from multiple, unstable, and incommensurate positions. In 1985 Transmission committee member Malcolm Dickson argued for a broader notion of engaged culture, and complained in print that "Currie claims to speak on behalf of a class which is depicted as a formless mass of socialized humanity . . . to fit reality into ideological theory, as presented by the British Communist Party. . . . [T]here is no room for, or an understanding of, a situation of plurality in culture and in politics."[41] Was it an act of

FIGURE 2.11

From *The Glasgow Keelie*, distributed freely and anonymously by the Workers City group.

depoliticization to rethink Glasgow in terms of cultural identity? Or was it a much-needed updating, a chance at a belated cultural turn for the Scottish left?

The Capital of Culture campaign only skewed the debate even further. For one thing, the campaign was an attempt on the part of the city's Labour Party majority to reckon with the extent to which capitalism itself had become less real, or at least less industrial and static and more entrepreneurial and flexible, more a matter of mobile, dematerialized flows. What stoked competition within the field of place marketing was not only the ability of businesses to more freely select location but the fact that that choice, the city as a whole, had become all the more decisive. In other words, with increasing globalization and informatization, the importance to any city of a single factory or even isolated industrial sector had diminished, but the city as a whole became a potentially more crucial unit in the accumulation process. (As Christian Marazzi writes in an early work on the new role within post-Fordism of cognitive or immaterial labor, or conversation as *economic* context: "Productivity cannot be measured on the basis of the quantity of goods produced per hour, nor can it be determined by reference to a specific company or economic sector. What is measured, instead, is a multiplicity of factors characterizing a social and regional space that transcends the single worker and allows her to create wealth by being *a member of a community*.")[42] Whatever Glasgow opted to brandish as the core of its identity—whether culture or industry, old cathedrals or former shipyards—it was not about disclosing essence (certainly not about untangling histories of religious intolerance, say, or abject working conditions, and most certainly not about the heavy masculinist prejudices of labor ideology). It was about product placement. Global competition for footloose business encouraged cities like Glasgow to define themselves outwardly and negatively, against one another and in response to outside demand, and this made any inherent distinctive quality—whether art or industry—recede behind how each city leveraged that quality to differentiate itself as a commodity on the market. It would be difficult to find a "real" Glasgow behind the sales pitch the city was turning itself into.

But it was also true that the workers' movement would feel this dispossession most acutely. And not only because left metaphysics had long invested in the idea of essence, of labor as essential reality and inherent, substantive value. Labor was also identified with other tropes belonging to a seemingly earlier modernism: it was a mass movement with a universalist ideology, associated with large-scale rationalization, with bureaucratic unions and housing projects, a culture of cradle-to-grave continuities, of fixed roles and the promise of a job for life. Class also presumed a notion of a fixed social body, with causally determined relations circumscribed inside an institutionally, politically, and economically organized totality, an assumption that aligned well with the figure of the industrial city as a bound and stratified territorial whole, centered around one business or even one large factory striated in vertical tiers from the lowliest workers up through management to the owner on top. Replacing a daily routine at the factory with a life meted out on state welfare was a grim reality but one embraced in working-class lore—being on the dole is a major theme of the Workers City books. But that other reality, of having to transition into an informal and part-time workforce organized around not production but projects and services, that reality was alien. And that was the kind of city Glasgow seemed intent on becoming, or being known for, less a bounded whole and more of a hub, a flexible space of transient contracts and endeavors, of nomadic, spectacular events and sporadic incoming and outgoing flows of people, cash, and conversation.

The new value placed on flexibility and impermanence, on a seeming liberation from routines, continuities, and limits, was something the discourse on class found difficult to assimilate, but which certain other cultural discourses did not, especially those that were already being appropriated into new-economy propaganda that extolled "nomadic" entrepreneurial lifestyles and "creative" freelance temp work. And one small but pivotal sector in Glasgow's cultural infrastructure, the contemporary visual arts community, could be pointed to as proof that success was indeed attainable through a formula of entrepreneurial initiative and flexibility, of agency conceived not in terms of large essentialized

collectives but small and temporary work teams, a "loose arrange-
ment as opposed to a group." "What has happened in Glasgow is
not truly rooted in institutions but in individuals," former Trans-
mission curator Katrina Brown explained about the city's growing
art buzz. "It is founded in a loose, sometimes tight but informal
association for which the city is a locus of operation rather than a
source of institutional or financial support."[43] Or, as *Frieze* editor
Matthew Slotover reported in 1992, "artists' initiatives have put
Glasgow on the map."[44]

Again, it was the "Windfall '91" exhibition that seemed the
tipping point. Among the qualities critics found so appealing was
how the show, even with twenty-five artists from eight differ-
ent countries, didn't stand for anything beyond itself; there was
no larger representational structure it felt necessary to demon-
strate or contribute to or undermine or comment on. "As 'Wind-
fall' makes no claim to be representative of anything other than
a group which constitutes it at the time," one critic noted, "it has
a certain freedom of action, a spirit which refuses to place itself
under anyone else's compunction. This gives the project as a whole
a lightness and mobility which seems very appropriate to the mo-
ment."[45] Liam Gillick made much the same point in his write-up of
the show in *Artscribe*. "As with most exhibitions of this type, one
had to view the various artists as an intentionally diverse grouping
rather than as sharing common interests or displaying considered
juxtapositions of intention and character."[46] Not even the site of
"Windfall '91," an old seamen's mission along the River Clyde slated
for redevelopment, seemed to pose any resistance, a need to be
acknowledged or negotiated. In a conversation with Gordon and
Martin Boyce in the same issue of *Frieze* that reported on the show,
fellow classmate Nathan Coley announced, "We feel that the term
site-specific has become meaningless."[47]

Gordon agreed. During an interview in 2002 he recalled how
"at some point around 1990 I began to feel uncomfortable about
this [site-specific] 'method' of working. . . . I had experienced many
other artists flying into Glasgow and completely misjudging the
site and the intimacies that exist in unfamiliar places. . . . I real-
ized that I couldn't use 'the method' in my own city. . . . I already

knew too much."[48] What seems to have dawned on Gordon, and on many other artists around the same time, given the increasing (and increasingly acknowledged) fragmentation of publics and constituencies, was a realization about the partiality of knowledge, the fact that no single vantage point could adequately sum up the meaning of a place, that such meaning, no matter how objectively understood, would always be conditioned by the limits, incompleteness, and instability of the position and point of view of the individual or group rendering it. But for Gordon the outcome of this realization was not a sense of lost objectivity and certainty, the sudden unavailability of the totalizing overview. Rather, in a striking reversal, he instead experienced a sense of fullness, of "knowing too much."

And so Gordon changed his method and began to interrogate not the city or its public sites but rather his own personal and social relationships, something from which he could extract much more finely grained information—more specific, not less. "Other people," he continues, "seemed to be the very thing that made up my memories, stories, wishes, past and future of this 'knowledge.'"[49] The result was a new mural, *List of Names*, 1990, which comprised more than fifteen hundred names sign-painted in sans-serif lettering and ordered in straight columns along a wall seventy feet long, the names belonging to everyone Gordon at the time could remember having met in his life. "The names were not based on a city, a country, a nation, or whatever. It was a broad sweep of my experience."

The only context, in other words, that became credible for Gordon was other people, people he had actually met face to face. That and himself; or rather, what Gordon trusted was his memory and its ability, as if in the absence of any more official or impersonal or institutional support ("city, country, nation, whatever"), to hold together this social field, to maintain the connection between him and it. *List of Names* is a membership roll, but unlike the names of honored citizens inscribed in public memorials, or of funders and trustees draped on the walls of most other art establishments, Gordon's list lacks any fixed criteria for who's in or out, any generally recognizable level of service or contribution or sacrifice for

the names to stand as synecdoches for the city's or region's greater good. The names seem to exist without a categorical heading or abstract definition that could make sense out of them, some larger cause or identity that subsumes them, of which they could all equally be representative—some but not all of these people know each other, some but not all are in the art world, some but not all are Scottish. The only category that ties them together, that connects them equally, is Gordon himself. He is the category, the determining context.

Or rather, in *List of Names* Gordon confuses the two, he substitutes context, the indexical association of things based on their being physically proximate to each other (face to face), for a lexical association of things based on their belonging to the same general semantic genus or classification. Such classificatory associations among lexical units exert a determining power over the meaning of each despite their not all being literally present in a given message—classification as relations within sets "unites terms *in absentia* in a potential mnemonic series," as Ferdinand de Saussure, in *Course on General Linguistics*, describes a language group's common aggregate of related signifying elements.[50] Saussure uses the architectural metaphor of a storehouse (Jakobson does too) to describe this virtual collection of available signs, thus conveying how, unlike when actualized in the temporality of speech, mnemonically related signs like synonyms and antonyms exist synchronically, as if in a state of static spatiality, "a self-contained whole" ordered by isomorphic comparisons and contrasts, differences and sameness, and thus are amenable to abstract categorization or predicative groupings.

Gordon's *List of Names* also presents a storehouse of sorts, it too collects together terms in absentia, people not physically in the gallery—and yet there is no ordering available, not even predicates to separate professional colleagues from casual friends from lovers, family members, or rivals. There is no possible filtering of such conditions and statuses, since that would require the introduction of abstract meanings able to stand on their own; the names are not allowed to be representative of something more than themselves, there's no code to which they belong. Indeed, as far as signs are

FIGURE 2.12

Douglas Gordon, *List of Names* (view of the exhibition "Self Conscious State," Third Eye Centre, Glasgow), 1990. Wall text. Courtesy of Studio lost but found/Heidi Kosaniuk.

concerned there's nothing absent, every name Gordon can think of is put on the wall. What is missing from *List of Names* is precisely a metalanguage. (As Jakobson elaborates Saussure, "The interpretation of one linguistic sign through other, in some respect homogeneous, signs of the same language is a metalinguistic operation.")[51] The names are available to Gordon only, the memory from which they are drawn is his alone. Gordon substitutes himself, his experience, for a general category or metalanguage, he institutes a personal, concrete, and syntagmatic history of his daily encounters in the place of an impersonal, communal, abstract, and paradigmatic set.

Like in his previous mural *Proof*, here again Gordon builds tension through the activating of contradictions, except now he relies on fewer preexisting and dispersed elements. No need for palace and train station; this time the wall itself, belonging to the local multimedia venue Third Eye Centre, emphasizes the mural's promise of architectural housing and permanence, it alone establishes a dominant grain for Gordon to cut across. For the mural that Gordon ends up executing is in fact about the impermanent and nonarchitectural; it's performative, the result of a task Gordon has set for himself—the list contains solely those names Gordon could recall on the spot, that were physically within reach of the power of his memory at the time the mural was sketched out in preparation for it being painted. Only information this verifiable, this immediate and local, was admissible. *List of Names* is concerned with establishing a new horizon of credibility, one that accords with a world oriented by far-flung travel and face-to-face talk, by temporary projects, by flexibility and discontinuity, in which the sphere to which one belongs—of shared interpretations, common cultural codes, and commensurate language use—is no longer convincingly delimited in the architectural or territorial terms common to social institutions, but rather in terms of acquaintances, social networks, who one knows. No other mediating form organizes this collectivity beyond the sense that each individual member has of it at any given moment.

This kind of intense but impermanent social grouping newly defines context not just for Gordon but for the emerging global city as well, the city as platform, or what Boltanski and Chiapello

call the "projectionist city," the city of projects. Recalling Boltanski and Chiapello's description of the project per se, the importance of the projectionist city as a whole is that it too "temporarily assembles a very disparate group of people . . . for a short period of time but allows for the construction of more enduring links that will be put on hold while remaining available."[52] This foremost capacity of the projectionist city, its power to serve as a platform for intersecting networks, was the key to Glasgow's success in the 1990s, at least in terms of its art scene. As Christoph Keller would later write, "Glasgow has developed into a strong role model for many other artistic circles in Europe, the ideal image of a friendly and socially connected artistic community rooted in collective, collaborative work."[53] In 1993 the curator Charles Esche, prior to organizing several megabiennials, moved to Glasgow to become director of the visual arts program at the Tramway Gallery. So, too, Maria Lind, the international curator—she "had to go to Scotland," as she exclaimed about her first trip to the city in 1994.[54] Two years later Hans Ulrich Obrist expressed wonder at what he hailed as "the Glasgow miracle."[55]

Potemkin Villages

In the same year as his Glasgow revelation, Obrist wrote in the catalog for his show "Life/Live," a survey of 1990s art activity in the UK, that artists' initiatives were one of the main "reasons for the extraordinary dynamism of the British art scene," not only in Glasgow but across the country, from Edinburgh to Nailsworth, Belfast to London:

> Artists are often limited by the spaces in which their work and activities are shown. Those who want to be free of such constraints have created their own experimental spaces. . . . Their organization puts the onus on participation and collaboration: decisions are taken quickly, without red tape, through open structures that can be adapted to changing situations. . . . Hierarchy is overturned. . . . As sites of independence and transgression artist-run spaces effect a permanent critique of the

traditional operation of art galleries and institutions, refusing any predeterminism, which imposes a certain way of looking on the spectator. . . . But the most striking thing about these groups is the circulation of information, the capacity to forge links with others, across the generations, locally, nationally and internationally.[56]

Two years later, Obrist found himself similarly weak in the knees when confronted by the scene in Los Angeles. While interviewing recent CalArts alumnus Dave Muller about his ongoing project Three Day Weekend, Obrist confided, "When I made studio visits in L.A. earlier this year I found that the dialogue between artists is stronger than in New York. It actually reminded me of the Glaswegian situation where spaces like Transmission go hand in hand with lots of other artist-run initiatives."[57]

Muller generally agreed. "The issues that Three Day Weekend might bring up through its sheer existence—the nomadic, DIY, temporality, situational/context, non-monumentality—I see as being topics pertinent to my immediate generation."[58] The two scenes had in fact developed a literal exchange, mostly through CalArts. It was at the beginning of all the hoopla in Glasgow in 1990 that Thomas Lawson, after being away for twenty years, returned to the city of his birth to participate in a group show there. And it was during that trip that he first met and was impressed by many former and current GSA students, including Gordon and Borland. He also visited with several of their teachers whom he had known since his days in Edinburgh, including Sam Ainsley, who headed the GSA's MFA course and was looking for other schools with which to set up exchange programs. Lawson agreed to establish such a program between the GSA and CalArts, and a year later Ross Sinclair showed up to attend classes in Southern California. There he met Muller and went on to participate in the second Three Day Weekend event, a show of Glasgow and Los Angeles artists that Muller organized with Dave Allen, who followed Sinclair to CalArts as a GSA exchange student.

In many respects Los Angeles and Glasgow couldn't have been more diametrically opposed. Rusting Glasgow on the one hand,

trying desperately to deflect tourist money its way by selling nostalgia for its bygone maritime industry, versus L.A. on the other, global behemoth of such virtual industries as media and finance, with its aerospace futurism and show-biz culture and seeming lack of any past. In terms of their art scenes, though, both cities had long experienced marginalization. Before the 1990s, according to local critic Christopher Knight, being labeled an "L.A. artist" was "ruinous."[59] Los Angeles suffered under New York's shadow much as Glasgow felt eclipsed by London's; both were deemed provinces, quirky at best, otherwise just sparse and irrelevant. Indeed, when Gordon first showed in New York in 1991, as part of "Walk On: Six Artists from Scotland" at the Jack Tilton Gallery, the show's catalog included an essay by Murdo Macdonald that quotes from Craig Beveridge's *The Eclipse of Scottish Culture: Inferiorism and the Intellectuals*, specifically the part of the book that frames Scotland's situation through Frantz Fanon's description of colonial oppression.[60]

Also like Glasgow, in the mid-1980s L.A. began to invest heavily in the arts as a way to shore up its global reputation. In 1986 the Museum of Contemporary Art opened (its name changed from the originally planned Los Angeles Museum of Modern Art, thus "signifying that it would present art from an international rather than regional perspective"),[61] and a year later the city hosted a sprawling, big-ticket international arts festival. As in Glasgow, the response was admiration from afar and disillusionment locally. "Potemkin Village," scoffed Linda Frye Burnham in the *L.A. Weekly*. The city, she lamented, "touts itself as the next capital of art, but treats its artists like illegal aliens. . . . We adulate state-supported geniuses like Pina Bausch and Maguy Marin, whose spectacles are the product of healthy arts environments elsewhere . . . [while] L.A. artists are in a desperate state, fighting over scraps, without career opportunities, funds or housing."[62] But of course local artists weren't the ones the festival's sales pitch was aimed at.

L.A.'s approach to its image makeover was distinct: while Glasgow tried to reverse its reputation as depressed, violent, and dark by going for a brighter, more intellectual look (the new generation of neoconceptualists, argues Macdonald in the Tilton catalog, is ultimately descended from the Scottish enlightenment), L.A.

tried to counter the overly sunny, "light and space" stereotype that burdened its art by demonstrating that it, too, had all the dystopian, noir characteristics of an authentic urban jungle. To that end, in 1992 the Museum of Contemporary Art opened "Helter Skelter: L.A. Art in the '90s," which applauded local artists for, as curator Paul Schimmel wrote in the catalog, their "use of debased signs and symbols and embrace of raw subjects from everyday life."[63] ("Teen delinquency and antisocial behavior take center stage," enthused a museum brochure.)[64] Despite such brand differences, though, the goal remained the same for the two cities: getting "on the map." Schimmel was quite explicit on this point in his catalog essay: "L.A. does have a culture of its own . . . its community is different from others . . . 'regional' art need not bear the burden of provincialism." And the map he imagined L.A. finding a place on was very much the same as Gordon's—international, decentered, and networked. "Increasing globalization and changing economic conditions make it apparent that there will never again be singular cultural centers in the way that Paris and New York once were," Schimmel concludes. "In fact, it is clear that there are to be many centers, with L.A. playing a prominent role in that international circuit."[65]

Beyond marketing, the two cities also shared certain structural features that gave them a potential competitive advantage in the newly emerging global circuitry. Unlike other metropolises, neither L.A. nor Glasgow (nor London, for that matter, at least not until later) would have to host any international biennials or art fairs to generate buzz and gain international visibility. For one thing, like in Glasgow, young artists coming out of Los Angeles art schools could look to certain important members of the immediately preceding generation—Mike Kelley, for instance—who had decided to stay in town even after gaining recognition abroad. But they also had their teachers as examples. Indeed, "Helter Skelter" was very much a school show; it identified L.A. with a roster of mostly area instructors (Chris Burden, Paul McCarthy, Charles Ray, Nancy Rubin, and Kelley himself) along with some of their recent graduates (Meg Cranston, Victor Estrada, Liz Larner) and ignored the formerly dominant cadre of local painters like Charles Arnoldi and Ed Moses, who perhaps accepted an occasional teaching stint every now

and then but had no permanent associations with area campuses. Also, as at the GSA, much of the student energy in Southern California gravitated toward discussions about and classes in conceptual, poststudio, and site-specific art. At CalArts, Michael Asher's once-a-week, all-day critique class, called "Post-Studio Art," had attained the status of an unofficial requirement for seniors and graduates, while at Otis College of Art and Design students attended meetings and classes with Christopher Williams, and at Art Center with Kelley and Stephen Prina (Williams and Prina were two of Asher's most renowned and closely aligned former students). Furthermore, Asher, Prina, and Williams had achieved international success but showed infrequently in town. Along with Kelley they were especially active in Germany. What they could teach their students, then, was about the importance of both talk and travel.

Through their teachers, the students at these schools met European artists and were given opportunities to visit and exhibit overseas. Art Center in particular helped maintain constant traffic between Germany and Southern California, in the early 1990s hosting Chris Dercon, Diedrich Diederichsen, Jutta Koether, Martin Prinzhorn, Albert Oehlen, and many others as visitors and teachers, most of whom needed local students to drive them around or assist with projects. Especially helpful at the other end was Diederichsen, who lived in Cologne and taught at Stuttgart's Merz Akademie. Christopher Williams, for example, while teaching a workshop in Stuttgart at Diederichsen's request set up a show there of work by Sharon Lockhart, Frances Stark, and other L.A. graduate students. In turn, Muller's very first Three Day Weekend event was a response exhibition of work by Diederichsen's German students. Only months after her graduation from Art Center, Lockhart was invited by Diederichsen to teach a workshop in Stuttgart; with her help Muller and fellow CalArts grad Laura Owens made their first trips to Germany. And so on.

As with so many other types of operations or "actors" responding to increased globalization, no less for artists did the decisive factor become circulation over location. Flexibility came to characterize not only how this generation approached roles and contexts but location more generally. To be seen as a viable art center at a

time when, in Schimmel's words, "it is clear that there are to be many centers," a city's art scene didn't overly concern itself with vertical integration, it didn't isolate itself within an airtight aesthetic, discourse, or patron base. The secret to Los Angeles's emergence as a center in the 1990s was that it succeeded at functioning less like a self-contained hierarchy and more like a hub or platform—it didn't root itself more deeply in a local identity and economy but grew more porous and horizontally interpenetrated, more easily exchanging its art, artists, and art money with other places. "You can't tell an L.A. artist anymore," dealer Daniel Weinberg bragged in a *New York Times* article from 1989 about how "the identities of the coasts were becoming blurred."[66] And much like its artists, the city itself became more interchangeable, one more commodity on the retail shelf of art cities. Young graduates looking for a place to set up shop talked about L.A.'s comparative advantages, that living there wasn't a necessity but a preference. Liz Larner, for example, confided that "after graduating in 1985, I felt if I went to New York I would be overwhelmed with too much information. I wanted to be someplace a little quieter. I needed to have more space around me— mental, physical and artistic space. L.A. was a lot cheaper than New York."[67] No less for artists did the question of geographical location become more like a consumer choice.

Another similarity between Glasgow and L.A. was the lack of commercial prospects. If the 1990 art market crash had dimmed the allure of New York and its galleries, it also meant that chances for freshly diplomaed L.A. artists to find accommodating galleries locally had gone from slim to none. But even before the recession hit, young artists were coming up with their own exhibition venues. In 1987, three Art Center undergraduates renting a house together in Pasadena—Gayle Barkley, Jorge Pardo, and Ken Riddle—decided to use their garage to hold a group show featuring work made by classmates and objects contributed by neighbors ("one of those ideas a group of friends and roommates derives from just sitting around drinking beer," critic Julie Joyce later remarked).[68] The following year the threesome made official the house's status as an art venue by giving it a name, Bliss (after Guy S. Bliss, the house's Craftsman-era architect), and Pardo opened his first solo show

there, five months before receiving his BFA. That gallerist and dealer Thomas Solomon, ex-director of New York's White Columns, who had moved to L.A. to run a short-lived Venice Beach branch of Manhattan's Piezo Electric Gallery, stopped by the house to view Pardo's work, and would later give him his first commercial-gallery show, upped the stakes considerably. Also in 1988, CalArts graduate Dennis Anderson turned heads by opening a "guerrilla gallery" with a group show featuring current and recent students from his alma mater—"not a curated show," clarified admirer Bonnie Clearwater, "nor was there an attempt to make a statement about the type of work these artists are producing."[69] Clearwater found the exhibition's informality and diversity "surprising . . . since recent exhibitions of CalArts graduates"—like "Skeptical Beliefs," in 1988, which featured famed pictures-generation alumni like David Salle and Eric Fischl—"seemed unusually cohesive for group shows."

Remarkably, it was during this time, with the down market choking off L.A.'s already emaciated ranks of white-cube commercial galleries, that serious talk arose about the city finally securing its place on the international map—or, as Clearwater declared in 1989, "that the much anticipated emergence of the city as a viable art center has become a reality."[70] And what especially drew attention were the new DIY spaces, L.A.'s version of "artists' initiatives." Although here it wasn't just artists driving the movement: besides Bliss and Dennis Anderson, and the room that artist Russell Crotty dedicated in his home for solo art exhibitions (called "The Guest Room"), gallerist Solomon opened an exhibition space in a single-car garage accessed through a back alley in the Fairfax District. Then in 1992 came a flood of impromptu spaces, including TRI, Nomadic Sites, Food House (which would eventually grow into the blue-chip ACME Gallery), and 1301 (named after the street address of proprietor Brian Butler's apartment-cum-gallery on Franklin Avenue). The following year even power broker Stuart Regen arranged for Richard Prince to install work in a beat-up West Hollywood one-bedroom slated for demolition. "In contrast to the market's contracting top is the expanding bottom," was how the *New York Times*'s Roberta Smith framed her 1992 write up of Los Angeles's "new image"—an image featuring "no-frills . . . shoestring

galleries . . . [some in] unrefurbished storefronts or private homes; others lack permanent addresses. Most concentrate on showing the young artists coming out of the area's unusually plentiful and unusually good art schools."[71] Anticipating descriptions by Obrist and others of the game-changing impact of DIY spaces in the UK, Smith concludes, "What's emerging at the grass roots level may be a gallery for a small art scene, something flexible, modest and right in the living room."

What had changed in Los Angeles, in other words—with the disappearance of top-tier galleries leaving only an expanding field of smaller, just-in-time operations—was the replacement of a hierarchical structure with *something flexible*, with a network. Off the beaten path, often located in not commercial but residential neighborhoods, and identified as neither for-profit businesses nor nonprofit community services, the new DIY spaces in L.A., as in Glasgow and other cities, helped to fragment and disperse the spatial layout of the local art community, both as a part of urban geography and as a set of institutional and conceptual categories. And the city's ability to impose a single definition on the art it produced slackened as well; having been obscured by the overly used, albeit dismissive, totalizing stereotypes of "finish fetish" and "light and space," L.A. artists now appeared likewise more spread out and undercategorized, identified simply as individual practitioners, all the more so as they routinely left town to travel, thus becoming unanchored, nomadic, and undefined by place per se. L.A. artists were now seen as "an arrangement as opposed to a group," less a cohesive category than an informal collection, a weak- rather than a strong-tied network.

Nevertheless, it was the impromptu nature and sociality of the network, despite its loose ties, that participants emphasized. What these younger artists seemed to be gesturing toward was a differently imagined frame or apparatus that situated and underwrote their art, that redistributed emphasis away from rigid institutional and ideological categories toward a more loose, intimate framing. They wanted something more closely resembling an organic community, something that seemingly existed outside or beyond or after institutions, in a space as if without fixed ordering

FIGURE 2.13

Richard Prince, *First House Installation* (detail), April 3–30,
1993, 540 Westmount, Los Angeles. Courtesy Regen Projects,
Los Angeles © Richard Prince.

and striation, one that morphed back and forth from streetlike an-onymity at one extreme to face-to-face connectedness at the other. And this desire extended to much of their art.

Contrast, for example, Stephen Prina's solo exhibition at the freshly opened Luhring Augustine Hetzler Gallery in the fall of 1989 with the show his student Pardo mounted at the same space two years later. For Prina's show, which christened the new West Coast partnership between New York's Luhring Augustine and Max Hetz-ler of Cologne, he presented *Inaugural Mailing List: Santa Monica, September 1989*, 1989, a work (yet another list of names) consisting of eleven stationery-store boxes filled with copies of the announce-ment card for his show stuffed in envelopes that were postmarked and addressed to the gallery's mailing list, with all the boxes placed side by side on one long pedestal made of birch veneer plywood. Pardo's later exhibition would also call attention to the gallery and its business operations: in his piece *Rug*, 1991, for example, Pardo placed the receptionist's desk—a squarish white cubicle—atop a slightly larger square of green carpet, so that the edges of the car-pet-*cum*-pedestal formed a kind of outline around it. But what was strikingly different about Pardo's show was the degree to which his references were specific and intimate. The works included so many peculiar or personal details as to defeat their being read as discur-sive, as revealing generally applicable knowledge, as illuminating the function of the gallery, or art's contextualization or its commodifi-cation or anything else in general. The checklist and titles disclosed, for example, that a completely inconspicuous piece attached to the gallery's ceiling was titled *My Mom's Soffit*; one could ask the recep-tionist, or Pardo himself, and learn that a tastefully designed set of wood shelves displayed near the gallery's storefront windows was filled with the clothing of Jorge's close friend George Porcari. Also that the rug under the receptionist's desk had belonged to L.A. col-lector Robert Rowen and had suffered water damage. Alas, given the egalitarian, nondiscriminating conditions of the everyday, even a powerful collector can suffer the consequences of a leaky roof. (Pardo would go on to execute his own list of names in 1997, when he included in the catalog for his midcareer retrospective a compilation of important influences on him over the course of his life, ending up

FIGURE 2.14

Stephen Prina, *Inaugural Mailing List September 1989*, 1989.
Offset lithography on card stock and envelopes; mailing
labels and postage; cardboard boxes. 7 × 77 × 13¼ in.
Courtesy of Friedrich Petzel Gallery, New York.

with a roster that mixed people both known and unknown to the art world, along with several family members and even the name Jorge gave to a favorite pillow he had as a kid.)

Later in the 1990s Muller would also draw on art world publicity as source material, producing watercolor recreations of exhibition announcements advertising his friends' shows at other galleries or spaces around town. The careful watercolor renderings would in turn make more wholesome and innocent this otherwise business-minded information by passing it through the medium's characteristically gentle rhetoric, its veils, mists, and tints, its careful hand-directed bleedings and blottings of liquid color softly absorbed into the paper support. Here the art world as an institutional apparatus or commercial racket was remade into a more homespun, everyday image, the image of passing hand-drawn notes back and forth with friends, or simply of enjoying some pat-on-the-back peer support.

Such was the aim of much 1990s art—to be, as L.A. critic Bruce Hainley put it, "airily honest about how things get done, stuff gets made, and the art world works."[72] Familiarity replaced the sense of revelation that had previously accompanied awareness of the complex apparatus that framed and underwrote the work of art. The (representation-based) idea of "unmasking" art's institutional conditions and supports was replaced by something closer to the more recent (communication-based) idea of "radical transparency" (a phrase popularized by *Wired*'s Clive Thompson, who explains, "Your customers are going to poke around in your business anyway, and your workers are going to blab about internal info—so why not make it work *for* you by turning everyone into a partner in the process and inviting them to do so?").[73] Suddenly the art world's operations, its institutions, exhibitions, publicity, marketing, and commodification, all were treated in a nonchalant and conversational way; they were no longer turned into models or examples but rather lived and breathed on a mundane, daily basis. They became the very means of increased communication.

Many people who first saw this art, or who attended the crowded openings in people's small living rooms and noted the sharing of resources and tasks that such endeavors entailed, regarded it all

FIGURE 2.15

Dave Muller, *Rolling*, 1998. Acrylic and pencil
on paper. 32 × 40 in. Courtesy of the artist and
Blum & Poe, Los Angeles, CA.

as evidence of a healthy, young community beginning to come to-
gether. And it could well have been that, but it was also a commu-
nity existing fully inside, not outside, the art world. These artists
were no less professionalized, perhaps only more diversely so—
and thus perhaps more intensely or fully so, to the degree that a
wider range of administrative and professional tasks became part
of one's overall art practice. Using one's apartment as an exhibi-
tion site meant not having to sign a separate lease, connect a new
phone line; it meant working at home, but also turning one's home
life into work, or disregarding any distinction between the two. It
also didn't affect the rent, but it did get listed on one's CV; the
same with curating a show at your friend's place—you took credit
for it but it didn't mean you suddenly stopped being an artist and
switched career paths. There was less of a sense of long-term com-
mitment, more impermanence and turnover. And this increase
in flexibility, in the turnover of temporary spaces and job titles,
meant there was no excuse to delay or hold back; nothing stopped
one from always being visible, involved, contributing—even be-
fore graduation, one's career was always in progress, the CV always
expecting the next entry. The feeling grew that the art world as
customer was always waiting for each month's new round of ex-
hibitions, new batch of magazines and catalogs. The result was a
greater need for the next job and the next space and possibly yet
another title—in other words, a constant supply of readily avail-
able players and occasions for ever-new temporary projects.

 And while a somewhat more fluid and horizontal scene might
have emerged in L.A. during the 1990s, it was still very much a sep-
arate sphere of activity. Perhaps more so: the new spaces mostly
addressed themselves to niche or insider groups, namely art school
classmates. As everyone who reported on them noticed, the apart-
ment galleries were literally hard to find—not identifiable from
the street by signage, with spotty advertising and little or no ad-
ministrative structure like a reliable contact number and regular
hours of operation. This was part of the modesty and authenticity
they exuded, how they strictly eschewed any claim to broadly rep-
resent the city's art population as a whole. Who these spaces ad-
dressed was not some abstract entity, the public or civic society in

general, but specific audiences, people one knew. "The participants are your friends?" Muller was asked the year he started Three Day Weekend. "Yes," he answered, "and friends of friends."[74]

Anti-hub, or Cultural Welfare as We Knew It

Rather than white-cube galleries, it was the previous alternative devised by artists to exhibit their art—namely, the not-for-profit artist spaces that emerged in the 1970s—that the new DIY outfits most directly pitted themselves against. Prina, for one, talked about initiatives like Bliss "as a reaction to [local nonprofits such as] LACE."[75] Such apartment galleries looked most flexible when compared not to single-proprietor commercial outfits like galleries but to large nonprofit corporations like the local Los Angeles Contemporary Exhibitions (LACE). As with any corporation, LACE was hierarchically and bureaucratically structured, with an executive director who both answered to an executive board (consisting of lawyers and assorted civic leaders alongside a handful of local artists) and also oversaw staff positions related to different departments including development, the bookstore, and of course the various exhibition programs, each with its own jurying committee that helped review artist applications and determine what got shown. By 1990 the fourteen-year-old LACE had become one of the nation's largest alternative spaces outside of New York City, housed in a two-story abandoned industrial warehouse in downtown L.A. that the city's Community Redevelopment Agency had helped purchase, and boasting a total annual budget of just under a million dollars. Its operation was anything but "spontaneous" and "organic."

But LACE's growth meant not merely more staff and committees and bureaucracy, it meant an increased emphasis on routine, on anonymous structure and formality per se. As the recipient of increasing tax dollars from city, state, and federal levels, and of tax-exempt donations from individuals as well as businesses and private and public foundations, everything LACE did was held publicly accountable. It literally couldn't afford to appear cliquish, as the outgrowth of insider machinations; it instead had to prove that it was serving not private but public interests. And so the faceless boards and juries and bureaucratic application processes by

which artists requested shows. Those with decision-making power, whether sitting on the board or on one of the exhibition juries, were volunteering their time, supposedly motivated by a sense of community service, not self-interest. Everything ran by rules and procedures that were intended to be fair, democratic, and neutral: jury members decided on shows by consensus, and each member's appointment to a jury was for a limited time, after which new members were selected by a vote. A liberal plurality of views and positions was sought in the makeup of each board and jury, for a variety of reasons including appeasing funders who favored a model of corporate paternalism and beneficence and were therefore leery of any form of apparent partisanship. Jury deliberations at LACE thus seldom resulted in forcefully coherent agendas but were instead muddled by compromise. Even the equal allotment of space and resources to a gallery, a performance hall, a video room, and a bookstore was an expression of the organization's democratic mandate. When it came to dividing and composing its building, or the membership of its boards and committees, or the artworks that its various exhibition programs presented each year, LACE operated by a representational logic; it managed a diversity of parts with the objective of bringing them together as a single entity, a delimited whole that stood for a preexisting constituency its role was to serve. It did see itself as based on "a city, a country, a nation, whatever," responsible for broadly representing the city's art population and for representing to the city of Los Angeles as a whole a sampling of contemporary art adequate to the criteria of the national peer groups assembled by its funders. Activity was undertaken not for its own sake but in relation to an a priori abstract entity, that fictive collective subject or topic which functioned as a framing device or category that preceded and determined the meaning of every movement or connection that occurred within it. The unity it sought to forge out of diverse parts signified the preexisting selfsame unity and centeredness of that subject. LACE was structured like a picture, not a hub or a network.

The issue of nonprofit artist spaces and their relationship to the public couldn't have been more pronounced during the heyday of L.A.'s DIY initiatives in the late 1980s and early 1990s, given

the uproar at the time over efforts by the Republican Party and conservative groups to abolish the National Endowment for the Arts and thus all federal funding of contemporary art. LACE had hosted some of the controversy's biggest headliners, like Karen Finley, who performed "Yams up My Grannie's Ass" there in 1986. Although in its infancy the NEA had spoken, as Ross Sinclair would some twenty years later, of "artists' self-determination" when advocating for federal funds to be diverted to the new artist-run spaces then emerging around the country, by the 1980s the success and growth of such funding had necessitated administrative responsibilities, the adoption of industry-wide professional criteria, and the creation of a lobbying organization (the National Association of Artists Organizations) to advance the interests of the field in DC.[76] Operating in relation to the public trust and as a representative cultural institution made a place like LACE more political, if even in a mitigating, liberal way; such an institution needed to be attentive to the issues of diversity and inclusiveness, which meant not only that it naturally allied itself with the multiculturalism and identity politics prevalent in the art world at the time, but it also began to act in ways similar to community arts organizations, opening up resources and programming beyond the area's professional artists by reaching out to underprivileged communities—through, for example, programs designed for the area's homeless population. LACE did see itself in terms of community, as working both for and between the art community and other area communities, but it performed that work through a rigid system of deadlines and paperwork, managers and spokespeople.

For a number of reasons, as the decade of the 1980s closed LACE quickly lost credibility and support, perhaps because of its impersonal size, or because its corporate, representational structure couldn't accommodate the new generation's desire for more direct and "spontaneous" organizing, or perhaps because of the various conflicted interests that, as a state-sponsored organization, it needed to mediate—namely, the contradiction between serving the mostly professional interests of its core artist constituency and paying more than just lip service to the egalitarian, civic-minded propaganda in which much of its funding came wrapped. Even as

it stood firmly behind the embattled NEA and, by extension, artists' free speech rights, LACE received less attention from the local art community, especially younger artists, and the size of its budget and bureaucracy became unsustainable. Near the end of 1990 LACE's finances collapsed, the director was fired, and half of the staff was laid off. (Interestingly, no article about this dramatic turn of events—and what it meant for L.A.'s "new art image"—appeared in the *New York Times*.)

The celebration of L.A.'s emergence as a viable art center thus coincided with the sudden implosion of its most prominent government-backed, nonmuseum exhibitor of new experimental art. In this way the situation again paralleled that in the UK, where DIY artists' initiatives were discussed by some as a reaction to waning state sponsorship. "In Britain, there is much less support for contemporary art from public money," remarked Obrist to *Vogue* in 1995, "but the artists don't sit around complaining—they do it themselves."[77] Stuart Brisley of the *Guardian* was more pointed. Recent art, he wrote, "has a particular energy because we have been moving from the welfare state to the free market. It doesn't suffer from the constraints of state patronage. There is an atmosphere of libertarianism and a release from social responsibilities."[78] Others drew similar attention to how this changing map of culture—both more international and more intimate, with high-altitude mobility offset by an "expanding bottom" of DIY activity, between which an institutional middle ground seemed to increasingly disintegrate—rhymed with an advancing conservative agenda distilled in Margaret Thatcher's chilling 1987 dictum that "there is no such thing as society, there are only individuals and their families."[79] Indeed, by the mid-1990s London's entrepreneurial YBAs would be labeled "Thatcher's children." (The situation in Glasgow was somewhat different, at least when money was being made available as part of the "Capital of Culture" campaign, but even then local artists expressed anxiety about the "retraining" schemes and other strings that came attached to grants, and feared what awaited once the campaign was over. Already in spring of 1990 Transmission Gallery mounted the group show "Dependants," in which participating

artists were allocated funds equivalent to a week's worth of government welfare to offset production costs.)

In the US, however, the association was seldom made between the rise of neoliberalism and the new artists' initiatives and apartment galleries, which were more likely described (including by myself) as rooted in punk culture or early 1970s endeavors like 112 Greene Street and Gordon Matta-Clark's Food, or the situationist activities of the 1960s and neo-avant-garde episodes even earlier.[80] This left (and continues to leave) unacknowledged the fact that NEA programs in the US that helped nurture the nonprofit artist-space movement were all established as part of an expanding welfare state in the 1960s, whereas the larger context for the DIY initiatives of the 1990s was a dramatically reduced welfare state and a shift in policy away from social and workplace security to individual risk taking, speculation, and entrepreneurialism. And so it goes to this day. The art world remains in the habit of attributing to its "avant-garde" practices the same social critique as that made by artists twenty to thirty years earlier. Not only does this mean replacing a social frame of reference with an art historical one, thus diverting attention from ruptures between then and now toward a reassuring illusion of historical continuity. Worse, actual present-day social conditions are often simply glossed over.

Exhibiting Sociality, or How the Social Life of Contracting Free Agents Emerges as Art's New Institutional Frame

The generation of the 1990s adopted a DIY or self-reliant, antiauthoritarian approach not just literally, not just to the actual enlisting and managing of artists and their labor for projects, but symbolically as well, by greeting with suspicion any form or relationship through or within which authority was seen as exerted externally and unilaterally, from on high and as if in isolation. Among the consequences, the relevance of canon formation and general developments and trends in critical discourse waned. Also the practice of curating theme shows all but disappeared.

Over and over again, liberation from themes was, and continues to be, celebrated, from Dennis Anderson Gallery in 1988

avoiding "an attempt to make a statement" and "Windfall '91" "mak[ing] no claim to be representative of anything" to the 2007 Istanbul Biennial curator Hou Hanru avoiding "a thematic exhibition in the traditional manner." "It's (usually) a suicide mission to group of-the-moment artists under the pretext of a theme," wrote *Los Angeles Times* critic Susan Kandel in response to a 1997 collaborative exhibition between Sharon Lockhart, Laura Owens, and Frances Stark.[81] If a standard 1980s complaint was about heavy-handed curators imposing labels and "The Distractions of Theme" (as Carter Ratcliff titled a 1981 *Art in America* essay), the absence of theme shows is what gets remarked on in the 1990s. Documenta 9 in 1992, for example, was unprecedented for not being set within a theoretical or thematic context, aspiring instead, according to organizer Jan Hoet, to be "a documenta of locations" that "takes the artist and the artist's work as its sole point of departure."[82] As Daniel Birnbaum noted in *Artforum*, "There was a time when every exhibition required a commentary by one French philosopher or another, and we all got sick of that. Now that we've reached the other extreme, I kind of miss Jacques Derrida."[83] Preferred instead are "arrangements as opposed to groups," or group shows made to look as if they weren't curated at all, as if the people and artworks came together spontaneously, of their own accord. Just hanging out becomes an aspiration, a sort of desired destination, even for traditional art objects. "Ultimately," Laura Owens told *Artforum* in 1999, "you really want to make the painting that you want to be with. Not one that is constantly telling you everything it knows."[84]

Rather than theme shows, what gains in popularity are social shows, exhibitions about specific circles of friends or art scenes in different cities. Scenes emerge as a celebrated category of 1990s iconography, as in the work of Wolfgang Tillmans and Elizabeth Peyton; the show that Lockhart, Owens, and Stark mounted together was based simply on their mutual friendship, "an investigation into the nature of discourse and dialogue among friends," as the gallery's press release announced. The majority of Three Day Weekend shows were, as Muller admitted, of friends—"and friends of friends." The same with the other apartment shows in L.A., as well as those in Glasgow and elsewhere. Even if such shows

FIGURE 2.16

Sharon Lockhart, *Untitled*, 1997. Framed chromogenic print. 48 × 48 in. Edition of 6. Courtesy of the artist and Blum & Poe, Los Angeles, CA.

lasted the entire month, visiting hours were scant and not always reliable—not to mention potentially awkward, given that viewing the art meant intruding on someone's private life. So typically everybody interested in seeing the show would attend the opening: apartment galleries reduced the exhibition of art down to a single temporal event, thus guaranteeing along with the art's staging a social group that gathered with it for a set period of time.

There also appear exhibitions that document social networking as a historical phenomenon, such as the enthusiastically received "In Memory of My Feelings: Frank O'Hara and American Art" at L.A. MoCA in 1998, a show that curator Russell Ferguson conceded "started for me in thinking about much more recent art."[85] The London art scene was made the subject of a number of shows, at times coupled with a look at Glasgow's scene (as in Obrist's "Life/Live"); the Glasgow scene in turn got presented in tandem with the L.A. scene in Christoph Keller's series of "Circles" exhibitions (which examined, the curator writes, "the conditions of local social networking and communication structures through presentation of exemplary 'friends groups'").[86] Interaction between the scenes in New York and Cologne was given the same treatment in PS1's "Parallax View" in 1993 (then a second time in Bennett Simpson's "Make Your Own Life: Artists In and Out of Cologne" at the Philadelphia Institute of Contemporary Art in 2006).

Group shows also become occasions for artists to make work about meeting the other artists in that exhibition. Sarah Seager's contribution to the 1993 group show at Brian Butler's 1301 Gallery (see figure 2.8) was seven copies of a xeroxed booklet that transcribed a long phone conversation between her and Pardo in L.A. and Tiravanija and Tobier in New York. In a review of "Traffic," the 1996 show with Gordon, Pardo, and Tiravanija, among others, and for which curator Nicolas Bourriaud first debuted his idea of relational aesthetics, Carl Freedman wrote, "Pleasure and enjoyment were not to be found in the exhibition itself but in the week-long gathering of the 30 artists involved. Under the auspices of an 'exchange of ideas,' the artists talked, drank, dined and danced together whilst creating, preparing and installing their different works. . . . The gathering was central to

[Bourriaud's] theme, awkwardly formulated as 'the interhuman space of relationality.'"[87]

Finally, socializing not only emerges as a leading feature of the art shown at galleries as well as museums and *Kunsthallen*, but also becomes a service-product in its own right, which these latter spaces directly advertise and sell. Vying with hotels and restaurants to attract corporate parties and sponsorship for social events becomes a crucial source of revenue for art institutions. And so they devise numerous ways to, in the words of Anthony Davies and Simon Ford, "formalize informality . . . provid[ing] what are essentially convergence zones for corporate and creative networks to interact, overlap with one another and form 'weak' ties. The prominence that events such as charity auctions, exhibition openings, talk programs and award dinners have attained demonstrates how central face-to-face social interaction is to the functional capacity of these new alliances."[88] Hangar-size lobbies and multiuse or "event" spaces begin to accompany a majority of new building renovation or expansion projects at museums. According to architect Brad Cloepfil, "Once you take away the sacred sanctuary notion [of the museum], it's just a question of programming and security."[89]

When exactly were museums disabused of this "sacred sanctuary notion"? Well into the latter half of the 1980s, museums were still being portrayed in the basic terms Buren had laid down over a decade earlier. The imagery of "frames, envelopes and limits" was elaborated in a number of ways by, among others, Carol Duncan and Alan Wallach, whose 1978 essay "The Museum of Modern Art as Late Capitalist Ritual" described how, "like the church or temple of the past . . . the museum transforms ideology in the abstract into living belief"; and by Douglas Crimp in his 1980 essay "On the Museum's Ruins," which sized up the museum using Foucault's work on such early modern disciplining institutions and discourses as penal law and medicine; by Hans Haacke in his 1984 essay "Museums: Managers of Consciousness," which borrowed from Hans Magnus Enzensberger's notion of a "consciousness industry" made up of media and education; and by Craig Owens three years after that, whose essay "From Work to Frame" argued for the continued relevance of Buren's and Asher's brand of institutional critique and

how it "shifted attention away from the art object and its producer and onto its frame—focusing on the location [and the] institutional practices that define, circumscribe and contain both artistic production and reception."[90] "Ultimately," Owens concluded starkly, "artistic production is contained within the boundaries, the frame, of the nation-state itself."

Loosening the museum's frame, making it more permeable— more of a convergence zone or "interhuman space of relationality"—is credited to the generation that emerges in the 1990s. Not only artists like Gordon, Muller, Pardo, and Tiravanija but their administrator-champions including curators like Bourriaud, Obrist, Glasgow's Charles Esche, and Maria Lind. Together they usher in what has been called a "New Institutionalism," a term that, as Claire Doherty summarizes, is

> *characterized by the rhetoric of temporary/transient encounters, states of flux and open-endedness. It embraces a dominant strand of contemporary art practice—namely that which employs dialogue and participation to produce event or process-based works rather than objects for passive consumption. New Institutionalism responds to (some might even say assimilates) the working methods of artistic practice and furthermore,* artist-run initiatives, *whilst maintaining a belief in the gallery, museum or arts centre, and by association their buildings, as a necessary locus of, or platform for, art.*[91]

Face-to-face socializing serves not only as a ground—or "working method"—for artistic practice but becomes the very object that the institution's curators and directors commission and display. For institutions as well as artists, what fills the breach in the absence of definitional categories and historical narratives, what provides direction, is the group or milieu itself, an immediate social situation the handling of which entails a set of rituals in its own right, including dialogue and affect transacted internally among core members and externally between those members and simultaneous points and conversants beyond. Sociality quickly engulfs

the form and content of art works as well as art business, especially as the two overlap in the executing of projects.

But what kind of sociality is this—the transient encounters of "New Institutionalism," its dialogue and participation—especially if it's imagined to unfold in the absence of former disciplinary and social apparatuses? The assumption here is that such socializing will be mostly operational, concentrated on constructing agreements between people to "do things," and thus will contain an often unspoken or implicit contractual basis. Also assumed is an art worker or subject who, as primarily contract-framing, calculating, and optimizing in her or his project-mindedness, is close to the rational-choice actor of classical economic theory, only no longer sovereign and self-constituting but rather postmodern since always constituted within contexts and groups, formed not prior to but within the relational and differential play of embodied, performative signification. To paraphrase Robert Morris, the individual becomes not less important but less *self*-important (or, like Flavin's fluorescent tubes, "individual units possess no intrinsic significance beyond their concrete utility"). But perhaps individual is no longer the right word; Gilles Deleuze, for instance, instead calls this new subject who emerges in the transition from boxes to networks a "dividual," someone who is not a "discontinuous producer" (making discrete objects one at a time) but is "undulatory, in orbit, in a continuous network."[92]

If on the one hand this figure no longer fits the liberal humanist definition of the individual who stands equal to all others despite contextual factors like differences in economic and social conditions, it's also not the structurally determined subject of Marxism, which often overlooks individualism per se precisely in favor of economic conditions. Rather, the actor who is more communicational and "dividualistic" simply does things, just in time and on demand, functioning in certain ways depending on the immediate contextual specifications, and doesn't abstractly "represent" anything, whether the private self or the social totality. If the docile body was the object of disciplinary power, which cut the individual to the order of a fixed, idealized referent, then it's the feedback and pattern recognition of information management that conjures,

surveils, and regulates persons under control power. Expected to be as mobile, operational, and instrumentalizable as information, the subject now fragments its identities and functions across a variety of social situations and work conditions and their different ways of processing and filtering data; it is produced by and modulates according to immediate contingencies, and is expected (and often can be made) to disappear just as immediately.

As cyberphiles like to say, information wants to be free. Such is the freedom of the new free agent, who is both communicational—therefore performative, exteriorized, connective, and context-dependent—and also informational, which means weightless and eventlike, immediate and punctual, compliantly modular and easily fragmented, on the spot and just in time. Not just free, information wants to be—scratch that, it practically begs to be—managed. And so this is the new norm of post-Fordist contingent labor, what Marc Bousquet calls "labor in the mode of information"—labor that "is required to present itself to management scrutiny as 'independent' and 'self-motivated,' and when the task is completed, labor organized on the informatic principle goes off-line, off the clock, and—most important—off the balance sheets. . . . Laboring in an informatic mode does not mean laboring with less effort—it means laboring in a way that labor-management feels effortless."[93] Recalling Deleuze's undulatory, orbital "dividual," Bousquet describes "the networker or flex-timer [who] is in constant motion, driving from workplace to workplace, from training seminar to daycare, grocery store and gym, maintaining an ever more strenuous existence in order to present the working body required by capital: healthy, childless, trained and alert, displaying an affect of pride in representing zero drain on the corporation's resources." (Or, as Andrea Fraser says of her poststudio, flex-timer practice, "I don't have a typical day. Sometimes my work as an artist is doing research in a library and reading critical texts, sometimes it's writing, sometimes it's doing graphic design, sometimes it's going to galleries and museums or being in an exhibition space and trying to install a show or conducting interviews, sometimes it's going to the gym and practicing Samba.")[94] Skills that need to be built up and maintained through daily routine, as with a studio-based art

practice, decrease in value, since such skills can't be dropped indefinitely or retrieved on demand, they can't be changed or erased as if with a single keystroke. Old habits prove to be the antithesis of information. They die hard.

What makes for a "free" agent, then, is one's flexibility and mobility in relation to contracting and situational functionality. That's how the individual actor can become so crucial in the new economy even as she or he cedes priority to the functioning and dynamics of contexts and assembled groups (groups of collaborators, facilitators, and/or audience members and clients). Free agents are the necessary resource when it comes time to piece together the project's temporary work team but are also crucial in keeping that team or group (or better still, "an arrangement as opposed to a group") always piecemeal, always short of developing too much inflexible solidarity, from forging a group identity or cause into which the separate identities of individual agents get submerged. What's important is that the ties between actors are only operative and situational, and thus are also contingent and weak, the immediate group nothing more than a functional context and its actors nothing more than context-dependent. As with the individuality of the different actors, so too with the principle underlying their mutual commitment—neither is allowed to represent anything too authoritative in itself. Not "intrinsic significance" but "concrete utility" (or perhaps the more prescient 1960s line is LeWitt's about the artist "function[ing] merely as a clerk cataloguing the results of his premise"). In other words, not symbolic values but what Jean Baudrillard calls "organizational values," the privileging of relationships "no longer of an instinctive or a psychological but, rather, of a tactical kind."[95]

Thus sociality in the absence of social institutions is likely to hold together less through the metaphoric and psychic transactions of projection, investment, and transference between subjects and predicates (an object, a group, an other) than through a collaborative metonymy of engagement, contribution, reliability, generosity, openness, responsiveness, and mutual support—acts and qualities that, in their just-in-time operativity, grow less distinguishable from the more mechanistic acts of coordinating, calculating,

organizing, planning and maintenance, all of which could perhaps still be happily called social if not for all the disembeddedness, transience, mobility, and fragmentation, all the personalizing of management, risk, and survival, that is their underlying condition. A personal-scaled managerialism floods the plane of the everyday. Marginalized in the more anonymous contexts of bureaucracy and the market's cash nexus, these personal capacities now move to the center, forestalling the threat that too much selfishness or distrust would pose to the launching and completing of projects, thus becoming the very linchpin of a system that relies increasingly on scattered, overlapping, and ill-defined service frameworks and short-term contractual relations.[96] In this way, even as society itself frays, socializing or acting sociable, rather than being bracketed out, gets subsumed into the functioning of the field at its most administrative and professional—in circulating information, setting up contacts or otherwise framing interaction, arranging and putting on events, planning events generally, following up and through on those plans, creating and distributing publicity, attracting audiences and getting feedback, keeping in touch about the possibility of future plans, etc. It's within such personal terms that business, including the business of being an artist or an art institution, is conducted and careers are advanced. Being sociable, a good collaborator, eager to participate, having good communication skills, being trustworthy, being generous with information—these become leading assets.

According to those who've studied such trends more generally across various sectors, the crisis that befell hierarchical management schemes in the 1970s and 1980s was overcome by networked relationships that "democratized" managerial expectations, spreading them down the employee ladder as the burden of each and every communicational actor. As a free agent, one needs to become self-coordinating and self-managing. But one needs to also join projects, to enter into temporary contracts or other interactional frameworks, to coordinate with others who are likewise self-managing and always interacting (everyone coordinating their schedules, their mutual availability, their moods, the number and variety of their commitments, and

the levels of energy that they can devote to each). Free agents avail themselves to, and are judged by, one another as reliable connections, deemed trustworthy or not in a way that, rather than imposing an abstract, essentialist ethical standard by which individuals are measured as if each in isolation from one another, instead addresses only exterior and contingent capacities, how a person operates and acts responsibly within communicational situations and contexts. Communication needs to proceed unhindered by too much doubt, suspicion, irony, or detachment.[97] One cannot cling to a position of refusal or autonomy or aesthetic contemplation, but rather must engage and contribute, go beyond and outside oneself. But one can't be too passive and agreeable either; some surprise needs to be introduced, some new and unexpected information (fresh ideas!) to ward off the overorganization and stasis that threatens when feedback systems are starved of anything beyond what they already know and circulate.

As the sociality of free agents necessarily overflows the underspecified and inadequate frameworks of short-term contracts, so these contracts in turn usurp formerly fixed guidelines, guarantees, restrictions, and chains of command. The new type of organization that results promotes itself as less homogenous, authoritarian, and patrician, and instead becomes more volatile and insecure, but also potentially more "lively" and innovative (and, of course, cheaper). All this goes as well for the museum's organizational and institutional structure. "New Institutionalism" is often spoken of as the latest direction in the history of institutional critique, except that it posits an institution that has become less institutional—that is more open-ended, volatile, and event-based, less managerial and more entrepreneurial, more like "artist-run initiatives"—and also a critique that is less critical.

Again, the name "New Institutionalism" is closely identified with certain important independent curators who since the mid-1990s have made their careers shuttling between jobs at biennials, museums, and art schools, and from whose vantage exhibition spaces seem to be "constantly appearing, evolving and disappearing." At least according to Hou Hanru, "This is precisely the essence of the new paradigm of institution, always moving, flexible,

changing and reinventing itself."[98] Maria Lind, who since 1997 has served as curator at Stockholm's Moderna Museet, cocurator of Manifesta 2, head of the Kunstverein München, and director of the Center for Curatorial Studies at Bard College, applauds artists who engage in what she calls "constructive institutional critique," which she claims is "more nuanced, smart and sensitive" compared to the earlier work of Asher, Buren, and Haacke. "Whereas the critique of the older artists," she writes, "is perhaps negative, this one is more constructive. It is about skepticism and enthusiasm, affirmation and critique all at the same time."[99] Charles Esche—who in the mid-1990s gained recognition for his innovative programming as a curator at Glasgow's Tramway and later as cofounder of the nearby Modern Institute, and then went on to coorganize biennials in Istanbul and Gwangju as well as work as a museum director, first at the Rooseum Center for Contemporary Art in Malmö, then at Eindhoven's Van Abbemuseum (where, among other things, he initiated the "yourspace" program)—has hailed a new rapport between "artists and institutions," in which both sides manage "to move beyond the forms of institutional critique developed in the 1980s and to collaborate in the name of a larger potential. On both sides, there is a responsibility to avoid indulging in narrow forms of aesthetic essentialism (the return to painting etc.) or unconstructive critique."[100]

Such an argument has even found voice within those US circles most invested in the discourse of institutional critique. David Joselit, for example, has recently asked that the museum be considered not so much a bounded structure as a "welter of interpersonal actions." Realizing how "serious disagreements and debates occur among colleagues as a project moves upstream through the institutional flowchart from inspiration to public program," the solution he recommends is that institutional critique be replaced by a new attitude he terms "institutional responsibility." "Why is it that most 'institutional critique' has remained satisfied with the easy target of bricks and mortar, while setting aside the more volatile flesh, bones and brains that are just as much a part of an organization's equipment?"[101] This preference for what Joselit and Esche call "responsibility" over critique presumes a startling degree of

volunteerism; it places the onus for reproducing social organiza-
tion on the shoulders of interacting, project-making subjects, while
marginalizing both the naysayers and the yes-men alike, keeping
instead only those whose input is just "critical" enough to make
"constructive" their communication and feedback.

Trust

The discourse of New Institutionalism continues the trajectory of
institutional critique on some level, at least as it directs attention
away from the stereotypes of the studio, the lone artist-genius, and
the isolated art *objet*, and foregrounds instead the art world itself
as an array of interlocking spaces, functions, and discourses that
ultimately and necessarily frames all art. But it does so by stressing
not enduring, determining structures and apparatuses but tempo-
rary projects and the affective, interpersonal sense of "responsibil-
ity" that glues together otherwise disembedded agents. Left behind
are the "bricks and mortar" of the white-cube exhibition space that
minimalism, in its move from internal relationships toward an out-
ward, room-scaled ambition, had appropriated. Along with the mu-
seum's supposedly neutral, rational, and transcendently ordered
architecture, also left behind is the coldly rationalistic, impersonal
frame of what Siegelaub called "secondary information," the discur-
sive labeling of captions, catalogs, and publicity. These are replaced
by tighter, warmer but more effervescent forms of communication,
by myriad one-to-one, face-to-face, come-and-go exchanges. Insti-
tutional critique evolves into new institutionalism as the frame it
addresses becomes more flexible and impermanent—that is, the
more the institution itself is associated with, is pervaded and re-
placed by, short-term contracts and temporary projects.

The parallel between the New Institutional arguments of Esche
et al. and the ones mounted by business leaders and analysts dur-
ing the 1990s management revolution is striking. As Boltanski and
Chiapello write, "The solution envisaged by [these] management
authors . . . consists, on the one hand, in relaxing and streamlining
institutional mechanisms, which are invariably suspected of har-
boring the threat of renewed rigidity; and, on the other, in con-
ferring an important role in economic mechanisms on personal

relations and the trust people place in one another."[102] In a world where economic and social relations so thoroughly infiltrate and inflect one another, trust becomes key. It fills the breach when both constancy and flexibility are demanded in equal measure. "Given that the project is a complex, uncertain process," Boltanski and Chiapello continue, "which cannot be confined within the limits of invariably incomplete contracts, one must know how to *trust* those with whom connections are formed. . . . But since projects are by their very nature temporary, the ability to disengage from a project in order to be *available* for new connections counts as much as the capacity for engagement."[103]

On the one hand, trust smooths activity in the interpersonal networks of affective labor: it embeds people in the project, helping them open up, share more information, give honest and tough feedback; thus it heightens the quality of communication produced by connections leading into and out from the inner circle. As Harvard's Nohria explains, "The structure of face-to-face interaction [as compared to long-distance communication or typical customer suggestion-box mechanisms] offers an unusual capacity for interruption, repair, feedback and learning. . . . Without the full bandwith of face-to-face communication, how can you tell whether someone is being profoundly sincere or totally deceptive? . . . Face-to-face interaction is especially effective at making each person aware of changes both in the other and in his or her self as reflected in the other, thereby facilitating necessary adjustments in the relationship."[104]

But while trust encourages members to better invest in and build the group network, it also wards against one of the more glaring liabilities of network structures, which is their tendency to come apart as easily as they coalesce, to lose commitments as fast as they're gained, to disembed as well as embed. Thus "the recent development of an enormous [neo-management] literature on trust" is due, Boltanski and Chiapello note, not only to "trust [being] what makes it possible to relax control while banking on a form of self-control that is cheap for organizations, and does not seem to hamper mobility in any way," but also because of "the problems entailed by the emergence of new forms of opportunism . . . bound up with new network forms of organization."[105]

Personal reputation and status within the network—i.e., labor value—will therefore be measured by one's ability to function well as a node, to both accumulate new contacts and mobilize attention and participation among existing ones, to exploit mobility for accessing and drawing on as well as distributing and recirculating resources and information, rather than just listening in and hoarding what's valuable. Including others in your information circle, connecting and filtering information between circles, curating others into shows or offering your loft for others to curate their shows within, being a good participant in and/or platform for others' projects, all this helps build reputation. Using a network or a platform merely for self-promotion diminishes it (i.e., "Comrades, sorry for the mass email but in case you're in Brooklyn this weekend don't miss my show at _____").

As the short-term, temporary contract becomes the basic unit of organization and administration, it's little wonder that artists and institutions (or action and determining structure, practice and its conditions of possibility, subjects and social organization) appear to grow more reconciled—the two seem to all but collapse into a single phenomenon as both practice and its institutional conditions find a common plane of expression in the form of *projects*, where, as Esche says, they now appear "to collaborate in the name of a larger potential." Institutional critique has seemingly little left to expose or tear down; rather than question the neoliberal ideology that underlies the drive for more flexibility, or measure the subsequent institutional underpresence in terms of collapse—withdrawn or unreliable support, ever-tightening budgets, last-minute something-out-of-nothing programming—the myth grows that critique recedes because there really is no institutional level substantial enough to concretize and enforce domination. The agency of the "collaborative" project gains the upper hand over both individual refuseniks and structural determinants. Institutions claim to be themselves "sites of independence and transgression . . . refusing any predeterminism," to transplant Obrist's line about artist-run spaces.

With networks there are no frames, or rather what constitutes a frame has changed—what holds the network together, from the

more formal contracts of large *Kunsthallen* down to the quasi- or informal contracts of apartment galleries and artists' initiatives, is the contract's framing language and execution, which are themselves misrecognized as, and attributed to, the purely natural social feelings of mutual responsibility and responsiveness, the innately human propensity to enter into agreements, the inherent need to communicate. The face-to-face negotiating and executing of contracts is naturalized as spontaneous talk; the commodity relations of the international art and artist-labor markets that structure the supply and demand of poststudio contracts is romanticized as freewheeling nomadic travel. And the contracts themselves, as examples of bureaucratic framing or secondary information, are downplayed in favor of the primary, immediate, face-to-face performance of dialogue and debate. The art world's institutional and technical apparatus, which requires information to circulate, people to talk and travel, temporary projects to get arranged and executed, all this is subject to a thorough mythologizing and aestheticizing. Poststudio artists don't renounce framing languages in favor of something else (like, say, the studio artist's quest for visual "beauty")—instead they transform these very frames, making what had been the secondary information, or what Buchloh calls secondary *languages*, of institutional setting and discourse into primary events and experiences. Not theory but practice; not formal, written discourse or printed language, or the disciplinary context of catalogs and captions, but just face-to-face talking; the institution not as cold and authoritarian but as warm and welcoming, like a bar or hangout spot, as creaturely and comfortable, as existential, experience-based and subject-centered as anything the beauty crusaders could ever place on offer.

A magical resolution is here performed wherein any contradiction between knowledge and belief, disenchanting critique and reenchanting innocence, is dissolved ("skepticism and enthusiasm, affirmation and critique all at the same time"). Artists don't need studios anymore to muster aura; they're in their native element when talking and hanging out with each other. Language in the form of contestation and criticism isn't required to challenge authoritarian claims to essential, timeless, natural

primacy—language is itself transformed, bestowed with the grace and spontaneity of timeless art, into what Roland Barthes calls "the superior myth" of the primary, "by which the text pretends to return to the nature of language, to language as nature."[106] No more brick-and-mortar enclosures or bureaucratic documents; the only frames to acknowledge are those of spontaneous socializing, responsibility to and for community, instances of language that are authentic, immediate, primary.

Granted, there's no question of how seductive this image of the network can seem—the plane of social existence wiped entirely clean of its institutional middle ground, leaving only an Edenic blank slate for free agents to lark about and concoct projects within. Since the early 1990s numerous art exhibitions have given into that seduction and tried to make the image a reality. Consider, for instance, a group show organized at Glasgow's Tramway in 1995 by Esche, the director there at the time, along with curator Katrina Brown and the artists Christine Borland, Roderick Buchanan, Jacqueline Donachie, and Douglas Gordon, all of whom had recently produced commissioned works at the space. Tramway, a performing and visual arts center located in an abandoned transportation depot on the city's south side, was a product of the Capital of Culture campaign, but ever since opening in 1990 its visual arts funding remained insecure; Brown, for instance, a former Transmission curator, was employed on a not-always-continuous series of three-month contracts. Getting past the constant fear of defunding and achieving a more stable commitment and endorsement from local politicians and administrators were major issues, and ones that, to Esche's thinking, a big, impressive group exhibition could possibly address. The show would be about how art can develop new relationships with audiences—not about what individual artists do on their own as they create in isolation, as if in disregard of audience; and not about what official lessons the paternalistic institution feels it should dictate to an audience it conceives of as a faceless "public." Instead, it would be about how artworks and audience members could construct more personal, affective, one-to-one relationships, how they could form networks. The title of the exhibition was "Trust."

The idea for the show "started with a conversation in a bar."[107] According to all involved, it was motivated by the sense of trust and support that glued together their immediate social and professional circles, the mutual faith and reliance that Esche, Brown, and the four artists had in and for each other as well as for the numerous art world professionals with whom they had made important connections over the years—"the importance of interpersonal relationships," as Brown described, "and the process of exchange as the location of the true context for the work" (what Bourriaud a year later would call "the interhuman space of relationality").[108] Participating in the show were twenty-two internationally renowned artists from Europe and the US, "selected," according to Esche, "because we admired and felt passionate about their work, not because they fitted some notional theme." "One of the rules we had," he continues, "was that one of us had to have met the artist, and to have had some sort of reasonable personal encounter with them: that trust should be there on a personal level."[109]

The exhibition displayed work without any framing language or didactic materials. "We were trying to share rather than educate," Esche explained.[110] There was no theme, the press release reiterated: "the works do not serve as illustrations of an established idea." A catalog was scheduled to come out but only after the show closed. Instead, as Brown recalls, "we sought to create in Tramway a familiar, comfortable, open space in which a similar type of exchange between artwork and viewer could take place."[111] There were direct, visceral engagements on offer—visitors could help themselves to mints piled up in Felix Gonzalez-Torres's *Portrait of Dad*, or sip tea prepared by Carsten Höller, or eat Rirkrit Tiravanija's food. Andrea Zittel's invitingly plush *Pit Bed* provided a cozy rest spot, and there were plenty of videos to watch. There was also a sculpture by Cady Noland featuring three brand-new whitewall tires hanging by industrial chains from a brutalist aluminum support, which in most other contexts would appear a cold and grim monument, like a gallows, but here resembled a children's swing.

But "Trust" wasn't only about proximate, intimate encounters; it also pole-vaulted to the other spatial extreme and emphasized

the international backdrop for all this art. "'Trust' came about," according to Brown, "through a desire to bring something of the activity, ideas and works encountered by those of us based in the city but working internationally, back into the city. . . . It was dependent on the relationships between individuals that has been fundamental to the development of Glasgow as a site for art making and viewing."[112] As the press release stated, that was another rule for organizing the show: none of the exhibiting artists could be from Scotland.

The city greeted "Trust" with mostly scorn and condemnation. "Don't Trust Tramway" was the title of a review in the local *Herald*. "Conceptual art is difficult," wrote critic Clare Henry, "and yet 'Trust's' catalogue will not appear until after the event. So who is it for? Certainly not the public. . . . [The show's] presentation ignores the punters in favor of an inner circle."[113] That a divide did separate the art world network that "Trust" paraded and a "wider audience" was something the curators commented on but never could declare and acknowledge outright—networks, after all, weren't supposed to have exclusive borders, strict insides and outsides; the vantage they permitted recognized only individuals and their performed connections to one another. Responding to the charge of hermeticism and inaccessibility, Esche urged instead "an acknowledgement of the viewer's co-authorship of meaning. . . . If the audience view themselves as collaborators then interpretation becomes a means to share information rather than impart received understanding." "Access," he elaborated, "becomes about ensuring a welcome at the door." After that, "visitors are encouraged to use their imagination and not [be] overburdened with interpretative text . . . many of the pieces [don't] need 'interpretation.' Surely the only way to inform people about Höller's *Aphrodisiac Tea* is to offer them a glass."[114] After that, visitors were left to their own devices. "We have determined," Esche explained in a no-doubt-unintentionally condescending newspaper rebuttal, "that the best form of interpretation is personal."[115]

"Trust" was an exhibition about not only talk and travel but also about *artists* who talk and travel. That was its ambivalence; it wanted to bypass mediating frames and deliver firsthand experiences, and also wanted to qualify and predicate those experiences

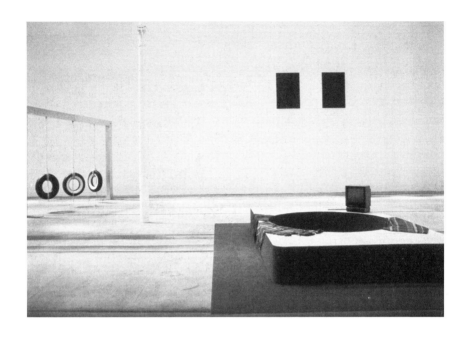

FIGURE 2.17

Installation view of "Trust," May 7–June 18, 1995.
(Foreground: Andrea Zittel, *Pit Bed*, 1995; left: Cady
Noland, *Publyck Sculpture*, 1993–1994.) Tramway, Glasgow.

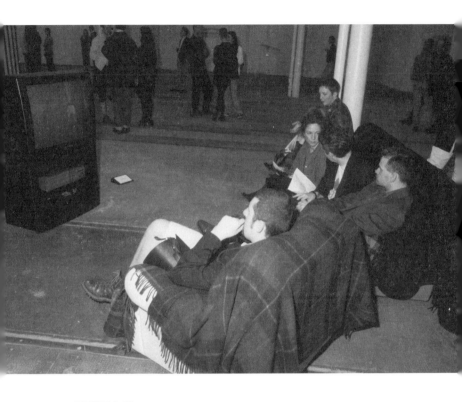

FIGURE 2.18

Opening reception for "Trust," May 7, 1995.
Tramway, Glasgow.

as being provided and/or had by "artists," a vestigial reminder of a world still divided and organized asymmetrically by predicates and labels, separated into specific institutions, discourses, professions, and competences. Esche has often expressed his devotion to art and artists, and spoke of "Trust" as likewise "privileging the experience of the artist" ("as much as Rembrandt or Van Gogh . . . so our artists look at our self-absorbed and alienated society to comment, judge and maybe even heal," he told the *Herald*).[116] But what can such words possibly mean outside of their institutionalized definitions, investments, and enactments? How can such categories be retained if the aim is to surpass the institution; how do *artists* and *artworks* overcome *art* (rather than merely stage the illusion of such a heroic overcoming)? These are the very categories that serve as the ultimate frame, that institute a sense of separation, abstraction, and unfulfillment, and it would be through the forgetting of this fact and the fetishizing of such categories that the poststudio artist becomes postinstitutional—i.e., posthistorical, postconventional, postsocial—and that the institution itself will be baptized "new."

"Trust" was about how the art world in particular had, by the mid-1990s, come to operate through talk and travel, through mobile networked connections, temporary projects and face-to-face relations. But it also was a demonstration of how the art world mistook this not as an organizational updating, a reinvention of art's institutional space in compliance with new mandates for greater flexibility, but as a liberation from the institutional per se, an escape from all the frames keeping art separate, aloof, elitist—indeed, not as a historical development but a transcendence of the very separation from life that was the initial condition of art's historical appearance in the first place. It was as if the struggle was over, and art and artists had arrived—no longer did their specialness need to be named as such, declared out loud and up front through the artifice of labels, it could just *be*, accepted as some incontestable fact or mystery, a divine gift with which only a lucky few are endowed, rather than a historical construction by which society enshrines the promise of surplus labor's freedoms within the view, but out of the reach, of a vast majority of its subjects.

As for the wider audience, they weren't buying it. From their position, as noninitiates and constituencies beyond the art world, defined precisely for being on the far side of the boundary between inside and outside, what they saw was separation. But this time it wasn't just the typical alienation from the museum's or gallery's patrician condescension or from art's broken promise of wresting freedom from necessity—this time they were further offended by confronting what appeared to be a closed network, a clique. Like a picture behind glass, the sociality of "Trust" existed apart. The dialogue and responsiveness on display were things visitors could contemplate, admire, but not engage with in a satisfyingly mean-ingful way—how could sucking on a mint or sipping tea seem like anything but empty interactions, a polite playing-along in response to an offer of cheap refreshments? Here was yet another hollow as-sertion of art's universality, only instead of being supplemented by inadequate didactic material on how to better partake of such tran-scendent experience, there was no assistance whatsoever. Instead of the alienation of being told what to think and feel, noninitiates were offered the alienation of witnessing a presumed intimacy without any weight or force, whose terms were completely opaque.

This was the quandary that not only "Trust" but other social shows of the 1990s found themselves in—obliged as art to exist in a public mode, such displays nevertheless suspected anything as explicitly formed as a public statement. The pleasure shared by the artists in "Traffic," for example, left even an ultrainsider like Carl Freedman cold, while in Los Angeles the publicly pledged ca-maraderie of Lockhart, Owens, and Stark was received as "a very cryptic show" that "in no way defined friendship or simplified the intricacies of influence"—"it's pretty much impossible," one reviewer conceded, "to document something as elusive as mutual support and its correlates."[117] Such intimate and casual feelings as trust and friendship had to remain unorganized and inarticulate to come across as convincingly genuine; they couldn't be declara-tively figured, made into theme or metaphor or position. Indeed, how Lockhart, Owens, and Stark tied their show together was in a literal, mechanistic way, by making all the work on display in four-feet-square formats.

The criticism leveled at "Trust" was even more extreme. How the organizers described the informality of the relationships that existed between themselves and the exhibiting artists was taken as secrecy and even underhandedness, conjuring previously dominant associations between the word "network" and illegal and clandestine trafficking and corruption schemes. No doubt the winking personalism and mutual back-scratching implied by the title helped feed this reaction. Esche, Gordon, and the other jet-setting curators and artists involved were charged with being part of an incestuous art world cabal, an insiders' club built on knowing the right people, manipulating favors, and pulling strings, without any wider legitimacy, uninterested in a larger audience and a fuller public accounting, in it only for themselves. "Esche was said to have used his tenure at Tramway to promote this gang of artists," gossiped one critic.[118] Ken Currie wrote to the newspaper accusing Esche of heading up a "mafia."[119]

The refusal to impose any sort of mediating frame on "Trust" didn't result in a frameless and immediate experience of the art, it instead opened the door for viewers to resort to all those reliable frames they were most familiar and comfortable with. Out came all the old resentments. In the op-ed letters and town hall meetings the questions asked were the same ones heard hundreds of times before—how to account for this use of public funds, what about fair representation? Why didn't Tramway show art the public could understand, why didn't it try harder to educate the public, why didn't it show more figurative painting? And so on.

The controversy surrounding "Trust" was intense enough to warrant coverage on the TV news, a citywide drama of misunderstanding, recrimination, and stereotyping, the middle ground's social and cultural divisions rematerializing with all the force of the repressed (the hubris continued in the months following, as Esche congratulated "Trust" for ultimately achieving its goal and proving "that provocation is still a worthwhile activity").[120] There were further shows that, as they married the tight intimacy of apartment galleries with the global reach of the international art world, much more willfully rode roughshod over the vanquished middle—social shows that verged on the sociopathic. Jorge Pardo,

for instance, has proven especially adept at this. A year after participating in Bourriaud's "Traffic," he was selected for the fourth iteration of Skulptur Projekte in Münster, choosing to intervene not only by adding to the city's popular Aasee lake a pier, a beautifully sleek public walkway jutting nearly fifty meters out into the calm lake waters, made entirely of imported California redwood, with an enclosed, hexagonally shaped viewing platform at its far end, but also by installing inside the platform a working cigarette machine, thereby pointedly undermining any reading that his gesture was either civic or beneficent. Then, a year after that, responding to L.A. MoCA's offer of a midcareer retrospective, Pardo used the museum's $10,000 commission money to offset costs of a private residence he was building for himself in the nearby Mount Washington neighborhood. His design for the new home infuriated nearby residents since, in place of a welcoming front yard, it called for a long, windowless blank wall to be erected along the entirety of the property's streetside curb.

The following year brought the Sixth Caribbean Biennial, perhaps the crowning achievement in the new genre of apartment-show-meets-global-art-event. The Caribbean Biennial was a weeklong piece of "humorous institutional critique" by Maurizio Cattelan, with Jens Hoffmann serving as coorganizer and Massimiliano Gioni, then an editor at *Flash Art*, acting as the project's "press officer" (see figure 2.2 and figure 2.19). Supported in part by the Jumex Foundation, it brought together a roster of ten international artists—including Vanessa Beecroft, Olafur Eliasson, Mariko Mori, Gabriel Orozco, Elizabeth Peyton, Tobias Rehberger, Pipilotti Rist, and Rirkrit Tiravanija—who all hung out together in a hotel on the small island of St. Kitts in the British West Indies. There was no art made or displayed for the biennial, nothing public in fact, other than an opening-night party that was billed as a "press conference." Rather, according to Hoffmann, the whole thing was "an opportunity to provide a few of the hardworking, incessantly biennial-participating artists on the contemporary circuit with a vacation."[121] Douglas Gordon was listed as a participant in the full-page ads taken out in *Artforum*, *Flash Art*, and *Frieze*, as well as in the two-hundred-page, full-color catalog subsequently

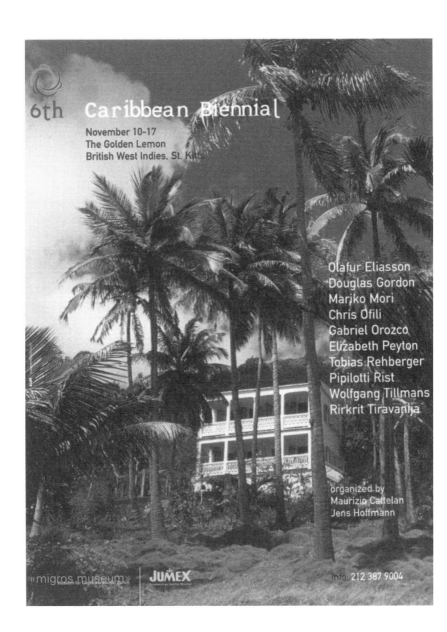

FIGURE 2.19

Maurizio Cattelan, *Advertisement for the 6th Annual Caribbean Biennial*, 1999. Courtesy of Marian Goodman Gallery, New York.

published by Les presses du réel, but in the end couldn't make it. He sent a letter to the group instead. "Lieber cher beste Jens & the whole crew," he wrote, "please have a drink for me."[122] In turn, all the Caribbean Biennial artists were included in Gordon's subsequent version of *List of Names* for MoMA in New York. Except, for some unexplainable reason, Mariko Mori.

Mute

Here is one last set of photographs. They deviate from the norm by showing artists conversing over books and xeroxes, not beers. Rather than pictured in the act of transmuting secondary to primary information through the alchemy of speaking and reacting spontaneously to each other, these people instead turn their faces downward, each reading from his or her copy of a shared text, focusing on *its* words. They don't suppress written text and professionalized discourse, they privilege it, submerse themselves in it. And these printed words don't spawn sui generis, firsthand exchanges and newborn communities on the spot; they're disciplined, peer-reviewed, they respond less to immediate context than to institutional metalanguages, to structured discourse. And it is structure—often social structure—that these words address in turn, even as they contest and critique it. Theirs is a more paradigmatic than syntagmatic language.

Even though this text-based group doesn't feel itself any less tightly knit, its constituents tend to prefer the phrase *intellectual community* to describe themselves, rather than something as fuzzily informal and everyday as *friends*. Some outsiders prefer to call them a cult.[123] Like Esche and his "gang," this is another network "not saddled with the burden of representation," according to one of its more influential mentors, Mary Kelly.[124] Like Art Center and the Environmental Art department, it was a school that provided these people's meeting ground, that brought them together not only with one another but with other powerful art world figures both nearby and faraway. But this school, the Whitney Independent Study Program (ISP), is located in New York, and unlike the situation in L.A. or Glasgow, where art education compensates for the general absence of other forms of institutional support

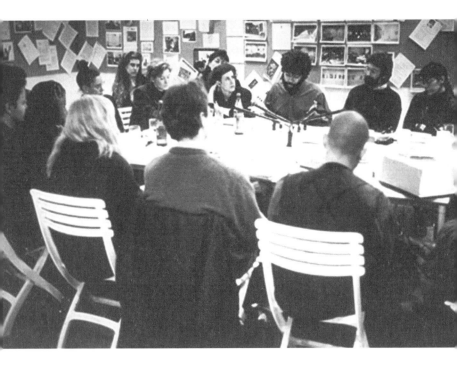

FIGURE 2.20

Services: Conditions and Relations of Project Oriented Artistic Practice, organized by Helmut Draxler and Andrea Fraser, 1994. Working group discussion at the Kunstraum der Universität Lüneburg.

for contemporary practice, the ISP is itself a wing of a major modern and contemporary museum. Little wonder these students embrace a discourse that's more specialized and canonical than spontaneous and everyday.

But Mariko Mori and Rirkrit Tiravanija also went to the ISP, as did Maria Lind. Why did they end up aligned with groups opposed to this more bookish one? The issue seems to boil down to whether one faces writing or faces a face, whether intertextual or "interpersonal relationships [are] the location of the true context for the work," to quote Tramway's Brown again. In this respect, 1990s social art manifests a backlash against not just theory in general but 1970s and 1980s poststructuralism in particular by reinvesting in speech as the enchanted other to duplicitous writing (a backlash that only gains momentum with the later rise of cell phones and social media, which elevate talk's breathy intimacies over cold and distancing imagery as technology's dominant metaphor). As opposed to talk, writing is imagined to share with the institution its anonymity, standardization, and conventionality, and can even be understood as one name for what precisely makes buildings and groups of people into institutions, what invests them with an "artificial" authority and social position.[125] It was indeed writing that Esche saw as the real enemy of the primary. "Too often critical writing resorts to . . . a deliberately hermetic language which disconnects art from its context," he argued in defense of "Trust" and its lack of explanatory information.[126] "Thus, rather than the autonomy of art we have the autonomy of art discourse where the work is only comprehensible for an informed elite. In fact, while the work is packed with the contingent and the personal, the texts around it often avoid the use of 'I,' preferring anonymous pronouncements."

Like the second-person pronoun of Esche's "yourspace," the first-person "I" of his ideal respondent is semantically empty, has no paradigmatic referent and thus no disciplinary monologue at its disposal, but is instead entirely flooded by its immediate environment, with only its context to frame dialogue or feedback. According to Roman Jakobson, such a "merely reactive" syntagmatic speaker is "unable to utter a sentence which responds neither to

the cue of his interlocutor nor to the actual situation." This "defect in the 'capacity of naming,'" Jakobson continues, "is properly a loss of metalanguage."[127] Or a liberation, as "Trust" and other manifestations of 1990s relational or social art tried to demonstrate, as it packed the artist and artwork with the contingent and the personal, shearing off each and every metalinguistic affiliation, so as to wholly forget the institutional basis of such categories as "artist" and "artwork." Purely syntagmatic artists and artworks, with their purely indexical relationship to their immediate surroundings, "substitute the registration of sheer physical presence for the more highly articulated language of aesthetic conventions," as Rosalind Krauss elaborated Jakobson's theory in her 1970s work on the index. They "could be called sub- or pre-symbolic," she writes, "ceding the language of art back to the imposition of things."[128]

But unlike Glasgow, New York did have galleries and museums in abundance, it was chock full of the art world's most paradigmatic institutions. And yet, right around the time site specificity went bankrupt for Gordon and his GSA cohorts, in the late 1980s many champions of institutional critique in New York also sensed a dead end approaching. Here again a new generation was emerging for whom the system of standardization no longer seemed an architectural one, a series of white cubes extending from the studio to the gallery to the museum. Even Craig Owens, in "From Work to Frame," had to admit that a lot of artists he admired now found the approach passé—he quotes Jenny Holzer, for example, complaining as early as the late 1970s that "as far as the systematic exploration of art's context is concerned, that point has by now been made."[129] Gregg Bordowitz, one of Owens's more avid students at New York's School of Visual Arts (SVA) as well as an ISP alumnus, arrived at the same conclusion in 1989. While at SVA he had been the studio assistant for Joseph Kosuth, another instructor there, and in the years just before and after graduating he mounted projects heavily indebted to institutional critique, including for the exhibition "Rooted Rhetoric," a 1986 show in Naples that featured Kosuth and Thomas Lawson, also an SVA teacher at the time; Michael Clegg, Kosuth's former assistant, and Clegg's collaborator and SVA classmate Martin Guttmann; as well as L.A.

artists and former Asher students Christopher Williams and Stephen Prina, among others. "The subject of the exhibition is the space itself," Bordowitz wrote about Kosuth's work in 1986, in an essay published in Lawson's *Real Life* magazine. "The gallery space is coextensive with much larger systems of organization that are contained within the context of the gallery walls."[130] But in 1987 Bordowitz became radicalized by the AIDS crisis and devoted himself to activism. "I have no more questions about gallery walls," he declared toward the end of the decade. "What's useful now is to go out and do directly engaged work that's productive."[131]

Fareed Armaly, who succeeded Bordowitz as Kosuth's assistant, also came out of SVA practicing institutional critique but soon deviated from the norm. Or so Isabelle Graw argued in 1990, writing that, while "the investigations of Haacke or Buren were designed to increase awareness of the nature of the art institution and its public . . . younger artists [like Armaly] are concerned with aspects that have no exclusive relationship to the visual arts system or its distribution channels."[132] Graw's article for *Flash Art*, appropriately titled "Field Work," also singles out Mark Dion, another SVA and ISP classmate and fellow "Rooted Rhetoric" participant, who continued to find institutions useful as long as they weren't associated with art. "For artists in my general category," he stated in 1993, "working with institutions is infinitely more exciting than working in a modernist white cube."[133]

Between 1990 and 1993 this roster of young SVA and ISP alums would be fleshed out and firmed up, resulting in an identifiable group that both fans and detractors alike could point to as representing the official legacy of Asher, Buren, Haacke, et al. One critic would come to describe it as "a renaissance of institutional critique in art practice."[134] Along with close friends Bordowitz and Dion there was Andrea Fraser, another Owens student from SVA and ISP who in the mid-1980s spent time as Lawson's studio assistant and roomed with Bordowitz on the Lower East Side. The three of them first showed together in 1985 at Four Walls, an artist-run space in Hoboken (in the mid-1990s Four Walls would be remembered in these by-now-familiar terms: it "started as a conversation," its curatorial program was "more polyglot than cohesive," and its

exhibitions lasted only one night, which "made looking at art an event").[135] Christian Philipp Müller was also annexed, his work discussed along with that of Fraser, Dion, and Armaly by Graw in both her "Field Work" essay and another piece of writing, "Jugend Forscht," that she published in Germany the same year.

Somewhat like Glasgow and Los Angeles, in the late 1980s New York and Cologne began to develop myriad connections between one another's artists and art institutions. Müller had moved from Düsseldorf to Cologne in 1986, where Graw was based; in 1990 former Munich gallerist Christian Nagel moved there also, as did Armaly, who had been traveling extensively throughout Europe for Kosuth. Relationships quickly proliferated: by 1989 Dion and Fraser had aligned themselves with the New York gallery American Fine Arts, whose proprietor, Colin de Land, would go on to be the hit of the Cologne Art Fair that fall (earning his own separate write-up in the reviews section of *Flash Art*). A few months later Armaly and Müller collaborated on a piece for the Cologne-based show "Nachschub," whose accompanying catalog included a text piece by Fraser and was edited by Graw. By the end of 1990 Nagel was exhibiting both Armaly and Müller and also gave Fraser her first solo show, with Dion exhibiting there the following spring. Renée Green, a more recent ISP grad, mounted a show with Nagel in 1992, around the same time that Müller began showing at American Fine Arts and relocated to New York. Cologne even boasted its own pendant DIY artist space, Friesenwall 120, "a comfortable place for the reception of information" run by Nagel artists Josef Strau and Stephen Dillemuth.[136] (About Cologne during this time Strau would later reminisce, "I would characterize the prevailing attitude as a lack of interest in the procedures of production, with more emphasis on positioning oneself as an artist within the social fabric.")[137]

Already by 1993 the stature of this particular New York–Cologne axis was formidable enough to garner museum recognition both in Europe and in the US. Curator Peter Weibel selected the American Fraser and the Swiss-born Müller, along with Austrian artist Gerwald Rockenschaub, to represent Austria in the Venice Biennale that summer, and in the fall, in one of his typically grand gestures, he organized a big group show for the Neue Galerie in

Graz called "Kontext Kunst: Art of the '90s," which placed the artists associated with Nagel and de Land at the center of what Weibel christened "a new art form." Context Art, he wrote in the catalog, "is no longer purely about critiquing the art system but about critiquing reality and analyzing and creating social processes. . . . Artists are becoming autonomous agents of social processes, partisans of the real."[138] Choosing a more intimate, less big-picture approach, the show "Parallax View: Cologne–New York," curated by Daniela Salvioni for PS1 and also mounted in 1993, emphasized instead the specific discussions and social interactions between the de Land and Nagel artists—or, as Salvioni phrased it, "the group as a discursive formation"—even while the show tried to "preserve the *relative autonomy* by presenting each artist in a well-defined and separate space." Salvioni (who had shared a New York apartment with Kosuth, Graw, Clegg, and Guttmann in the 1980s) wrote in the catalog, in words strongly reminiscent of Craig Richardson describing IMMA's "Guilt By Association" and Esche and Brown on "Trust," that "the resonance between the work is always already grounded in a discursive exchange between the artists."[139] (Bennett Simpson would repeat this in the catalog for his 2006 curatorial remake about the same 1990s New York–Cologne phenomenon: "I too am attracted to these Cologne artists . . . because of their perceived autonomy," Simpson writes, even though "frequently art works from this time and place rely on anecdotes and the appearance of inside references. . . . With much of this work one has the impression that meaning is fugitive . . . wound up with social dynamics, artistic persona and the close, 'private' communities that define Cologne.")[140]

James Meyer made a similar if more precise argument at American Fine Arts with an exhibition (running concurrently with Weibel's and Salvioni's shows) in which he brought together Bordowitz, Dion, Fraser, Green, Müller, and another SVA and ISP alum, Tom Burr, as well as Zoe Leonard, an early member of ACT UP and a participant in the "Nachschub" show. Developments in art practice "have extended and displaced the terms of previous institutional analysis," Meyer wrote in his catalog essay—an edited version of which was simultaneously published in the "Kontext Kunst"

catalog. "The gallery has become one of many sites of investigation, a site positioned at the intersection of discursive fields, *an institution among institutions*."[141] But what distinguished this group for Meyer was its embrace of a mostly paradigmatic language, including its desire to be framed by such a historically weighty label as institutional critique. Indeed, the title of Meyer's exhibition, "What Happened to the Institutional Critique?" (borrowed from a rhetorical question Bordowitz asked aloud in the same 1989 interview in which he disavowed his former interest in gallery walls), was meant to indicate less a sense of the crisis and disarray into which the practice of critiquing institutions had fallen than the emergence of a new phase in its development. Theories of art, of its historical development and its underlying conditions, supplied the terms with which the group was described and positioned, by its own members as well as by others. This wasn't spontaneous and horizontal interaction, people brought together through mutual admiration of one another's networking skills, like, say, the "Windfall" artists; this was a more formally assembled group whose members all faced the front of the classroom, as it were. They took their cues from the same syllabus, same set of discourses, same teachers even (who were admired precisely for constantly lecturing about everything they knew, to paraphrase Laura Owens).

Indeed, if the crucial role that schools played in its formation didn't set this group apart, the fact that its members spoke of their teachers more than of each other did. (Müller's attraction to Armaly, for example, had to do not just with his art but also with the stories he told of the classes he attended and the teachers, like Owens and Buchloh, that he worked with.) The group also had its own journal, the Cologne-based *Texte zur Kunst*, which Graw cofounded in 1990. (It perhaps would have had a second journal if the short-lived ACME, started in New York in 1992, had lasted beyond two issues.) Quickly becoming known as "the house organ of institutional critique,"[142] *Texte zur Kunst* made its paradigmatic ambitions crystal clear in its very first issue, which featured Graw's "Jugend Forscht" alongside Anne Rorimer's monograph on Michael Asher titled "Context as Content" and a long theoretical essay by Thomas Crow on the historical relationship of

modernization to modern art. On the front cover, the inaugural issue ran an image not of an artwork or an artist but of the critic Clement Greenberg as captured in a Hans Namuth photograph circa 1951—just his fleshy mug filling the entire space, cropped ear to ear, forehead to chin.

This was the backdrop the group posed itself against, not only a historical master narrative about the passage since the 1960s from autonomy to context, essence to effect, conviction to critique, but also an elite institutional lineage tracing who this group's teachers studied under and learned from themselves, a history and dynastic bloodline that the 1970s theorists of postmodernism—Krauss and her students, like Foster and Owens—resurrected and continued precisely through their critique of the ur-mentor Greenberg's earlier modernist account, a history that now would be critiqued and interrogated anew in order for it to be claimed and continued by a new generation in the 1990s. As Meyer writes in his 1993 catalog, these artists are themselves would-be teachers: they "are engaged in critical pedagogy," their poststudio projects borrowing "the model of instruction at the School of Visual Arts and the Whitney Program in the mid-'80s" in which "students are encouraged to think carefully about the conditions of the production of knowledge; about their own situations; and to consider, in the teacher's example, the strategic choices a producer makes to explore a field of concerns." Art was to be praised not for its syntagmatic spontaneity but the opposite, for its methodological competence and historical self-consciousness and justification, for its ability to align and articulate with certain "anonymous" paradigms, canonical metalanguages, and institutionally preestablished sets of references—in short, for its ability to follow, to reproduce the teacher's example, and by extension the institution's. "The most powerful critiques," Meyer concludes, "surely derive from a competence in a discourse."[143]

The relationship between this group of artists and the interpretive frame within which they worked was the opposite of the relationship promoted by social shows like "Trust"; rather than absent, here the frame was overbearingly present, dictating which terms and problems the artists were said to preoccupy themselves

with. But undermining the explanatory and evaluative force of this disciplinary frame was the fact that, in its own way, it was almost as exclusively narrow as the group to whom it was applied. Theoretical models and historical accounts were drawn on and deployed but with little or no critical reflection on the institutional and disciplinary contexts and conditions within which those texts had originally been hatched; it was as if the immanent logic of art historical development had itself picked out these particular artists for special mention, as if the group's membership had been determined purely by right thinking. And the art historical account itself had a purified, connect-the-dots quality to it that betrayed its insularity. As a frame, it was too formulaic—*too* rigidly paradigmatic—to acknowledge a host of mitigating social and historical factors, resulting in an interpretative context nearly as blinkered as that used by the champions of art as unframed, spontaneous socializing. Paradigm, not syntagm, was here idealized. Just as "Trust" presented itself as an oasis of socializing, so the SVA and ISP were remade by Meyer and many of their students into transcendent havens for the free exercising of intellect, portrayed not as a set of historically limited, implicated and implicating institutional conditions but as the simple, transparent manifestation of critical thinking at its most abstract and exalted. And again, all this left too broad a gulf between the academicism of the ISP's disciplinary schemes and the specific interventions into the "real world" by the few artists it deemed worthy of recognition.

Which once again begs the question: what about the missing middle ground? Does it always have to be one or the other—does art always have to choose between either a purely syntagmatic or a purely paradigmatic approach? Is there an alternative response other than dutiful submission to or utter denial of metalinguistic categories and other discursive and institutional frames? Can one fill in the space between being an exemplar of the historical model and method known as institutional critique and being simply a contingent, context-minded, first-person "I"? Can an existentially full but semantically empty indexical pronoun engage a definite but abstract predicate that it both is and isn't, the two directly linked while remaining separate?

The answer, at least according to one ISP alum, is yes. "I am the institution," Andrea Fraser has pronounced over and over again—the first time, at least in public, at a symposium in Europe in 1992; more recently in 2005 in the pages of *Artforum*, where she repeated that "the institution is inside of us . . . we are the institution."[144] Such a statement stands in stark opposition to an injunction like "do it yourself," in which the highlighted verb's energy ricochets mirrorlike between a subject and object that, because both are indexical or paradigmatically "empty," conform to one another in their mutual context-dependency, each serving as the other's defining syntagmatic situatedness, resulting in a mechanistic feedback loop or what Baudrillard calls the "call and response" of communication.[145] But in the formulation "I am the institution," subject and object are not activated as mere echoes of one another; instead the subject is objectified paradigmatically while the object in turn is specified concretely by the indexical pronoun. Thus, somewhat as Esche and Joselit maintained, Fraser's equation of herself and the institution seems to shift emphasis away from the brick-and-mortar housing of art world practices toward individual practitioners themselves. And indeed, Fraser's work has always been credited with utilizing the genre of performance as a means to reintroduce subjectivity and desire into a rationalistic conceptual art tradition from which such things were initially banished. But still, the first-person "I" in Fraser's sentence is decidedly not liberated and empowered, not a free agent—rather than spontaneously engaging with and providing feedback within various contexts, Fraser's work is instead often described as simultaneously "narcissistic" and "programmatic," both too inward-turned and too agenda-driven. Whether she's acting pedantic or haughty or emotional or drunk, she is always somewhat statuesque, attired in official costume, standing under a spotlight, sometimes behind a podium, reciting memorized scripts that have been laboriously researched and jigsawed together from historical documents and disciplinary discourse. Working as a performance artist without objects, Fraser herself becomes the object—or, again, she is objectified. She is the "I" pushed up face to face against her determination, with a razor-thin "to be" verb equating subject and object

while keeping the two asymmetrical and noncoincidental. Such paradigmatic predication or objectifying of oneself can be seen as a form of *self-reflexivity*—again, a very different operation than the frictionless self-*repetition* of DIY. "Reflection, when it is a case of mirroring, is a move toward an external symmetry," Krauss wrote in the 1970s, "while reflexiveness is a strategy to achieve a radical asymmetry, from within. . . . Reflexiveness is precisely this fracture into two categorically different entities which can elucidate one another insofar as their separateness is maintained."[146]

Indeed, Fraser has consistently defined her approach this way. "To the extent that I am recognized in the artistic field and authorized by its institutions to speak," she says, "I speak with its authority. For me, Institutional Critique is the self-reflexive analysis of that authority."[147] Rather than criticize institutions—whether those of art or not—or simply take into account her critical stance relative to them, Fraser places her own position in the crosshairs, predicates or objectifies *herself* paradigmatically as a speaking subject in the very act of speaking—that is, in the syntagmatic context of her speech as performative event. In this she explicitly follows Pierre Bourdieu, for whom self-reflexivity means "objectifying one's own universe," so that the subject doesn't think "that he is placed outside of the object, that he observes it from afar and from above." Most importantly, a self-reflexive practice, through its "objectivation of the tools of objectivation[,] . . . continually turns back onto itself the scientific weapons it produces."[148]

This approach distances Fraser's practice not only from the unmediated, spontaneous social art applauded by Esche et al., but also from the descriptions that Weibel, Meyer, and others rendered of 1990s institutional critique. The art world is in fact not a syntagmatic "context" for Fraser, one she can move in and out of at will, nor is it a purely abstract, transcendent storehouse of methods and historical precedents at her disposal. It is instead constitutive of her very agency in the concrete world, an agency which draws its resources from her position within its institutions even as that position is itself limited and determined by being defined negatively in relation to those institutions'—or paradigms'—other concurrent positions. Any returns on her

FIGURE 2.21

Andrea Fraser, *Kunst Muss Hängen*, 2001. Performance
at Galerie Christian Nagel. Photo: Simon Vogel. Courtesy
of Friedrich Petzel Gallery, New York.

actions and statements, no matter the context, will accrue back to that position. In contrast, Meyer's nomadic poststudio artists, who "swap one social or project-related setting for the next," seem to transcend such determinations; their work not only "engages several sites and institutions at once," but they themselves are at liberty to "move between roles" and apply their professional methodologies "more widely."[149] Such capacity to choose freely and move at will could only be available to subjects who are radically self-constituting, and who therefore can position themselves as if at a calculating, instrumentalizing distance from—and thus better capitalize on the fragmentation and dispersal of—contexts, discourses, resources, even identities. According to Meyer, artists who focus their analysis on the art world betray "a reflexive bias" that is ultimately a vestigial Kantian leftover from Greenbergian modernism. The immaculately schooled, late 1980s graduates of the ISP are instead more like outward-oriented free agents—they are, Meyer writes, "beyond reflexivity."[150]

How does any of this make a difference in Fraser's art? There are, after all, plenty of similarities. Like a lot of recent social sculpture or relational aesthetics, Fraser's projects typically get people to open up and speak their minds. On the other hand, her work isn't about her hanging out with other artists. She takes as her starting point the social institution of art and yet doesn't play up gratuitous, spontaneous acts of socializing (her perceived narcissism and political rigidity are precisely the characteristics most avoided when it comes to selecting good team players for a temporary project). She addresses not so much primary individuals as the secondary frames and positions they occupy, subjects she specifies as much professionally and contractually as in the flesh. She assumes institutional roles (acting as curator, docent, spokesperson, museum visitor, as well as artist) and appropriates institutional forms (writing wall labels, designing posters, recording audio tours). It's by balancing the syntagmatic and the paradigmatic, the first-person pronoun and the generic institutional frame, that Fraser is able to picture an institutional middle ground between embedded, performative contexts and the high-flying mobility of international, supposedly self-constituted free agents.

But while this approach equips her with a much greater overall syntactical range, that in itself doesn't compel Fraser to render a more healthy portrait of the contemporary role of art in society, to come up with magical resolutions to art's many contradictions and historically unresolved debts—if anything, it empowers her to reckon more broadly and deeply with such tensions and deficits. In other words, the middle ground Fraser pictures is not a pretty sight. No matter who speaks, whether Fraser or the museum professionals and patrons and private collectors she interviews, the talk always goes around in circles, always ends in conflict with itself. The most tortuous contradictions stem from the very notion of art's autonomy: the autonomy of noninstrumentalized, unalienated artistic activity contradicted by the autonomy of the alienated art commodity on the "free" market; the contradiction of art as a self-regulating, autonomous social profession that nevertheless is haunted by the lack of broad public efficaciousness it feels it needs to legitimize itself; the autonomy of "free" critical thinking and political dissent that when enacted results in a kind of propaganda in contradiction with the notion of autonomy as functionlessness; ultimately the instrumentalization of autonomy itself as it is reified by the very category *art* into a status symbol marking transcendence over an instrumentalizing society.[151] And still the subject and the institution, the "I" and the predicate, remain locked together, each looking to the other to answer its needs and justify or complete it, and each experiencing again and again that desire's frustration.

One last point about what makes Fraser's work distinct. She doesn't hide the contract. Indeed, instead of treating institutional settings and disciplinary discourses as the natural offspring of spontaneous socializing, instead of handling secondary information as if it were itself primary, Fraser literally places her contracts on exhibit. In 1993 she drew up a set of what she called "Preliminary Prospectuses," four different versions of a basic contract corresponding to projects to be undertaken with individuals, corporations, "cultural constituency organizations" (including nonprofit foundations and advocacy groups as well as commercial galleries), and general audience organizations (i.e., museums)—printing

them out in bulk and displaying them as the centerpiece of a solo exhibition at American Fine Arts. Fraser's contract, however, is more than a means of insisting on the continued importance of secondary language and framing mechanisms. It is also, or perhaps more so, her way of exerting some measure of control over already established frames and agreements that govern transactions in the art world and elsewhere but tend to be largely unspoken or ill-defined and thus overlooked or, worse, naturalized. Fraser's contract, in other words, enforces an *explicit* distinction between what is and isn't included in her commissions. Thus, upon completing a contractually agreed-upon project for the Austrian EA-Generali Foundation (the art program for the multinational Generali insurance company), Fraser announced in a speech at the opening reception that she didn't want to say *thank you.* "I was engaged by the Foundation to undertake a certain job which I define as providing a service," she explained. "My hope, simply, is that the Foundation has found that job well done."[152] The contract represents for Fraser a modicum of autonomy in a field of always already framed activity and exchange.

Perhaps nowhere is this aspect of the contract more foregrounded than in Fraser's *Untitled*, 2003, a work that began with the artist asking her New York dealer to find a collector willing to have sex with her as part of an artwork. Among the requirements were that the potential participant be heterosexual and unmarried. "I first imagined the piece," Fraser says, "as a kind of Huebleresque contract."[153] The agreement with the collector stipulated a price as well as established consent that the sex be recorded for use as an artist's video, to be sold in an edition of five, with one copy going to the participant himself. The recording that resulted was publicly screened at Fraser's gallery in accord with restrictions outlined in the elaborate sales contract for the four remaining DVDs—on a monitor no larger than thirty inches in a room without seating (under no circumstances is the work ever to be projected—these terms, and others having to do with related publicity, extend as well to all future owners of the piece).[154] On the small TV screen gallerygoers could witness, as usual with artist projects and commissions, the once separate

FIGURE 2.22

Andrea Fraser, *Please Ask for Assistance*, 1993. Installation view with *Preliminary Prospectuses*, American Fine Arts, Co., New York. Photo: Colin de Land. Courtesy of the artist.

FIGURE 2.23

Andrea Fraser, *Untitled*, 2003 (installation view). DVD, sixty
minutes. Courtesy of Friedrich Petzel Gallery, New York.

spheres of production and reception now knitted together in an intimate, responsive collaboration—this time in an upscale Manhattan hotel room, documented with a camera set surveillance-style high up in one of the ceiling's corners. But unlike all of Fraser's other projects, this one produced no sound. The screen was mute. The only speech or text to be found was in the show's concise and dryly worded press release. And to this day, not many critics or theorists have shown an eagerness to discuss the work's import ("It is hard to know what to say," George Baker writes in the catalog accompanying the artist's recent retrospective, "so I will refrain from saying much").[155] A contract was written up and the requisite task performed. The rest, *Untitled* seems to suggest, is none of our business.

Coda: Where Do Social Networks Come From?

The fact that the ISP artists are usually portrayed, and portray themselves, as bookish, that they intend what they say and do to be understood as rooted in, rather liberated from, written texts and disciplinary discourses, doesn't alter the fact that, as a network formed initially in the context of an art school, they are no different from any of the other groups I've discussed in this chapter. Many artist networks could be added to such a list (for example, Christoph Keller's 2000–2002 series of "Circles" exhibitions covered the school-driven art scenes in Frankfurt and Geneva). It's hard not to draw from this the conclusion that art schools now provide a new system of standardization to compensate for the growing obsolescence of the former studio-gallery-museum system, and that instead of a series of white cubes dictating conformity in the production, distribution, and reception of material art objects, today it's the school that enforces conformity and interchangeability of parts in the production of art subjects.

In his 1999 book titled *Art Subjects*, which examines graduate art education, its recent proliferation, and its impact on how contemporary art is itself conceived, Howard Singerman argues that, unlike on the undergraduate level, where priority is given to instruction in the material techniques for making art objects, it's "artists [who] are the subject of graduate school."[156] With their

emphasis on critiques, studio visits, and visiting-artist talks, MFA programs are exemplary at getting people to open up and say what's on their minds. More generally, what further recommends situating art and artists in an educational context is how well this answers the demand that art now devote itself to transmission and access. If the value of school once owed to its solitude, its encouragement of the undistracted pursuit of studies, today it's the opposite: with availability and porousness the new norms, art schools are looked to as models for exactly how to replace monological display with proliferating information platforms; they're prized for being far ahead of museums and other kinds of institutions in having a diversity of media equipment and infrastructure so as to easily disseminate and access content, for their rearrangeable, multiuse spaces, and for their general adeptness at assimilating art to a switchboard of audience feedback, professional tips, and scholarly exchange. "The art academy seems to me to be an extraordinary institution with potentially the greatest relevance to current art practice of any in the art world—whether museum, kunsthalle, commercial gallery or studio workshop," proclaims none other than Charles Esche, who soon after leaving Tramway accepted a research fellowship at the Edinburgh College of Art in 1998, and while there initiated along with a collection of his postgraduate students the Protoacademy, "an educational project based on ideas of non-hierarchy and peer-led learning, supported by Esche's international experience and network."[157] During its six years the Protoacademy hosted guests, arranged symposia and reading groups, and facilitated international exhibition opportunities. In the rush to formulate more flexible, communications-based art institutions, art schools are leading the way.

Also helping explain the current attraction to art schools is the fact that they systematically produce social networks, yearly admitting and graduating artists who share not a common cause or ideology or even cultural obsession but are always only loosely affiliated within a dispersed yet coherently defined professional field. It takes nothing away from the earnestness and intensity of student interactions to point out that the more highly regarded schools—whether traditional or alternative—are also the more

How to read the Geneva Diagram:

_____ Invitation to exhibition

- - - - - Collaboration between artists

Forde

Low Bet

Ecart booth at the Basel Art Fair

Centre Genevois de Gravure Contemporaine, now Centre d'Edition Contemporaine

In Vitro

La Régie

*also JRP éditions, founded 1997

FIGURE 2.24

Mai-Thu Perret, *Geneva Diagram*, 2002. Created for publication in *Circles: Individuelle Sozialisation und Netzwerkarbeit in der zeitgenössischen Kunst*, ed. Christoph Keller (Frankfurt: Revolver, 2002).

FIGURE 2.25

Steven Duval and Protoacademy, from *Privacy—A Programme of Symposia*, May 2004. Ten-day project involving talks, films, printed matter, interventions, and general debate, in collaboration with The Henry Moore Foundations Contemporary Projects and Olaf Nicolai.

well-connected, the ones with the most recognizable names among their faculty, alumni, and visiting-artist rosters. What justifies today's steep tuitions is entrée to such potentially valuable social circles, certainly not the opportunity to learn the proper plaster mix or the many differences between stand and linseed oil or some other technical skill (and this goes for skill sets in departments beyond art; as a recent *New York Times* article titled "What a College Education Buys" advises, "In recent decades the biggest rewards have gone to those whose intelligence is deployable in new directions on short notice, not to those who are locked into a single marketable skill . . . it's best not to specialize too much").[158] Given that survival today depends on access to resources and opportunities, what all students seek is to leave college with a choice network of contacts, a dispersed social circuitry from which to gain job tips, project ideas, important social introductions, data that's as far-flung as possible while remaining professionally relevant. A bunch of interesting and well-connected people—this is the ideal that art schools now hold out for other institutions to emulate. A new institutional model has emerged that, according to Irit Rogoff of Goldsmiths in London, is "part university and part museum."[159] (As for the museum's fate in this equation, to repurpose itself to be more like a school it must reverse its previous orientation and become less retrospective, less about a fixed past, and more about formulation and process; the canon is therefore replaced with something like the school's open house, maybe portfolio day, an unending parade of temporary projects featuring ever-newer talent.)

The central role played by art schools today is evidenced by, among other things, the number of major movers and shakers who have left top curatorial positions for school administrative posts and vice versa (along with Esche there are Daniel Birnbaum, Okwui Enwezor, Russell Ferguson, Maria Lind, Ute Meta Bauer, and Larry Rinder, to name only a few), or the growing list of schools that have erected their very own world-class *Kunsthallen* (Frankfurt Stadelschule's Portikus, UCLA's Hammer Museum, CCA's Wattis Institute). Several recent museum shows and published anthologies have propounded an "educational turn" in contemporary art, and there have even been international exhibitions

like "Manifesta 6" in Nicosia and "unitednationsplaza" in Berlin, both in 2006, which advertised themselves as short-lived schools. Increasing attention has also been awarded to new artists' initiatives that take the form of, or at least call themselves, schools— either university affiliated groups like Esche's Protoacademy or unaccredited, DIY outfits like the Bruce High Quality Foundation University and 16 Beaver in New York, or Sundown Schoolhouse and Mountain School in L.A.

But while the idea of art schools grows in allure, what is to occupy class time becomes less clear. As all the recent studies and symposia on art education have pointed out, métier, medium, and art history have receded in importance; so too has interest in theory. "As long as I've been here," Charles Ray remarked about his teaching job at UCLA in 1998, "I've never written a curriculum, never prepared for a class."[160] Taking the place of traditional techniques, formal curricula, and abstract thought is open-ended discussion and peer interaction, along with a general shift away from humanities topics toward more practical interests in architecture, design, new media, engineering, even business. The sense grows that art graduate students are outward-going and action-oriented. "An art school is not concerned solely with the process of learning, but can be and often is a highly active site of cultural production," writes Anton Vidokle, both a "Manifesta 6" co-curator and "unitednationsplaza's" headmaster. "Producing tangible results that move beyond commentary requires research, groundwork and a continuous process of involvement and production."[161] At the same time, precisely because such activity is still identified as schoolwork, it also represents something of a retreat, as if enacted within a free space at a distance from the lures and limitations of complicit reality. (Esche also invokes art school as a relatively autonomous preserve, a "halfway house" and "shelter for artists.")[162]

This ability to combine a sense of autonomy with the promise of real-world agency helps explain the over-the-top utopian rhetoric that so often colors recent discussions of art school. Indeed, a certain amount of idealism is perhaps endemic to the whole idea of the art school, which is thought of as an enclave of innocent creativity that is at once protected by the presumed autonomy of

academia and yet also so spontaneous, unaccountable, and intuitive as to be irreducible to teachable formulas and rigid disciplinary protocols. Even some of the most traditional academies and university art departments now strike a pose of casual idealism, underplaying the commercial firepower of their celebrity faculty or the rigorousness of their critiques in favor of how well they manage to formalize informality and package openness, invention, and effervescent sharing. "Artists and students from other schools were invited to stay in our studios," enthuses Daniel Birnbaum, since 2000 the rector of Frankfurt's Stadelschule. "We all met, cooked, ate and talked for an entire week."[163] Not only are assumptions about art's unique and superior capacity to positively influence society taken for granted here, but so is the virtuousness of education per se, thus leaving unacknowledged the crucial role that education plays in reproducing unequal social relations. No wonder so many museums and publishing houses have turned to art schools as theme for their exhibitions and anthologies. For those charged with promoting society's reigning values, there's plenty to like: earnest idolatry of art, preservation of an autonomous sphere of creativity, postwelfare reliance on volunteerism, staged displays of seemingly spontaneous everyday democracy. The ideology of some of society's most crucial institutions is thus reaffirmed, even as art schools pose as something apart from institutions, fashioning themselves as platforms for free repartee rather than for reproduction. Thus does the school replace the museum as the central institutional frame for art, and at the same time also disowns and naturalizes that fact, so that its centrality and institutionality are "usually not perceived and certainly never questioned," as Buren described the museum-based art system in 1971.

But that's not all: add to the mix—along with all the school-based exhibitions, anthologies, and symposia, the schoolish artists' initiatives, the prowling of MFA studios by dealers and collectors—the mounting interest in starting new PhD programs in studio art, and the result is that school no longer represents a short interim or distinct segment in one's path into the art world, but instead stretches out to involve more and more types of art activities over the entire course of one's career. In this way, as Katy

Siegel remarks, the art world adapts to broader changes in the role of education in the new economy, changes such as "the constant imperative to learn new skills, to give oneself over to the 'retooling process' (as Bill Clinton called it), perpetually starting over as an amateur and having to figure out the new, next thing." Rather than strive to manufacture rigidly disciplined graduates with specific skills, schools now instill flexibility itself as a skill, promoting the ideals of roaming interdisciplinarity and lifelong learning. "As the practices of schools morph into making art," Siegel concludes, "it's extremely common for artists to talk about the integration of their teaching and art-making."[164] Here Buren's fears from forty years ago are realized all over again, only now it's art school that becomes, literally, the "enclosure where art is born and buried."

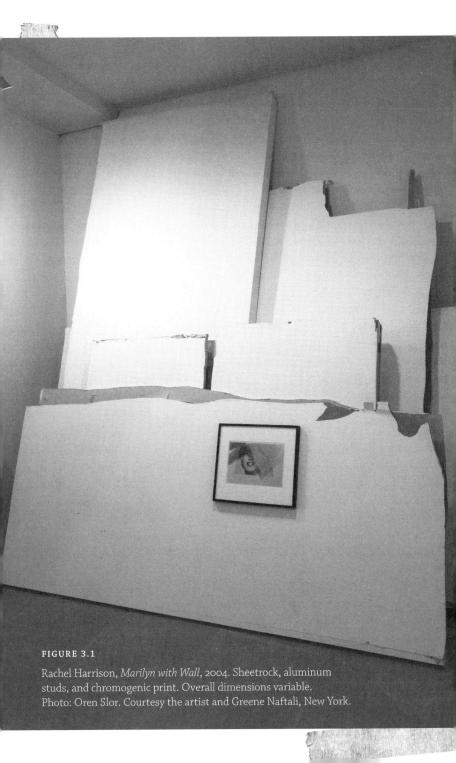

FIGURE 3.1

Rachel Harrison, *Marilyn with Wall*, 2004. Sheetrock, aluminum
studs, and chromogenic print. Overall dimensions variable.
Photo: Oren Slor. Courtesy the artist and Greene Naftali, New York.

3 **Ruins**

At moments of destruction and transformation, ruins accumulate in art as elsewhere. Or so it seems: think of late eighteenth- and early nineteenth-century European paintings by Hubert Robert and Caspar David Friedrich in which fragments of the past are portrayed in monumental fashion. Or, at the other end of the spectrum, the more humble collage of the early twentieth century ("Painting is jewellery," Louis Aragon observed, "collage is poor").[1] But collage itself is conflicted and internally divided in terms of the ends it serves; it can be thought to develop in several directions at once, with Tatlin taking it toward constructivism and a more engineered and industrial idea of sculpture—sculpture as a building outward

through relations of piece elements rather than subtracting from wood or stone block as taught by the fine arts academy. At the same time collage also gets inflected by dada artists during and after World War I to include more scatology and disfigurement, thus becoming representative of the sensibility not of the Soviet "New Man" but something closer to Walter Benjamin's famous description of the shell-shocked urban denizen whiplashed between registering only either modernity's standardized and predictable culture industry banalities or its traumatically unpredictable flux. In the late 1950s, at the very moment many consider the first full flowering of consumer culture, there appears a revived or neo-dada, which by 1960 Lawrence Alloway had labeled a "junk aesthetic." Ruins in art have thus marked the withering of the *ancien régime*, as well as the annihilation of the classic bourgeois European social order and also the rise of commodity culture and spectacle. Which begs the question: why have junk and debris reappeared in art today? What destruction and transformation does this shattering of form herald?

"We live amid the decay of structures," goes the introduction to a recent cultural studies anthology, "that once organized our collective and individual experience: political orders and antagonisms, criteria of value, categories of judgment . . . traditions and forms of collective expression, memorial and archival institutions."[2] No doubt many institutions of art could be named as belonging to such a landscape. "Today the canon appears less a barricade to storm than a ruin to pick through," Hal Foster wrote in 2002.[3] But what the figure of ruins costs in terms of loss of totality and closure, it compensates for by providing the scenography not just of a traumatic dispossession but also of a more elegiac lamentation, and even something bordering on romantic heroism—as the writer's ascendant gaze surveys, in lieu of totality, the vast terrain covered by its wreckage. In the end, doesn't the very ability to contemplate such a scene depend, after the withering and collapse and destruction have run their course, on a commentator who remains the only one left standing, unvanquished?

Lately there have appeared a lot of people fitting that description. Think, for example, of all the newspaper and magazine articles reporting on the rise in popularity in US policy circles of

Joseph Schumpeter, the early twentieth-century economist who championed the heroism of the entrepreneur and promoted capitalism as a process of "creative destruction."[4] Or think of Chris Anderson, editor in chief at *Wired* magazine and author of the book *The Long Tail*, describing the new sense of empowerment experienced by today's Internet-based consumers who watch and cheer recent transformations in the entertainment marketplace, as a former broadcast-based, monolithic blockbuster culture "scatter[s] to the winds and markets fragment into countless niches," resulting in what now gets called "the aftermarket."[5] With most of these examples, the upshot tends to be the same: one person's—or business's or culture's or community's—debilitating catastrophe will represent another's unique opportunity. That's the rub of Schumpeter's now triumphant worldview: that we should appreciate how, from wave upon wave of disaster and all the debris and information coughed up in its wake, there arise opportunities—namely, opportunities for gain. Indeed, our culture's current imaginative involvement with a sense of mounting levels of debris can be considered the very condition for the heightened sense we now have of individual agency, our ability to act, to act on opportunities.

Tear Down

It was 1989, the same year as the dismantling of the Berlin Wall, when Gregg Bordowitz realized he had "no more questions about gallery walls." Mere coincidence? Or was there something else at work, something broader, perhaps having to do with changes in official policy, new corporate business models, developments in instrumentalized and instrumentalizing technologies, all related on one level or another to an increasingly inadequate technological diagram of disciplinary power and the subsequent reorganization of society according to a new diagram of control power? Such a paradigm shift, requiring that enclosures be replaced and augmented by networks, would lead to radical changes in such things as gallery walls—that is, in the institutional structure of museums, indeed in their very architecture—causing them to suffer more than just the neglect of artists who turned to other concerns. The message seemed clear. *Museums, tear down your walls!*

As an exemplary instantiation of the disciplinary diagram, the museum wall was both a metaphor and a literal fact, ideology as concretely enacted belief. The museum as metalanguage is figured in its walls, as those walls subsume all objects they gather into a larger, shared importance. It was the wall itself that won the allegiance, again both literally and figuratively, of modernist painting. Rosalind Krauss has even described the rise of modern aesthetic discourse in terms of an architectural construction. "Aesthetic discourse as it developed in the 19th century," she writes, "organized itself increasingly around what could be called the space of exhibition . . . constituted in part by the continuous surface of the wall, a wall increasingly unstructured for any purpose other than the display of art."[6] The whole of the wall, the wall as wholeness—its flatness, its smooth continuity, its edges—all functioned not just architectonically, as stability and permanence, as underlying and overarching support and frame, but discursively as well, and importantly where the two overlap on the level of disciplinary organization. The wall "was also the ground of criticism," Krauss continues, "on the one hand the ground of a written response to the work's appearance in that special context, on the other hand the implicit ground of choice—of either inclusion or exclusion." The wall's continuous lateral reach supplied the necessary register not only for establishing the paradigmatic set of canonical signifiers but also for the linear left-to-right sequencing of those signifiers to form master narratives about nation, culture, and civilization. Critical judgment was also a function of the wall in so far as the wall was bounded, a framed enclosure, with a clear inside and outside, a harsh yes and no. Modernist painting was said to develop historically on behalf of the wall, both extending it and defensively patrolling its edges, maintaining it as "pure," allowing in only pictorial concerns, pushing out everything considered extracurricular. Painting in the late nineteenth century—"particularly landscape painting," Krauss writes—became modern as it grew more flat like the wall itself, as it "began to internalize the space of exhibition."[7]

Internalizing the wall of course meant more than art having to emphasize its materiality, or paintings having to stress their flatness. It meant internalizing the whole system of knowledge that

the museum organized, its alleged unity, fluency, and integrity. To be subsumed into the museum's space of comprehensive culture, the work of art needed to itself become cultivated and comprehensive in turn, its sensitizing and composing of materials made to stand as a synecdochic part representing the whole of the cultural tradition, including that tradition's depth and reach of sensibility, *its* level of composure. Each artwork supposedly had to internalize that continuity, summarizing in its single instance the tradition and the meaningfulness of its evolutionary and comparative relations. History not just conditioning the artwork and its viewing but history as the very thing viewed. "The way a painting or sculpture makes the past part of its present," Krauss wrote early in her career, "the way it both gives access to and outmodes the past, is as material to it as anything else one might say about the experience of it."[8] As Krauss explains this model, she ends up reaching for another architectural metaphor, that of the hallway. "The history we saw," she continues, "from Manet to the Impressionists to Cézanne and then to Picasso was like a series of rooms *en filade*. Within each room the individual artist explored, to the limits of his experience and his formal intelligence, the separate constituents of his medium. The effect of his pictorial act was to open simultaneously the door to the next space and close out access to the one behind him. . . . The aching beauty of those works [lay] in their constant invention of formats that collapsed into one instantly perceived chord the sounds of all those doors to the past closing at once."[9]

Such was the presumed harmony and dramatic coherence of the museum and its discipline, each room, each wall, each and every artwork telescoping past into present, dialectically folding context into content, at once eclipsing, absorbing and summarizing all of the paradigmatic collection's historical elaboration and interrelated variety into a single definitive experience of aesthetic judgment, with that experience serving as a single, instantaneous constant around which the arc of time proceeds, each advance in each culture's history, each step taken by the museum visitor in her or his stroll, measuring up equally, yet in its own way, to the same judgment, renewing that judgment each moment.

Since the promise of the modern museum wall was to orga-
nize art for public display—and to display art as the embodiment
of the public's collective values, the public as itself whole, indi-
visible—one of the primary ideological functions of this inward-
turned, seemingly disinterested and closed address was to posit in
turn a likewise static, eternalized referent, a presumed normative
subject of the museum's centering aesthetic experience. If defined
tightly enough, the museum's paradigmatic set would generate a
sense that the only positions and meanings available to citizens
were those designated by the set itself. Hence, whether the people
to whom this self-satisfied, authoritarian monologue was issued
actually found themselves and their culture represented and ide-
alized in the museum's walls raised considerable stakes, a whole
politics of recognition. To contest the museum's imposition of
values meant interrupting that display, breaking up its consistent
space and its air of self-legitimacy—it meant broadening that nar-
rative and making it less inevitable-seeming, more open to debate,
so that monologue could be made into dialogue, a potential argu-
ment over the turning points, the "therefores" and "but thens" of
the museum's rhetorical structure. It meant reversing the gravita-
tional pull of the institution's temporal model, challenging its die-
hard opposition to incommensurability, questioning the primary
importance it placed on continuity and on organization as subtrac-
tive composition rather than additive accretion.

Some who took issue with the museum argued less about its
presumed power to represent the culture of its constituents back
to them and more about how it wielded that political responsibil-
ity, about whose interests were served and denied by its inclusions
and exclusions. On the other hand, the museum's whole represen-
tational premise stood as a prime candidate for a deconstruction,
for an analysis of how frantically its textual system had to work
to hide the fact that it was always already unstable and incoher-
ent due to the inherent polyvalence and promiscuity of its signi-
fying operations. In the 1980s these two approaches would come
to dominate a robust discourse about museums on the part of
the cultural left, and even lead to internal battles waged between
its various factions. Indeed, not just conservatives lamented the

demise of canonical coherence: Marcos Sanchez-Tranquilino and John Tagg, for example, writing in 1992, described bitterly how "those who never made it now arrive to find the Museum in ruins . . . their Identity already gone, their Culture in fragments, their nationhood dispersed and their Monuments reduced to canonical rubble. Welcome to the new art history. There's room for everyone and a place for none."[10]

At the same time, however, many museums, for a variety of reasons, were beginning to accommodate a greater degree of incoherence, preferring that their collections be organized by weak ties rather than strong ones. Increasingly the calendars at museums were devoted to temporary shows, particularly rotating, traveling blockbuster exhibitions. Museums expanded merchandising activities, and prioritized attendance and customer satisfaction. Susan Cahan remembers how, as curator of education at New York's New Museum in the late 1980s, "I became interested in developing new ideas about museum education that drew on literary criticism, specifically reader response theory and reception theory. I was interested in looking at cultural reception as a form of cultural production . . . concretizing the process of reception, trying to give what happens to people when they look at art some kind of visible form."[11] Cahan cites as a source of inspiration the corporate art collecting program at Minneapolis-based First Bank, where employees were allowed to voice their opinions about which artworks the bank should acquire and where those works should hang in the corporation's headquarters, even what they did and didn't like about the art already amassed in the bank's collection. "It was argued," wrote one observer, "that employees would make better, more effective teams if they could work openly together, voice conflicts, and thus find 'true resolutions'. . . . [E]mpowering the employees in this way made them better at their jobs, made them more creative, more flexible, more 'process-oriented,' less 'conflict-averse.'"[12] As in the business world, so too did museums begin to incorporate contestation and feedback as a function of the exhibition space itself.

Thus, at the same moment that residencies and commissions of temporary, poststudio projects were helping to overcome the

formerly mute relations between artist's studio and museum canon, so too was the viewer brought into the loop, made less passive and contemplative, more participating and responsive. Rather than remaining inward-turned, museums began to circulate information outward, and also to solicit input, not only speaking to visitors but spurring them to speak back, to become loquacious.

Having to anticipate viewer response and interaction meant a number of things. For one, the public wouldn't have to devise its own reasons and ways to break up the consistent space of the museum's narrative; the museum would facilitate that for them. Focus would be dispersed. The art on display would be more passive and compliant, allowing not just interaction but a more aggressive manipulation—assuming the status of something like information, becoming more weightless, connective, compliantly modular and easily fragmented, on the spot and just in time. If in the past induction into the museum's collection had the effect of elevating a work into a master set, making it paradigmatic and exemplary, part of a metalanguage, now the museum would need to treat its contents not in terms of paradigmatic correlations but as potential resources for metonymic and syntagmatic chains. Instead of concerning itself with establishing fundamental and overarching premises and criteria, with categorical boundaries and vertical hierarchies, with essentializing, strongly tied cultural groupings ("School of Paris," "Harlem Renaissance," "Family of Man"), the museum would now facilitate individual practices of horizontal sequencing, juxtaposing, and combining.

No more dictating to audiences an ideological master narrative dressed up as a static, timeless truth; now the museum's items would be arrayed to seem as if waiting to be designated anew with value and meaning, like "an endless and unstructured collection of images, texts and other data records."[13] It was precisely this kind of museum that a number of critics saw emerging as early as the late 1970s. "The new museum," according to James Roberts, "is very much the museum of architectural diversity and multiple use, of expanded subjectivities and aesthetic traditions, of anti-elitist education and popular entertainment, of gallery walls and café tables."[14]

A history of this transformation would no doubt need to include a telling of postmodernism's rise and fall during the 1980s, of the passage away from culture seen as incapacitated and schizophrenic, with subjective experience collapsing, as Fredric Jameson put it, "into a rubble of distinct and unrelated signifiers,"[15] and toward a new account of culture that rose to dominance in the 1990s, according to which subjects were pictured as empowered rather than plagued by such fragmentation. If postmodernism modeled culture on theories of signification (in contrast to modernism's equation of culture with being cultured, with the individual's aesthetic judgments), the late '80s witnessed the emergence of yet another paradigm, one that would soon eclipse both modernism's feeling subject and postmodernism's semiotic social systems. Information would become the culture's new common denominator.

Since it belongs to a communicational rather than a representational paradigm, information has little need for either aesthetic discrimination or analysis of the sign. Indeed, information operates as if entirely independent of the acquisitive subjectivity presupposed by knowledge or cultural refinement, which individuals are thought to pursue and internalize. Instead information exists in a perpetually external, denotative state, requiring neither reflection nor contemplation but rather constant reaction, handling, and recirculation. And it encounters no threat from fragmentation, which always promised loss within a representational paradigm with its privileging of order and wholeness. On the contrary, for information fragmentation is a basic condition, what makes data mobile and modular, operational and instrumentalizable. Thus it was possible in the 1990s for appropriation in art to be recoded as no longer involving the critique of authorship and aura—indeed, the very opposition between appropriation and original creation disappeared. Instead, as Nicolas Bourriaud tells it, "artists who insert their work into that of others contribute to the eradication of the traditional distinction between production and consumption, creation and copy, readymade and original work."[16] With consumption thus repositioned from being a disempowering affliction to being just one more variant of everyday practice wielded by empowered cultural agents, the former antithesis pitting creative

hero against conformist consumer was transcended by new popular figures like the bricoleur, the DJ, and the web surfer, all "'semionauts' who produce original pathways through signs."[17] *New York Times* critic Ken Johnson more recently registered this shift when commending painter Mary Heilmann as being a type of bricoleur in her own right. She is "a Postmodernist scavenger," Johnson writes, "but unlike Sherrie Levine and Peter Halley, whose parodic abstractions deconstruct Modernist myths, she takes twentieth-century art history as her personal toy box."[18]

To facilitate today's bricoleurs and semionauts, art exhibitions no longer try to come across as something static and aloof, seemingly permanent and timeless, but rather ask to be picked and searched through, temporarily assembled in this way and that. The better a museum or *Kunsthalle* can do this, the better it will fall in line with the general business trend toward service provision, of offering different modular experiences from which customers can choose depending on whim or preference. As Marc Pachter, director of the National Portrait Gallery in Washington, describes his museum's recent renovations, "You can choose your portal, you can mix and match as you want."[19] Even museum architecture has adapted accordingly—by, for instance, literally incorporating more interior passageways. Again, this is a development that Krauss has carefully tracked over the years. "The reigning idea," she writes,

> is the vista: the sudden opening in the wall of a given gallery to allow a glimpse of a far-away object, and thereby to interject within the collection of these objects a reference to the order of another. The pierced partition, the open balcony, the interior window—circulation in these museums is as much visual as physical, and that visual movement is a constant decentering through the continual pull of something else, another exhibit, another relationship, another formal order, inserted within this one in a gesture which is simultaneously one of interest and of distraction: the serendipitous discovery of the museum as flea-market.[20]

FIGURE 3.2

Yoshio Taniguchi, the Museum of Modern Art, New York, renovation
2004. View from the sixth floor of the Donald B. and Catherine C. Marron
Atrium during the exhibition "Martin Kippenberger: The Problem
Perspective," March 1–May 11, 2009 (below: *Happy End of Franz Kafka's
"Amerika,"* 1994; above: *Spiderman-Atelier*, 1996). Photo: Patrick Andrade/
The New York Times/Redux.

FIGURE 3.3

Jacques Herzog and Pierre de Meuron, Walker Art Center, Minneapolis, 2005. View of the Hennepin lobby with ceiling aperture revealing restaurant lounge and bar above. Photo: © Duccio Malagamba.

This bombarding of the viewer with solicitations and choices makes the museum less of a stable enclosure and instead aligns it with today's communicational priorities, qualities like extensiveness and open-endedness, availability and retrievability across that extension, easy access and navigation by searchers, and the responsiveness and mobility of those elements being searched. This is what makes the museum more like a flea market, or, in the terminology I've been using, more like a database. In contrast to canons, databases are radically open-ended, they don't tell stories, don't have a beginning or end, there's no determined development that mandates a certain sequence of their elements. They are simply collections of individual items, each with potentially the same significance as every other item in its field. It is this particular logic of the database that weakens the ties within the museum's collection, renders it more passive and informational, that transforms it from being a canon or a tradition or an ideology into being, simply, one's personal toy box.

Criticism and Database

Aside from museums, one can look at published criticism, at the smooth white surface of the art magazine page, for another concrete example of the impact of today's emergent database paradigm on art's discursive and disciplinary organization. Consider some of the changes made over the last fifteen years at *Artforum*. Many of these changes—for example, the increased interspersing of advertising and editorial content that began in the late 1990s—have been cited as evidence of the magazine's decline, its having sold out. The old *Artforum*, so the usual complaint goes, was a magazine you read, whereas today's *Artforum* is a magazine you only glance through. But such an argument is too simplistic; it would be more accurate, albeit paradoxical, to say that *Artforum* has never been stronger. This is not to claim that the criticism it prints has grown better or worse. For indeed criticism per se has become somewhat beside the point.

On the one hand, especially in the last twenty years, the actual practice of criticism has expanded from a proclivity of elites to a broad form of social labor: rating and recommending objects

and experiences has become a mainstay of today's ubiquitous so-
cial media, as well as an important cost-free source of value-adding
for retailers. On the other hand, individual response to individual
objects, the baseline formula for the work of critics, dwindles in
significance, especially as network connectivity overwhelms the
formerly isolating boundaries of sovereign individuals and dis-
crete artworks, the two poles between which free aesthetic judg-
ment is supposed to be punctually exercised. A communicational
paradigm places too much stress on ever-changing relations and
constant interaction and feedback to support criticism's still domi-
nant myth—that of a lone individual, armed with little more than
her or his well-tuned sensibility, facing off against a similarly de-
limited object like a framed artwork or precisely themed exhibi-
tion. Criticism, at least when it's imagined to be issued from some
fixed position at a distance from the field of practice, will appear
limited and diminished by its immobility and withdrawal from the
field's circulatory movement. Liam Gillick is one of many in the art
world who have noticed how, with the "general melding of roles be-
tween artist, curator and critic," one result today is "a concurrent
diminution of the role of the semi-autonomous critical voice."[21]

In addition, little value is attributed to the ability of criticism
to "unveil" or "unmask," since communication doesn't raise the
question, as does representation, of a referentiality or truth be-
yond the connection. What matters instead are links and circula-
tions. The rise of networks might not mean the end of all insides
and outsides, but it does mean that, with boundaries and the ex-
clusions they effect being more communicational rather than rep-
resentational, one now gains entrée by mastering not paradigms
and metalanguages but circuits of connections. Again, *Artforum*
provides a perfect example.

In 1993 the magazine initiated a contributors page immedi-
ately following the table of contents. What the contributors page
implied was, for one thing, expansion; in the newly globalized art
world, it was no longer reasonable to assume that the magazine's
readership would recognize its authors by name alone, as both
the authors and the readers were growing too broadly dispersed.
But the other assumption behind the page was that recognition

between readership and authorship was indeed needed. It should be remembered that the author's byline is itself a relatively recent invention, a modernizing innovation of the magazine and newspaper format for the purpose of rooting the previously sufficient text in an author, in a scene and an act or performance of writing as origination, in much the same way that sound recordings would later replace the previously dominant form of sheet music with a singular, originary act of embodied musical performance. The difference with *Artforum* in the 1990s is that it, like a lot of other magazines, introduced a contributors page not so much to tie each of its articles to a singular, unique, and isolated source or origin but more to open the articles out, to use the author as a sort of hyperlink to myriad other professionals and sites and projects. On the contributors page authors are introduced by a standardized biographical blurb listing professional accomplishments and affiliations, and thus each is plotted across a map of other publishers, exhibition venues, schools, art institutions, and so on (and this at a moment when other areas of the magazine were becoming similarly hyperlinked, such as the ads, which increasingly in the later 1990s listed e-mail addresses and web sites). On the contributor's page each author's one-hundred-word blurb—the bureaucratic CV written out in prose—gets accompanied by a thumbnail head shot, the style of which ranges from off-the-cuff and personal to slick and stylish. Here, as a response to the twin problems of growing dispersion and anonymity on the one hand and increased interconnectedness on the other, the answer is a very standardized, professional, institutional form of introduction and disclosure, which is also able to invite intimate identification and psychological investment because of the addition of the author's face and its effects of personalization and direct address.

Another change at *Artforum*, one that the contributors page helps track, is the allotment of column space in the magazine to fewer independent critics and to more professional art historians. The critic, when compared to the historian, looks isolated and unconnected: she or he is too inward turned, still supposedly privileging a subjective interior, the place where the experience of art is received and submitted to aesthetic judgment. The art historian

instead privileges an exterior, a field not only of other objects but also of disciplinary discourses, all bridged and related, contextualized and categorized. Art historians are strongly identified and integrated as professionals; they conduct their practices within institutionally defined fields that are striated and organized by title, rank, and collegiality; they belong to professional associations; they advance their respective fields by situating their efforts first and foremost in relation to previous and current contributions by fellow practitioners. In short, they are abundantly hyperlinked; with their widely disseminated and standardized institutional base of training, historians of contemporary art exist and operate within networks. Critics don't; they have no equivalent of academia or the museum world, they lack institutional grounding and organization, there is no well-organized system of training that erects high educational barriers and weeds out the unqualified. They don't have the transcontinental academic archipelago of professionally linked colleagues, sites, and organizations, with their cross-advertised conferences and symposia, through which to travel, mingle, connect. Compared to professional historians, critics are unincorporated, amateurish, and undisciplined, a motley crew lacking the filtering, disciplining, and coordinating of a highly codified system.

Also since the mid-1990s, *Artforum* has run more interviews, roundtable discussions, and multiauthored features, which represent, beyond whatever specific topics the discussants happen to be addressing, the connectedness and "liveness" of communicational interface. Here writing, with its associations to interiority and "thinking to oneself," is replaced by something closer to talk, which is more exteriorized and socialized, thinking that's always addressed *to*, that's about transmission, that's heard rather than overheard (to borrow John Stuart Mill's famous distinction between rhetoric and poetics). This is one crucial way that art magazines contribute to the redrawing of a new art world map—a map that, while omitting a centered and centering idea of culture, and leaving instead just overlapping concrete practices, appears both much bigger and much smaller, its boundless extension providing backdrop to small pockets of proximate, spontaneous conversation.

(Indicative here is the "Scene and Herd" column headlined on *Art-forum*'s website, where art events spanning the globe are covered in an intimate tone and scale, an intimacy reinforced by the accompanying photos in which effervescent encounters with fellow attendees and personalities are captured with small digital cameras or cell phones that don't peer in on the action from outside but seem entirely immersed in it.)

Also, whereas up until the late 1980s *Artforum* seldom ran anything but art ads, limiting the few product advertisements that were accepted to the back of the magazine, over the course of the 1990s more and more such advertising appears—for clothes, liquor, mints, eyeglasses, restaurants, bars, airlines, hotels, even financial services. And indeed, whereas formerly the ad section and the editorial content had been strictly segregated, now they comingle, alternating page to page. But this shouldn't be seen as merely the magazine's capitulation to the demands of an expanded advertising base. Importantly, what this mingling does is help to disarticulate and fragment the editorial content, which in turn allows for more diversification, as short "think pieces" by intellectual columnists are now interrupted by upcoming exhibition "previews" and various types of news reporting—on art institutions and their intertwined affairs, on the comings and goings of curators, etc. Whereas advertising, like information, has always been "by necessity a fractured narrative," in the words of one digital marketing CEO, today it's editorial content that needs "to hold up to that kind of fragmenting and reassembling."[22]

Artforum also runs many lists ("Hot List," "Top Ten"), in which the designation of a certain person, artwork, film, etc., as the "best" no longer separates and isolates but integrates items into series, into short inventories lined up against other inventories. Such lists serve the function of search filters, distilling from the expanding ocean of art world output a simple, manageable selection of high-value *hits*. And this kind of filtering obviates even further any need for criticism—nothing needs to be assailed for its shortcomings and missteps, since not making it onto the list already means being condemned to the same fate suffered by almost all information, which is to sink, without any outside help, into the cold, dark

depths of obscurity. The goal in searching information is always to filter things up, not down.

Many of the magazine's newer sections ("Openings," "500 Words," etc.) also appear regularly. Which means that not only does it take on a more diverse institutional art system as its subject matter, but the magazine itself, as it becomes more diverse, also becomes more systematized, more templated, accommodating only those changes in content that don't exceed its structure's built-in flexibilities. And finally there is more emphasis on practical information, on news and the art world's general functionality, which makes the magazine more a resource and guide and less a venue for criticism. It could be argued that this is indicative of a larger tension in art today—between an emphasis on practice and practicality on the one hand, on the everyday and design and even activism, and on the other hand the supposed continuing need for criticism, with its negativity and its policing of borders. The annual "Best and Worst" section, an occasion for more lists introduced in 1994, had the "worst" half permanently deleted only three years later, in 1997.

While many of these changes are precisely what some people point to as the reasons they look down on *Artforum* for not being what it used to be, for no longer being a magazine one reads, that hasn't stopped it from becoming all the more exemplary of what it means to be an active participant in the art world today. *Artforum* still dominates—not despite but because of its being a magazine you only glance through. That's how it has succeeded in updating and modernizing itself—by loosening its allegiances to an older print culture and the techniques of silent reading, so crucial to ideas of individual autonomy and interiority, of critical distance and thinking as an isolated, independent act, and instead aligning itself with the protocols of information management, with the practices and effects of user interface and instantaneous electronic communications. Criticism might indeed matter less to *Artforum* today, but that doesn't mean the magazine's dominance has diminished one iota. Indeed, if you look at the "Statement of Ownership" published in each year's November issue, you'll find that after a long stagnation lasting from the early 1980s through the

mid-1990s, *Artforum* has experienced an increase in overall print run of nearly sixty percent during the past fifteen years. It's never been more popular.

Between Aftermath and Aftermarket

The rise of such communicational protocols can be detected not only in the new international geography of the art world, or the new layout of museum galleries, or the reconfigurations of the art press. You also find it on the level of individual art works themselves. Sculpture, for example, has also become networked. Over the last ten years, a number of large sculpture surveys have opened in the US that include many of the same artists—Isa Genzken, Rachel Harrison, and Lara Schnitger among others. Featured in all these shows are works that cobble together three-dimensional non sequiturs, that present portable barrages of auxiliary parts, wardrobe accessories, random appendages, what in tech merchandising are called "peripherals"—all exploding from or collapsing in on an overwhelmed or simply absent main trunk. Here sculptural objects tend to overflow with surplus information, but the information isn't neatly laid out on one flat, smooth, continuous surface; it's instead compressed in strata, tucked into little niches, hidden behind or underneath various supports. Each object is like a shelving unit or pantry or information kiosk that's been dynamited or hurled off a rooftop, slices of architectural order made into mini flea markets.

Seldom, however, have these shows been mentioned in the same breath as information handling or new retailing and management approaches, or anything high-tech or corporate.[23] Instead, the exhibitions were initially advertised by their organizers and received by most critics as representing a counter trend: here was art that stood against the relational in favor of the substantial, against the digital in favor of the analog, against white-collar data management in favor of blue-collar sweat and grime, against far-flung communicational networks in favor of the dense, specific, and obdurate material mass. The new sculpture was even hailed as a backlash to poststudio forms of art in general, to institutional critique and site-specific work and other types of commissioned,

FIGURE 3.4

Installation view of the exhibition "Unmonumental: The Object in the 21st Century," December 1, 2007–April 6, 2008. The New Museum, New York. From left to right: Lara Schnitger, *Rabble Rouser*, 2005; Anselm Reyle, *Pflug*, 2002; Aaron Curry, *Fragments from a Collective Unity (Reclining)*, 2006. Photo: Allison Brady. Image provided by the New Museum of Contemporary Art, New York, NY.

temporary projects. Instead, these collaged objects—or *bricolage* as they are typically called—were said to pledge allegiance to the individual, to the private workspace and to materiality.

In her catalog essay for one of these shows, "The Uncertainty of Objects and Ideas" mounted by the Hirshhorn in 2006, curator Anne Ellegood writes that the reason such sculpture appears so attractive today is that it features "a mode of production rooted in the material and the physical," it "give[s] us something tangible rather than streams of data"; such works "embody physical exertion and dirty hands; they are the evidence of actions—composing, building, constructing, stacking, bending, connecting and adorning."[24] The very title of a similar show mounted by the UCLA Hammer Museum a year earlier—"Thing"—makes obvious this preference for indexicality over lexicality, for an indifferent and mute existence or *thisness* that defies any conceptual, word-based identity that would appropriate that existence into an paradigmatically ordered and cross-referenced mapping of names and categories. The catalog for "Thing" also includes photographs of the participating artists' studios, as well as references to critic Libby Lumpkin's 1997 essay "The Redemption of Practice" (a down-with-theory screed that applauds how "artists are making things again . . . everywhere you look, there are objects that come in substances, colors, shapes, and sizes that matter").[25] And in the catalog for "Unmonumental," yet another look-alike exhibition that the New Museum opened in 2007, co-curator Massimiliano Gioni refers to the last few years of art making as inaugurating a "headless century"—another metaphor for today's sense of rising decentralized activity in the wake of ebbing dominant structure.[26] The Hirshhorn's Ellegood nods in agreement: "These artists have found sculpture to be the most meaningful medium in which to explore and represent the complexity, rapidity, and ultimately the confusion of contemporary life . . . the feeling that beliefs and meanings are continuously unmoored and in flux."[27]

And yet what was put forward by these sculpture shows, despite their praise for the studio and the individual fabrication of physical things, were not autonomous objects. Instead of new and unique creations or singular forms, emphasis fell on the

repurposing, resequencing, and recontextualization of existing ones. In this way such shows demonstrated just how much continuity exists between contemporary studio and poststudio art practices. The bricolaged everyday materials that constitute much of the new sculpture, though manually manipulated or "hacked" in some way by the artist, still remain identifiable as belonging to broader realms of common commerce. This is precisely the distinction (often rehearsed in the shows' catalogs) between bricolage and more traditional forms of collage: the already-made parts being utilized retain their prior, separate identities even while they function together within the new work, the parts don't submerge their previous existences within the compositional blending of the rehashed whole. The results are conglomerations of heterogeneous, loosely related or weakly tied items—in short, object networks.

By presenting source materials left intact rather than artistically transformed, these artists make clear their debt to modernism's earlier strategies of appropriation and the readymade. But they also reverse the critical effects of these strategies. If the readymade was said to demystify the art object by aligning it with the realities of social or mass production rather than with an antiquated craft model and the individual artist's creative genius, today registering such effects is confounded as the general culture moves away from mass consumption and standardization and toward what gets called mass customization or prosumerism, whereby technological innovations increasingly oblige consumer interface and personalization (i.e., dictating design specifications of online merchandise, or downloading and sorting through MP3s and personalizing TV programming using digital video recorders). "The market today," writes Douglas B. Holt, professor of marketing at Oxford's School of Business, "thrives on . . . unruly bricoleurs who engage in nonconformist producerly consumption practices."[28] In other words, what the appropriated commodity or assisted readymade signifies today is precisely uniqueness and creativity, the showcasing of, to use Steven Levy's description in his book *Hackers*, an act "imbued with innovation, style and technical virtuosity."[29]

Thus, like with the turn toward the syntagmatic over the paradigmatic or the informational over the critical, in the prioritizing of

practice and the indexical by today's bricoleur one finds a changed relationship to signification, now approached as a disparate collection of specific, individual acts rather than the homogeneous, authoritarian dictates of an abstract system. In this, the new sculpture doesn't resist so much as explore and elaborate the sense encouraged by advanced digitization and communicational networks that the world is now managed proximately, not by a few heavy institutions but by the scads of independent mobile operators that such networks take as their primary functional units, a mass of individual bodies each moving around his or her just-in-time information in a space no longer architecturally enclosed (no longer shackled even by desktop workstations or laptops, but liberated today in the ultimate exteriorization and disembeddedness of the cell phone). Borrowing Marc Bousquet's notion of the flex-timer who "labors in the mode of information," this is consumption in the informatic mode, practiced by prosumers who don't consume so much as manage their personal status and account activity vis-à-vis the corporate databases of consumption.

Instead of a culture of spectacle, portrayed in the 1980s as a master code that organized the world of objects, today we are surrounded by a culture of databases, in which private consumption appears active, touted as a form of production in its own right. And yet it still remains a question how much of an improvement this newly active consumption-as-bricolage represents, since it too helps erase what is at base the social nature of production, not by treating culture as a means of passive and private consumption, as with spectacle, but by diverting attention away from the massive investment and profit taking generated by increasingly corporate-owned libraries, warehouses, and databanks, which too often are portrayed as themselves passive, like natural resources waiting to be mined and exploited by trailblazing, innovative bricoleurs. Again, to paraphrase Foster, it's the database that turns corporate culture from a barricade to storm into a ruin to pick through.

Another way to grasp how individual agency is thematized in the new bricolage is by comparing it to previous trends in sculpture in the 1980s and 1990s. Take, for example, the recent work of Genzken and Harrison. Perhaps more than the readymade, their

FIGURE 3.5

Rachel Harrison, *I'm with Stupid*, 2007. Wood, polystyrene, cement, Parex, acrylic, child mannequin, papier-mâché skull, green wig, festive hat, Spongebob Squarepants sneakers, Pokemon T-shirt, wheels, canned fruits and vegetables, fake carrot, fake feathers, fake grass, Batman mask, cat mask, necktie, scarf, and plastic beads. 65 × 31 × 24 in. Photo: Jean Vong. Courtesy the artist and Greene Naftali, New York.

bricolage is indebted to certain post-1980s tendencies found in the early work of Cady Noland, Karen Kilimnik, and Jessica Stockholder. Like these earlier "scatter" artists, Harrison and Genzken mix bits of found pop iconography with not the minimalist hard-edged geometric supports of Haim Steinbach and Jeff Koons but the spills and leanings of postminimalism. Furthermore, the bric-a-brac they appropriate is so quotidian and downmarket, so dated and recycled, as to seem unworthy of the display cases and spotlighting employed by 1980s commodity sculpture.

Indeed, the display case and spotlight were among the conspicuous devices by which 1980s sculpture neatly illustrated theories of blockbuster culture and spectacle. Much 1980s art presented the viewer not just with megamedia images and retail-mall objects but with ordered systems of signifying elements. Such work often adopted the very look of language, presenting evenly spaced like elements (whether Cindy Sherman's self-portraits or Koons's basketballs) in a semiotic interplay of differences and samenesses. In contrast to this, the newer work seems to hail from the less heavily administered spaces of the everyday, with its temporal improvisations and individual inflections. (Philip Dodd, former director of the London Institute of Contemporary Art, has described the new bricolage as "bedroom art," calling it "grubby, less designed, more do-it-yourself than the theatrical art of the Saatchi collection.")[30] Rather than being advertised and displayed, the new bricolage is mostly comprised of objects that one imagines were stumbled upon, and thus their ultimate precedent is not the readymade object, which Marcel Duchamp supposedly viewed with utter indifference, but rather the objet trouvé, the found object that so surprised and enchanted André Breton. Furthermore, today's bricolaged objects typically collapse in on themselves and thereby extinguish orderly separations and distinctions, while the items they juxtapose are so disparate as to defy any overarching code that could make social meaning out of them, thus redeeming them from the private and idiosyncratic. Neither studio-made *objet* nor store-bought commodity, most of the new bricolage seems either to precede production or to postdate consumption—it seems to come from

storage bins and trashcans, or more specifically from the storage bins and trashcans of Home Depot, Google, and eBay.

To borrow from an important analysis by the social anthropologist Mary Douglas in her 1966 book *Purity and Danger*, where there's trash and debris there should be system; trash is the by-product of a classifying and ordering structure, the name of that which doesn't fit, what's unnamable and inappropriate.[31] But as the recent interest in bricolage (and ruins in general) attests, trash and debris have undergone a change in status, as structure itself seems to fall away, fall into ruin. As paradigms, with their exclusionary, in/out borders, have weakened, trash goes from being the marked term—that which is excluded, a threat—to being that whose value is underdetermined, in flux, mobile. Like other kinds of databases, the spaces of trashcan and storage bin—the attic or closet or basement or dumpster or thrift store—become sites not of prohibition and exclusion so much as flexibility and conversion, places where things can shift identity, change in value, drop old functions and adopt new ones, where durable goods and objects of use that typically depreciate over time and are eventually thrown away can magically reemerge as collectibles, specialty items, souvenirs, oddities, conversation pieces, where emptied-out signifiers can wait their turn to be filled anew.

And yet the possibilities for such transformation are largely class-based. Folks with enough money and security to turn their concerns to accumulation of cultural capital will more likely see formerly "durable" goods in terms of the fluctuating values of fashion, cultural cachet, and lifestyle, and will thus mine the discarded items in thrift stores, vintage warehouses, and eBay looking for opportunities for cultural and semiotic conversion. This is a dramatically different context from the one in which trash was appropriated by midcentury neo-avant-garde art, which means it's fruitless to rehearse that discourse unaltered when discussing art today. Indeed, for the people who first used the word *bricolage* with reference to twentieth-century Western culture, it was precisely the existence of an overarching, determining structure that lent a political edge to their employment of the term. During the 1970s, when Stuart Hall, John Clarke, Dick Hebdige, and the other

cultural theorists of the Birmingham School transferred the concept from Lévi-Straussian structural anthropology to the context of contemporary capitalism, they openly admitted that bricolage was an activity confined to the realms of consumption, leisure, and fashion.[32] But they still perceived a challenge in how the bricoleur's activities entailed the smuggling of commodities across class lines. What that depended upon, though, was a model of culture that was clearly hierarchical, striated in tiers corresponding closely to class positions—a model that since the 1980s has grown increasingly problematic. And not only because, as Hal Foster writes, leftist cultural practice around that time witnessed a "shift from a subject defined in terms of economic relations to one defined in terms of cultural identity," as new social movements displaced class as the grounds for the formation of political subjects.[33] Rather, as subject identification per se, whether with class or culture, underwent a postmodern turn and its determinations were considered less empirical and causal and more semiotic and discursive—as deregulated capital weakened its ties to state and collective organizations like trade unions and professional associations, and the signifiers of job title and pay scale floated independently of individual lifestyle choices and social and political allegiances—those signifying operations now given primacy experienced increasing disarticulation and dispersion. All this while a more networked marketplace and cultural landscape emerged, eventually adapting to the new "long tail" merchandising paradigm, or what John Seabrook has called "nobrow" culture.[34]

As many sociologists currently argue, today the demonstration of symbolic mastery is more likely to unfold laterally, via the extent of one's horizontal and multidirectional reach across myriad cultural niches, leading to a new set of hierarchical distinctions drawn not according to high and low but between successful "omnivores" versus less-esteemed "univores."[35] Among the results of all this: the term *bricolage* undergoes an immense surge in popularity in today's art world largely because of the older political connotations it still manages to summon, even as the practice itself, as it involves the deft manipulation of far-flung heterogeneity, currently signifies not resistance but privilege.

Perhaps it's going too far to suggest that in the new bricolage we find something like a court art for today's network paradigm. Or to be even more pointed: that certain individual sculptures seem to offer themselves up as court portraiture, as portraits of the trader, the consultant, the networker or multitasker, the free agent or proximate manager. What we are looking at here, after all, is figurative sculpture: more times than not the artworks by Genzken, Harrison, Schnitger—even Glaswegian and GSA alum Jim Lambie, at least his work in "Unmonumental"—stand before us as surrogate individuals, collections of things that measure up to roughly head height, are taller than they are wide, and have the suggestion of arms, shoulders, and feet. Perhaps we should ask of this sculpture, if indeed it is at root figurative, who or what exactly it is representing. Is it the traumatized body from German dada photomontages, instances of the modern subject gripped by, in Benjamin Buchloh's words, the "terror that emerges from . . . the universal equivalence and exchangeability of all objects"?[36] Or are these highly fragmented figures more heroicized, more like present-day versions of the Soviet New Man—something like Bourriaud's semionaut "surf[ing] on a network of signs," or, as "Unmonumental" cocurator Laura Hoptman describes it, "stunningly intelligent arrangements strung together in ways so clever as to make one bark with laughter or gasp in astonishment"?[37]

Not only are most of these works figurative, they are indeed action figures. They are always in some sense placeless, precisely because they are always on the go. Motifs of temporality abound: think of the shoes at the base of Lambie's structure, or how Harrison employs as pedestals dollies or boxes wrapped and marked for shipping, as well as gray movers' blankets and Styrofoam packing peanuts. Perhaps the desire to look animated, on the go, not tied down, explains why so much of this work presents itself in midact, with its different elements propped, leaned, and balanced on one another à la the early postminimal work of Richard Serra. Any suggestion of the figure as a sovereign, self-contained unit with a clearly distinct inside and outside is put forward only to be gleefully transgressed. But even this comes across as a sign of health, as if it made the sculpture appear more flexible and networked,

FIGURE 3.6

Jim Lambie, *Split Endz (Wig Mix)*, 2005. Wardrobes, mirror, belts, training shoes, gloss paint. 72½ × 53⅞ × 47¼ in. Copyright the artist, courtesy Sadie Coles HQ, London.

empowered with greater mobility and versatility. Too internally diverse and intersected to be constrained by form, such bricolaged statues are also mobile and autonomous enough to escape the fetters of site and circumstance. These are actors who are both embedded and disembedded. Although figurative, the work in its flexibility won't commit itself to one identity; and although just a stack of literal materials, the work in its mobility won't commit itself to staying in one place.

At the same time, if these sculptures do appear animated, it's not the same as the body in motion. And that's because their parts never adequately unify, never reach the level of wholeness demanded by the criteria of a self-conscious, self-identical subject. Here the figure is shown always coming apart as much as coming into being and constituting itself. Such figurative bricolage therefore recalls more the infant prior to the acquisition of language, experiencing what Jacques Lacan calls an "imaginary" relation to the world, seeking out in external objects, including its own mirror image, a coherence and coordination it still internally lacks, desiring a unified referent (unification as referent) only to find the body always fugitive and multiple, always beyond itself.

But do subjects today still stand before mirrors? That is, does the self still depend on a reflected image for its construction? If the subject is actively produced by signifying operations and practices rather than existing outside and prior to them, what happens when communication supplants representation and the mirror is displaced by an interfacing screen or "participatory architecture" as the field in which dominant practices unfold, when digital dashboards or touchpads become the crucible in which normative subjectivity is forged? With its landscape rather than portrait orientation, the digital screen doesn't promise statuesque visual form, a closed silhouette that cuts the subject to a general rank-and-file social type. Its space is not physical or illusionistic but interstitial and connectionist, relaying input and feedback, command and performance, its legibility dependent on pattern recognition rather than the play of presence and absence. The monitor calls for an operator or manager, it hails a semionaut, someone engaged in what Jean Baudrillard calls "private telematics"—someone "at the

controls of a hypothetical machine, isolated in a position of perfect and remote sovereignty, at an infinite distance from his original universe; that is to say, in the same position as an astronaut in his bubble . . . in orbit, living no longer as an actor or a dramaturge but as a terminal of multiple networks."[38]

Perhaps the new bricolage brings together both the infant and astronaut in one entity. For a precedent one could look to the cyborg, which, as Donna Haraway explains, "is resolutely committed to partiality . . . needy for connection . . . [but] is also the awful apocalyptic telos of the West's escalating dominations of abstract individuation, an ultimate self untied at last from all dependency, a man in space."[39] As with the infant's use of the mirror in its search for identity, so too does the semionaut locate in the monitor a portal extending well beyond any single predicate or referent, finding instead ongoing access, constant mobility, induction into "the universal equivalence and exchangeability of all objects." At once infant and astronaut, both too close and too far away, presymbolic and managerially orbital, this is a subject that seeks omnipotence through tight identification with the contents of its immediate surroundings as well as through remote oversight of vast communicational networks; a subject whose reach extends everywhere, who has everything at its fingertips, but at the same time can't transcend its basic narcissistic tendency to see everything in terms of *me me me*. In other words, a subject tailor-made for today's society. A subject without a middle ground.

But where or for whom does such bodily fragmentation and placelessness get recoded as affirmative? Which kinds of terrains or modalities of existence does it most accord with? A type of artwork, or any entity for that matter, that is entirely makeshift, that is nothing but fragments and temporary solutions, seems surprisingly well suited to negotiate today's entrepreneurial and communicational mandates, in which supreme value is placed on flexibility, on the ability to improvise identities and relationships, to relentlessly search and capture, to connect and extend, to point-and-click things in and out of existence—in short, to cast the widest informational net possible and ad lib the most novel conjunctions out of whatever happens to wash up in the mesh.

Given such a state of affairs, the bricoleur or semionaut seems an exemplary figure, mobile and independent enough to profit where others, because of class or political commitment, only find downside and vulnerability, aftermath rather than aftermarket, as they try to persevere in the face of our present-day onslaught of catastrophes as usual.

Notes

Preface

1. See Richard Peterson, "Understanding Audience Segmentation: From Elite and Mass to Omnivore and Univore," *Poetics* 21 (1992): 243–258.

2. Miwon Kwon, "The Return of the Real: An Interview with Hal Foster," *Flash Art* 29, no. 187 (March-April 1996): 63.

3. Bill Readings, *The University in Ruins* (Cambridge: Harvard University Press, 1996), 39.

4. Paolo Virno, "Labour and Language," in *Lessico postfordista* (Milan: Feltrinelli, 2000); English translation by Arianna Bove available at *Generation Online* (http://www.generation-online.org/t/labourlanguage.htm).

Chapter 1 Welcome to Yourspace

1. David Harvey, *The Condition of Postmodernity: An Enquiry into the Origins of Cultural Change* (Oxford: Blackwell, 1990), 159.

2. Luc Boltanski and Eve Chiapello, *The New Spirit of Capitalism*, trans. Gregory Elliott (London: Verso, 2007), 363. Italics in the original. For an example of investment in the self as a brand by emphasizing individual over company uniforms, see Stephanie Clifford, "Power of Apparel: A Look That Conveys a Message," *New York Times*, March 5, 2011, B1. The locus classicus of branding the self remains Tom Peters, "The Brand Called You," *Fast Company* 10 (August/September 1997): 83.

3. Frances Stark, "A Little Untoward History: On Chinatown's Recent Influx of Art and Its Potential," in John C. Welchman, ed., *Recent Pasts: Art in Southern California from the 90s to Now* (Zurich: JRP/Ringier, 2005), 51.

4. Jean-François Lyotard, *The Postmodern Condition*, trans. Geoff Bennington and Brian Massumi (Minneapolis: University of Minnesota Press, 1984), xxiv; Michel de Certeau, *The Practice of Everyday Life*, trans. Steven

Rendall (Berkeley: University of California Press, 1984), 41. It should be remembered that when Lyotard spoke in the 1970s of the collapse of totalization and centralization, of master narratives and consensus, he acknowledged that this shift was not something launched by a cultural avant-garde but was being implemented by those in power—by, in his words, the "decision makers." The process of transition was not uniform, he emphasized, and its outcomes were still unsure.

5. Michael Hardt and Antonio Negri, *Empire* (Cambridge: Harvard University Press, 2000), 329.

6. Benjamin H. D. Buchloh, "The Museum Fictions of Marcel Broodthaers," in Peggy Gale and AA Bronson, eds., *Museums by Artists* (Toronto: Art Metropole, 1983), 48. Buchloh is explicitly referring here to the model of ideology Roland Barthes lays out in *Mythologies* (trans. Annette Lavers [New York: Hill and Wang, 1972], 109–159), according to which connotation or "second-order meaning" is added to and ideologically distorts a denotative or "initial" relation of signifier to signified. But Buchloh, rather than repeat the phrasing "second-order system" or "second-order meaning" preferred in the English translation of Barthes, instead chooses "secondary language," which strongly recalls Seth Siegelaub's phrase "secondary information." As originally defined by Siegelaub, primary and secondary information relate to one another representationally, but unlike with paintings or sculptures, with conceptual art the secondary information doesn't "bastardize" that art's primary, ideational form. Conceptual art's deadpan photographs or written descriptions were imagined to neutrally represent prior, abstract ideas. "When art concerns itself with things not germane to physical presence," Siegelaub explains, "its intrinsic (communicative) value is not altered by its presentation in printed media. The use of catalogues and books . . . is the most neutral means to present the new art. The catalogue can now act as the primary information for the exhibition, as opposed to secondary information *about* art in magazines, catalogues, etc." "On Exhibitions and the World at Large: Seth Siegelaub in Conversation with Charles Harrison," in Gregory Battcock, ed., *Idea Art: A Critical Anthology* (New York: E. P. Dutton, 1973), 168.

That this is an idealist approach to the relation between thought and language has been amply remarked on since (perhaps most succinctly by Mel Bochner in his 1970 wall piece *Language Is Not Transparent*). And indeed, the more the terms primary and secondary information were discussed, employed, and critiqued in the art world, the more their relation was reversed. That is, the idea or act was increasingly seen as secondary, as built upon and anticipated by the prior institutional and historical conditions and conventions necessary to give sense and value to anything that exists as art. This was in keeping with the development in critical theory away

from representationalism. According to Judith Butler, for example, individual speech performances are "supported" by institutions and convention. (Importantly the word Butler chooses is *supported*, not *determined*—indeed, for Bulter a certain level of determination is necessary for subjects to be constituted as actors: "Agency begins where sovereignty wanes," she writes in *Excitable Speech: A Politics of the Performative* [New York: Routledge, 1997, 16–17]. One "acts precisely to the extent that he or she is constituted as an actor and, hence, operating within a linguistic field of enabling constraints from the outset.") As Buchloh points out, for Barthes, too, the claim to primacy was not idealist but historical and materialist—what made a relationship between signifier and signified "initial" or "first-order" was its more direct grounding in and response to historical contingencies and conventions, a grounding distorted or occluded by ideology's subsequent naturalizing and essentializing. But Barthes himself would later reverse his argument, insisting instead that not only is denotation impossible to separate from connotation, but it often ends up as a type of connotation that serves "mythic meaning" the best. "Denotation," Barthes writes in *S/Z* (trans. Richard Miller [New York: Hill and Wang, 1974], 9), "is not the first meaning, but pretends to be so; under this illusion, it is ultimately no more than the last of the connotations (the one which seems both to establish and to close the readings)." In other words, suspicion should greet any declaration of primacy, whether idealist or materialist. As I go on to argue in this book, especially in the second chapter, the art world of the 1990s witnessed a fresh wave of attempts to claim the innocence and immediacy of the primary, as artists, curators, and others sought to naturalize and mythify both artistic acts and their discursive, institutional conditions, indeed to collapse and nullify the very distinction between the two.

7. Susan Buck-Morss, "Envisioning Capital: Political Economy on Display," in Lynne Cooke and Peter Wollen, eds., *Visual Display: Culture Beyond Appearances* (Seattle: Bay Press, 1995), 111.

8. Lyotard, *The Postmodern Condition*, 66.

9. Andrea Fraser, "Isn't This a Wonderful Place?" (2003), in *Museum Highlights: The Writings of Andrea Fraser*, ed. Alexander Alberro (Cambridge: MIT Press, 2005), 251. See also Pierre-Michel Menger, *Portrait de l'artiste en travailleur: Métamorphose du capitalisme* (Paris: Seuil, 2002). Other writers and artists, especially in Europe, have also called attention to "this idea of economics," as Marion von Osten puts it, "based on talent and initiative, [in which] cuts in social and cultural spending are legitimized under the paradigm of the self-sufficiency of (cultural) entrepreneurs . . . [and in which] artists and designers are taken as the model." Besides the projects and writings of Osten and others involved in the "temporary coalition"

k3000 (www.k3000.ch), see Jan Verwoert, ed., *Die Ich-Ressource: zur Kultur der Selbst-Verwertung* (Munich: Volk, 2003); Angela McRobbie, "'Everyone Is Creative': Artists as New Economy Pioneers?," openDemocracy (August 30, 2001), http://www.opendemocracy.net/node/652 (accessed July 2, 2006); and Aleksandra Mir, *Corporate Mentality: An Archive Documenting the Emergence of Recent Practices within a Cultural Sphere Occupied by Both Business and Art* (New York: Lukas and Steinberg, 2001). Tellingly, volume 5 of the British journal *de-, dis-, ex-*, devoted to the theme of "immaterial labor," had been compiled and edited by Melanie Gilligan and Marina Vishmidt in 2004 but never made it to press due to lack of funds.

10. Miwon Kwon, "Exchange Rate: On Obligation and Reciprocity in Some Art of the 1960s and After," in Helen Molesworth et al., *Work Ethic*, exh. cat. (Baltimore: Baltimore Museum of Art, 2003), 84.

11. Quoted in Tim Griffin, "Cabaret License," *Artforum* 44, no. 5 (January 2006): 94.

12. Jacob Hale Russell, "The Invisible Artist," *Wall Street Journal*, December 31, 2005–January 1, 2006, P3.

13. Boltanski and Chiapello, *The New Spirit of Capitalism*, 363.

14. Allan Sekula, "Between the Net and the Deep Blue Sea (Rethinking the Traffic in Photographs)," *October* 102 (Fall 2002): 4.

15. Lev Manovich, *The Language of New Media* (Cambridge: MIT Press, 2001), 219.

16. Boltanski and Chiapello, *The New Spirit of Capitalism*, 104–105. Manuel Castells also writes (in *The Rise of the Network Society*, 2nd ed. [Oxford: Blackwell, 2000], 177), "The actual operating unit becomes the business project, enacted by a network, rather than individual companies or formal groupings of companies."

17. Museum of Modern Art press release dated May 24, 1971 for "Projects: Keith Sonnier," the first installment of the "Projects" exhibition series. The Museum of Modern Art Archives, Department of Painting and Sculpture Projects Index, Book 1, Item I.1, Exh. #964, press release #58.

18. David L. Shirey, "Display by Nancy Graves Adds Vitality to Art Series," *New York Times*, December 18, 1971, 25. In a review of Barry Flanagan's Projects exhibition (*Artnews* 73, no. 3 [March 1974]: 99), Douglas Crimp wrote, "These exhibitions allow the public to see current art activity without the oppressive seal-of-approval ambience of a full-scale museum show. Furthermore, both artists and the younger curatorial staff are able to play a significant role in mounting the exhibitions . . . and their relative modesty (no catalogues or openings) allows the museum a continuing involvement with

contemporary art at a relatively low cost." An unsigned internal memo in the Museum of Modern Art archives, dated March 5, 1975, reports, "The strength of the program has proven to be its openness and flexibility—which permits the Museum to show work being produced both here and abroad soon after its conception. . . . Younger members of the Curatorial staff are the principal source of ideas for the series and work with the artists selected in preparing and installing the exhibitions" (The Museum of Modern Art Archives, Public Information Records, subseries II.B, folder 904).

19. Edit deAk and Walter Robinson, "Projects," *Art-Rite/LAICA Journal* 19 (June-July 1978): 5.

20. "Action Man: Paul O'Neill Interviews Seth Siegelaub," *Internationaler* 1 (June 2006): 5–7.

21. Kaelen Wilson-Goldie, "Sharjah Biennial 8: Still Life," *Artforum* 46, no. 1 (September 2007): 488; Hou Hanru, "Not Only Possible, but Also Necessary: Optimism in the Age of Global War," exh. press release, 10th International Istanbul Biennial, in *ArtNexus Newsletter* 6, no. 5 (August 16, 2007).

22. Alan Turing, "Computing Machinery and Intelligence," *Mind* 59, no. 236 (October 1950): 441–442.

23. See Sarah Douglas, "Fair Game," *Art and Auction* 31, no. 10 (June 2008): 142–147; and Carol Vogel, "One Fair Is Canceled, Others Vow to Proceed," *New York Times*, January 2, 2009, C32.

24. Remarks delivered during the discussion "Discovering New Artists: The Post-MFA Experience," part of the symposium "The Shaping of the Artist in the Institution," California State University, Long Beach, September 23, 2000.

25. Roberta Smith, "Dear Gallery: It Was Fun, but I'm Moving Up," *New York Times*, April 18, 2008, E29.

26. Philip Nobel, "Sign of the Times," *Artforum* 41, no. 5 (January 2003): 109.

27. Nicolas Bourriaud, *Relational Aesthetics*, trans. Simon Pleasance and Fronza Woods with the participation of Mathieu Copeland (Dijon-Quetigny, France: Les presses du réel, 2002), 8, 21.

28. Quoted in Griffin, "Cabaret License," 94.

29. Bernadette Corporation, *Reena Spaulings* (New York: Semiotexte, 2004). According to R. A. Hill and R. I. M. Dunbar in "Social Network Size in Humans" (*Human Nature* 14, no. 1: 53–72), a single functioning social network, excluding the other various networks it links to, supposedly includes on the average 125 members; the maximum is around 155.

30. Roberta Smith, "Art in Review," *New York Times*, January 12, 2007, E42.

31. Rosalind Krauss, "Notes on the Index: Seventies Art in America," parts 1 and 2, *October* 3 (Spring 1977): 68–81 and 4 (Fall 1977): 58–67.

32. Robert Morris, "Notes on Sculpture," in Gregory Battcock, ed., *Minimal Art: A Critical Anthology* (New York: E. P. Dutton, 1968), 231. (Originally in *Artforum* 5, no. 2 [October 1966]: 20–23.)

33. Benjamin Buchloh et al., "Conceptual Art and the Reception of Duchamp," *October* 70 (Autumn 1994): 129.

34. Daniel Buren, "The Function of the Studio" (1971), *October* 10 (Autumn 1979): 51.

35. Mel Bochner, "Serial Art. Systems: Solipsism," *Arts Magazine* 41, no. 8 (Summer 1967): 40.

36. Mel Bochner, "Systemic," *Arts Magazine* 41, no. 1 (November 1966): 40. For more on the appropriation of systems theory in 1960s art and culture, see Michael Corris, "Recoding Information, Knowledge, and Technology," in Michael Corris, ed., *Conceptual Art: Theory, Myth, and Practice* (Cambridge: Cambridge University Press, 2004), 188–190.

37. Jack Burnham, "Systems Esthetics," *Artforum* 7, no. 1 (September 1967): 31; see also Jack Burnham, "Real Time Systems," *Artforum* 8, no. 1 (September 1969): 49–55.

38. Lucy R. Lippard, "The Art Workers' Coalition: Not a History," in *Get the Message? A Decade of Art for Social Change* (New York: E. P. Dutton, 1970), 11.

39. Germano Celant, "Arte Povera: Notes for a Guerrilla War" (1967), in Giancarlo Politi and Helena Kontova, eds., *Flash Art: Two Decades of History: XXI Years* (Cambridge: MIT Press, 1990), 189.

40. Buren, "The Function of the Studio," 55.

41. Daniel Buren, "Function of the Museum," *Artforum* 12, no. 1 (September 1973): 68; see also Daniel Buren, "Function of an Exhibition," *Studio International* 186, no. 961 (December 1973): 216.

42. Michael Hardt, "Affective Labor," *boundary2* 26, no. 2 (Summer 1999): 93. Christian Marazzi (in "Rules for the Incommensurable," trans. Giuseppina Mecchia, *SubStance* 36, no. 1 [2007]: 29) describes the transition this way: "The basic premises of the new production paradigm are connections rather than separations, forms of integration rather than of segmentation, real-time simultaneity rather than sequential phases. In other words, production neither starts nor ends in the factory."

43. Seth Siegelaub, "On Exhibitions and the World at Large," 171. (Originally in *Studio International* 178, no. 917 [December 1969].)

44. Allan Kaprow, "Should the Artist Become a Man of the World?," *Artnews* 63, no. 6 (October 1964): 58. Only a year earlier, in response to one of Kaprow's happenings, Dorothy Seckler announced (in "The Audience Is His Medium!," *Art in America* 51, no. 2 [April 1963]: 63) that "it is only now that the artist is for the audience and not against it." This would be seconded over and over again throughout the decade, as when Brian O'Doherty bluntly stated, "Art is a social profession, not an anti-social phenomenon" ("The New Whitney Museum," *Art and Artists* 1, no. 7 [October 1966]: 61). That O'Doherty adds "profession" is significant; being social meant more than just getting out a lot. Allen Weller exclaimed how "in no earlier period in history was it the accepted practice to ask the creative personality to explain himself and his work to the extent which now prevails. . . . Perhaps it will not be long before our professional schools of art will introduce courses in statement writing, because no exhibition is now complete without an essay from the artist on what he's up to, what he is thinking about, how he got started" (in Lee Nordness, ed., *Art: USA: Now*, vol. 2 [New York: Viking Press, 1963], 248–249). "I doubt whether artists have ever been so articulate about what they're doing as they are right now," Siegelaub also noted. "The need for an intermediary begins to become lessened" (Siegelaub, "On Exhibitions and the World at Large," 171–172).

45. Quoted in Burnham, "Systems Esthetics," 34–35.

46. Quoted in Benjamin H. D. Buchloh, "Conceptual Art 1962–1969: From the Aesthetic of Administration to the Critique of Institutions," *October* 55 (Winter 1990): 140.

47. Siegelaub, "On Exhibitions and the World at Large," 168; Michael Fried, "Art and Objecthood," *Artforum* 5, no. 10 (Summer 1967): 12.

48. Buren, "The Function of the Studio," 53.

49. Lawrence Alloway, "Art and the Communications Network," *Canadian Art* 23, no. 1 (January 1966): 35, 36.

50. Gilles Deleuze, "Postscript on the Societies of Control," *October* 59 (Winter 1992): 4.

51. Michael Fried, *Three American Painters* (Cambridge: Fogg Art Museum, 1965), 14.

52. George B. Richardson quoted in William Powell, "Neither Market Nor Hierarchy: Network Forms of Organization," *Research in Organizational Behavior* 12 (1990): 297. In terms of scholarship today, the word *network* is perhaps most closely associated with the work of Manuel Castells on the "network society" and Bruno Latour and John Law on "actor network theory" or ANT. Both of these bodies of work have been important to my thinking

about networks, but for this book I have drawn most extensively from Boltanski and Chiapello's use of the term in *The New Spirit of Capitalism*, as well as from the work of Mark Granovetter, whose study of "weak-tied" networks features prominently in the book's second chapter. Other sources that have informed my use of the term include Jeremy Boissevain, "Preface," in Jeremy Boissevain and J. Clyde Mitchell, eds., *Network Analysis: Studies in Human Interaction* (The Hague: Mouton, 1973); Ronald S. Burt, *Structural Holes: The Social Structure of Competition* (Cambridge: Harvard University Press, 1995); Samuel P. Hays, "The New Organizational Society," in Jerry Israel, ed., *Building the Organizational Society: Essays on Associational Activities in Modern America* (New York: Free Press, 1972), 1–15; Paul M. Hirsch, "Undoing the Managerial Revolution?," in Richard Swedberg, ed., *Explorations in Economic Sociology* (New York: Russell Sage Foundation, 1993), 145–157; Bruce Mazlish, "Invisible Ties: From Patronage to Networks," *Theory, Culture and Society* 17, no. 2 (April 2000): 1–19; J. Clyde Mitchell, "The Concept and Use of Social Networks," in J. Clyde Mitchell, ed., *Social Networks in Urban Situations* (Manchester: Manchester University Press, 1969); Dennis K. Mumby, "Power and Politics," in Fredric M. Jablin and Linda L. Putnam, eds., *The New Handbook of Organizational Communications: Advances in Theory, Research and Methods* (Thousand Oaks: Sage Publications, 2001). In addition, I also found these anthologies to be particularly helpful: Mario Dani and Doug McAdam, eds., *Social Movements and Networks: Relational Approaches to Collective Action* (Oxford: Oxford University Press, 2003); Mark Granovetter and Richard Swedberg, eds., *Sociology of Economic Life* (Boulder: Westview Press, 1992); Nitin Nohria and Robert G. Eccles, eds., *Networks and Organizations: Structure, Form and Action* (Boston: Harvard Business School Press, 1992); and Michael Reed and Michael Hughes, eds. *Rethinking Organization: New Directions in Organizational Theory and Analysis* (London: Sage Publications, 1992).

53. Daniel McClean, "The Artist's Contract: From the Contract of Aesthetics to the Aesthetics of the Contract," *Mousse Magazine* 25 (September 2010) (http://moussemagazine.it/articolo.mm?id=607).

54. Quoted in Grace Glueck, "Museum Beckoning Space Explorers," *New York Times*, January 2, 1970, 34.

55. James Elliott, "Introductory Notes on the Matrix Project," in *Matrix: A Changing Exhibition of Contemporary Art*, brochure, Hartford, CT: Wadsworth Atheneum, 1975, n.p.

56. Ibid.

57. Lippard quoted in Andrea Fraser, "What's Intangible, Transitory, Immediate, Participatory and Rendered in the Public Sphere? Part II," in Fraser, *Museum Highlights*, 63.

58. Kynaston McShine, *Primary Structures: Younger American and British Sculptors* (New York: Jewish Museum, 1966), n.p.

59. Fraser, "What's Intangible, Transitory, Immediate," 78.

60. *Fortune*, June 17, 1991; *Business Week*, May 14, 1990.

61. Already in 1984 the US Supreme Court passed down its landmark ruling upholding the legality of individuals recording TV shows at home on their VCRs, which helped triple the number of households with video decks within a year and paved the way for the rapid industrialization of the video rental business, with a big-box approach using economies of scale to transform what had been a sleepy mom-and-pop retail sector. In 1985, for example, a year after World of Video debuted on Manhattan's Lower East Side, Blockbuster Video began operation and before the end of the decade passed the 1,000-store mark with new outlets opening outside the US.

62. Ami Barak, "Conversation with Douglas Gordon," *Museum in Progress*, 1996, available online at http://www.mip.at/attachments/183.

63. Jack Bankowsky, "Slackers," *Artforum* 30, no. 3 (November 1991): 96. The imagery of cracks and fissures would come to saturate writing on art in the 1990s. Curator Lisa Phillips, for example, in her catalog introduction to the 1997 Whitney Biennial, observes how "artists explode the seamless fictions of normalcy by revealing cracks in that seamlessness" ("Inside-Out: A Conversation between Lisa Phillips and Louise Neri," *1997 Biennial Exhibition* [New York: Whitney Museum of American Art, 1997], 44). Looking back, this all could be read less as a backlash to 1980s postmodernism as a strategy or theme of contemporary art than as an initial sensing of the further development of the postmodern as a condition, the process that Lyotard, Hardt and Negri, David Harvey, and others have described as the "breaking up" of society's "institutional walls."

64. Guy Debord, *Society of the Spectacle* (Detroit: Black & Red, 1977), n.p. (paragraph 1); "Free Agents, Close Connections," *Fast Company* 12 (December 1997): 16.

65. Michael Clegg and Martin Guttmann, "On Conceptual Art's Tradition," *Flash Art* 143 (November-December 1988): 117.

66. "Editor's Note," *Artpaper* 9, no. 5 (January 1990): 7.

67. Jack Bankowsky, "Ten Years Ago (10-20-30-40)," *Artforum* 41, no. 1 (September 2002): 40.

68. Lane Relyea, "What? Me Work? Richard Linklater Interviewed," *Artforum* 31, no. 8 (April 1993): 74.

69. Lev Manovich, "The Practice of Everyday (Media) Life: From Mass Consumption to Mass Cultural Production?," *Critical Inquiry* 35, no. 2 (Winter 2009): 324.

70. Boltanski and Chiapello, *The New Spirit of Capitalism*, 201.

71. Eve Chiapello, "Evolution and Co-optation: The 'Artist Critique' of Management and Capitalism," *Third Text* 18, no. 6 (2004): 592–593.

72. Louis Althusser, "Ideology and Ideological State Apparatuses (Notes towards an Investigation)" (1970), in *Lenin and Philosophy and Other Essays*, trans. Ben Brewster (New York: Monthly Review Press, 1971), 170, 173–174.

73. Quoted in Stuart Elliott, "Advertising: Nowadays, It's All Yours, Mine or Ours," *New York Times*, May 2, 2006, C1. "A turning point may have come in 1996," Elliot writes, "when Yahoo introduced a personalization service called My Yahoo. It has grown to about 55 million unique users each month."

74. Roman Jakobson, "Two Aspects of Language and Two Types of Aphasic Disturbances," in Jakobson, *Language in Literature*, ed. Krystyna Pomorska and Stephen Rudy (Cambridge: Harvard University Press, 1987), 101.

75. Fredric Jameson, *Late Marxism: Adorno, or, The Persistence of the Dialectic* (London: Verso, 1990), 143.

Chapter 2 Glasgow, Los Angeles, New York, Cologne

1. Meyer Schapiro, "The Nature of Abstract Art," in *Modern Art: 19th and 20th Centuries* (New York: George Braziller, 1979), 193.

2. Mark S. Granovetter, "The Strength of Weak Ties," *American Journal of Sociology* 78, no. 6 (May 1973): 1360–1380; Mark Granovetter, "The Strength of Weak Ties: A Network Theory Revisited," *Sociological Theory* (1983): 201–233. Granovetter's research defies the more romantic accounts of network culture as popularized by, for example, Chris Anderson, editor of *Wired*. According to Anderson, we are "becoming a niche nation . . . defined not by our geography but by our interests. Instead of the weak connections of the office water cooler, we're increasingly forming our own tribes, groups bound together more by affinity and shared interests than by broadcast schedules. These days our water coolers are increasingly virtual—there are many different ones, and the people who gather around them are self-selected." Anderson, "The Rise and Fall of the Hit," *Wired* 14, no. 7 (July 2006): 127.

3. Saskia Sassen's three major works on the international mobility of labor are *The Mobility of Capital and Labor: A Study in International Investment*

and Labor Flow (Cambridge: Cambridge University Press, 1988); *The Global City* (rev. ed., Princeton: Princeton University Press, 2001); and *Territory, Authority, Rights: From Medieval to Global Assemblages* (Princeton: Princeton University Press, 2008).

4. Nitin Nohria and Robert G. Eccles, "Face-to-Face: Making Network Organizations Work," in Nitin Nohria and Robert G. Eccles, eds., *Networks and Organizations: Structure, Form and Action* (Boston: Harvard Business School Press, 1992), 290. See also David Brooks, "The Splendor of Cities," *New York Times*, February 8, 2011, A27. "Humans communicate best when they are physically brought together," Brooks writes. "Cities thrive because they host quality conversations, not because they have new buildings and convention centers. . . . When you clump together different sorts of skilled people and force them to rub against one another, they create friction and instability, which leads to tension and creativity, which leads to small business growth."

5. Richard Florida, "Cities and the Creative Class," *City and Community* 2, no.1 (March 2003): 9, 16.

6. Emile Durkheim, *The Rules of Sociological Method*, ed. Steven Lukes, trans. W. D. Halls (New York: Free Press, 1982), 45.

7. Douglass C. North quoted in Blake Stimson, "What Was Institutional Critique?," in Alexander Alberro and Blake Stimson, eds., *Institutional Critique: An Anthology of Artists' Writings* (Cambridge: MIT Press, 2009), 21.

8. David Harding, "Friendship, Socialization and Networking among Glasgow Artists, 1985–2001. The Scotia Nostra: Myth and Truth," in Christoph Keller, ed., *Circles: Individuelle Sozialisation und Netzwerkarbeit in der zeitgenössischen Kunst* (Frankfurt: Revolver, 2002), 173–175. Harding also served in the early 1980s as senior lecturer in the Art and Design in Social Context program at the Dartington College of Arts in Devon, his thinking and teaching shaped in part by Joseph Beuys's notion of social sculpture as well as the motto "context is half the work" propagated by the Artist Placement Group (founded in 1966 by John Latham and Barbara Steveni, among others).

9. Thomas Lawson, "This Begins Here," in *Guilt by Association*, exh. cat. (Dublin: Irish Museum of Modern Art, 1992), n.p.

10. Jean-François Lyotard, *The Postmodern Condition* (Minneapolis: University of Minnesota Press, 1977), xxiv.

11. Lawson, "This Begins Here," n.p.

12. Ibid.

13. Nathan Coley et al., "Northern Lights," *Frieze* 1 (September-October 1991): 38.

14. Perreault quoted in Alexander Alberro, *Conceptual Art and the Politics of Publicity* (Cambridge: MIT Press, 2004), 152.

15. Nicola White quoted in *Transmission* (London: Black Dog, 2001), 30.

16. Ross Sinclair, "Bad Smells but No Sign of the Corpse" (1991), reprinted in Nicola White, ed., *Ross Sinclair, Real Life*, exh. cat. (Glasgow: Centre for Contemporary Arts, 1996), 85.

17. Ibid., 85–86.

18. Ibid., 83.

19. Coley et al., "Northern Lights," 38. As Sinclair notes in the "Windfall '91" catalog (*Ross Sinclair, Real Life*, 86), "The loose committee structure usually adopted in groups tends to devolve responsibility for curatorial decisions to such an extent that it becomes problematic to reach consistent levels of good work. . . . Organizing and discussing the project takes precedence over quality of work."

20. Miwon Kwon, "One Place after Another: Notes on Site Specificity," *October* 80 (Spring 1997): 101.

21. Luc Boltanski and Eve Chiapello, *The New Spirit of Capitalism*, trans. Gregory Elliott (London: Verso, 2007), 129.

22. Ibid., 361.

23. Kwon, "One Place after Another," 109.

24. Ibid., 88, 91. Echoing somewhat Glasgow's Craig Richardson from five years earlier about how "competing ideas . . . supply a context as dynamic as place or site," Kwon continues, "The art work's relationship to the actuality of a location (as site) and the social conditions of the institutional frame (as site) are subordinate to a discursively determined site that is delineated as a field of knowledge, intellectual exchange, or cultural debate"(92). In "The Functional Site," James Meyer writes that site is now considered "a process, an operation occurring between sites, a mapping of institutional and discursive filiations and the bodies that move between them (the artist's above all). It is an informational site, a locus of overlap of text, photographs and video recordings, physical places and things. . . . It is a temporary thing, a movement, a chain of meanings devoid of a particular focus." In *Platzwechsel: Ursula Biemann, Tom Burr, Mark Dion, Christian Philipp Müller*, exh. cat. (Zurich: Kunsthalle Zürich, 1995), 27.

25. James Meyer, "Das Schicksal der Avantgarde (The Fate of the Avant-Garde)," in Christian Kravagna, ed., *Agenda: Perspektiven kritischer Kunst* (Vienna: Folio, 2000), 82–84. My thanks to Kathleen Tahk for help with the translation.

26. Before publishing "The Functional Site" in the *Platzwechsel* catalog in 1995, Meyer had already elaborated his ideas of "the expanded site" and "nomadism" in *What Happened to the Institutional Critique?*, exh. cat. (New York: American Fine Arts, 1993). After the *Platzwechsel* catalog, Meyer republished an altered version of "The Functional Site" (this time including a discussion of Andrea Fraser and Renée Green) in *Documents* 7 (Fall 1996): 20–29 (this version is reprinted in Erika Suderburg, ed., *Space, Site, Intervention: Situating Installation Art* [Minneapolis: University of Minnesota Press, 2000], 23–37). In 2004, Meyer reworked a new version of the essay, now called "The Mobile Site," for a Stephen Prina exhibition catalog, *We Represent Ourselves to the World: Stephen Prina, Galerie Max Hetzler, 1991* (Los Angeles: Hammer Museum, 2004), 200–214.

27. Douglas Gordon, "A Short Biography—by a Friend," in *Douglas Gordon: Blind Sport*, exh. cat. (Liverpool: Tate Museum, 2000), 366.

28. Kwon, "One Place after Another," 91.

29. Ibid., 95.

30. Michel de Certeau, *The Practice of Everyday Life*, trans. Steven Rendall (Berkeley: University of California Press, 1988), 34.

31. Kristin Ross, "Streetwise: The French Invention of Everyday Life," *parallax* 2 (February 1996): 69. On de Certeau, see also Tom McDonough, "No Ghost," *October* 110 (Fall 2004): 116–122.

32. Lyotard, *The Postmodern Condition*, 14.

33. "Three Day to Today: Dave Muller in Conversation with Hans Ulrich Obrist (1998) and John C. Welchman (2005)," in John C. Welchman, ed., *Recent Pasts: Art in Southern California from the 90s to Now* (Zurich: JRP/Ringier, 2005), 58, 63, 67.

34. Hans Ulrich Obrist and Laurence Bossé, "ARS (Artist-Run Spaces)," in *Life/Live*, exh. cat., vol. 2 (Paris: Musée d'Art moderne de la Ville de Paris, 1996), 13.

35. Lyotard, *The Postmodern Condition*, 17.

36. Jean-Pierre Criqui, "Like a Rolling Stone: Gabriel Orozco," *Artforum* 34, no. 8 (April 1996): 91.

37. Kwon, "One Place after Another," 101–102.

38. David Harvey, "From Managerialism to Entrepreneurialism: The Transformation in Urban Governance in Late Capitalism," *Geografiska Annaler. Series B, Human Geography* 71, no. 1 (1989): 3–17.

39. Farquhar McLay, introduction to McLay, ed., *Workers City: The Real Glasgow Stands Up* (Glasgow: Clydeside Press, 1988), 4.

40. Ibid.

41. Quoted in Sarah Lowndes, *Social Sculpture. Art, Performance and Music in Glasgow: A Social History of Independent Practice, Exhibitions and Events since 1971* (Glasgow: Stopstop, 2003), 80.

42. Christian Marazzi "Rules for the Incommensurable," trans. Giuseppina Mecchia, *SubStance* 36, no. 1 (2007): 30.

43. Katrina Brown, "Trust," in Keller, *Circles*, 183.

44. Coley et al., "Northern Lights," 37.

45. Euan MacArthur, "Windfall," *Variant* 9 (Autumn 1991): 36.

46. Liam Gillick, "Windfall," *Artscribe* 89 (November 1991): 98.

47. Coley et al., "Northern Lights," 39.

48. Quoted in Lowndes, *Social Sculpture*, 137–138.

49. Ibid., 138.

50. Ferdinand de Saussure, *Course on General Linguistics*, ed. Charles Bally and Albert Sechehaye, trans. Wade Baskin (New York: McGraw-Hill, 1966), 123.

51. Roman Jakobson, "Two Aspects of Language and Two Types of Aphasic Disturbances," in *Language in Literature*, ed. Krystyna Pomorska and Stephen Rudy (Cambridge: Harvard University Press, 1987), 103–104.

52. Boltanski and Chiapello, *The New Spirit of Capitalism*, 104.

53. Christoph Keller, introduction to "One for One," the fourth installment of the exhibition "Circles," Zentrum für Kunst und Medientechnologie, Karlsruhe, Germany, September 2000–June 2001; http://on1.zkm.de/zkm/stories/storyReader$1717.

54. Maria Lind, "Notes on Contemporary Art in a Relative Periphery," in *Here and Now: Scottish Art 1990–2001*, exh. cat. (Dundee: Dundee Contemporary Arts, 2001), 28.

55. According to Ross Sinclair, Obrist lauded what he termed "the Glasgow Miracle" at a panel discussion accompanying the awarding by the Tate Museum of the Turner Prize to Douglas Gordon in 1996. See Sinclair's critique of Obrist's portrayal, "What's in a Decade: The Glasgow Miracle vs. Utopian Modernism Done by Third World Peasants," in Keller, *Circles*, 193–199.

56. Obrist and Bossé, "ARS (Artist-Run Spaces)," 12–13.

57. "Three Day to Today: Dave Muller in Conversation with Hans Ulrich Obrist (1998) and John C. Welchman (2005)," 58.

58. Ibid., 62.

59. Christopher Knight, *Last Chance for Eden* (Los Angeles: Art Issues Press), 333.

60. Murdo Macdonald, *Walk On: Six Artists from Scotland*, exh. cat. (New York: Jack Tilton Gallery, 1991), n.p.

61. Mike Davis, *City of Quartz: Excavating the Future in Los Angeles* (London: Verso, 1990), 78.

62. Linda Frye Burnham, "Art in Limbo," *L.A. Weekly*, March 18–24, 1988, 20, 24.

63. Paul Schimmel, "Into the Maelstrom: L.A. Art at the End of the Century," in *Helter Skelter: L.A. Art in the 1990s*, exh. cat. (Los Angeles: Museum of Contemporary Art, 1992), 21.

64. Quoted in Howard Singerman, "Pop Noir," *Artforum* 43, no. 2 (October 2004): 125.

65. Schimmel, "Into the Maelstrom," 20.

66. Richard B. Woodward, "For Art, Coastal Convergences," *New York Times*, July 16, 1989, H1, H33.

67. Larner quoted in "Speaking Volumes: 19 Interviews," *Art in America* 94, no. 10 (November 2006): 173.

68. Julie Joyce, "Neutral Grounds/Fertile Territory: A History of Bliss," in *True Bliss*, exh. cat. (Los Angeles: Los Angeles Contemporary Exhibitions, 1997), 6.

69. Bonnie Clearwater, "Our Gang," *Visions* 3, no. 3 (Summer 1989): 9.

70. Ibid.

71. Roberta Smith, "The Los Angeles Art World's New Image," *New York Times*, December 29, 1992, C11–12.

72. Bruce Hainley, "Sharon Lockhart, Laura Owens, Frances Stark," *Artforum* 36, no. 3 (November 1997): 119. Ditto Dave Muller's work, which "recalls the anxiety-driven cliquishness of adolescence, in which hand-made posters are produced to advertise the class play. But his art also slyly reverses the common polarity between ad and exhibition, deftly placing as much value on the agency of distribution as on the works of art that get funneled

through it" (Christopher Knight, "Riding Tradition's Currents to a Higher Consciousness," *Los Angeles Times*, October 10, 1996, F4).

73. Clive Thompson, "The See-Through CEO," *Wired* 15, no. 4 (April 2007): 137.

74. Leanne Alexis Davidson, "Three Day Weekend: Owner/Operator David A. Muller Interviewed," *Real Life Magazine* 23 (1994): 34.

75. Prina quoted in Joyce, "Neutral Grounds/Fertile Territory," 43. See also "Three Day to Today," 60, in which Dave Muller comments that LACE "is a colossal institution, akin to a small museum."

76. See Grant Kester, "Rhetorical Questions: The Alternative Arts Sector and the Imaginary Public" (1993), in *Art, Activism, and Oppositionality: Essays from Afterimage* (Durham: Duke University Press, 1998), 103–135.

77. Obrist quoted in Andrew Graham-Dixon, "The British Art Buzz," *British Vogue* (June 1995): 122.

78. Brisley quoted in Simon Ford, "Myth Making," *Art Monthly* 194 (March 1996): 5.

79. Thatcher's original comment, made during an interview, was in response to her own rhetorical question, "Who is society?" "There is no such thing!" she continues. "There are individual men and women and there are families." (In Douglas Keay, "Aids, Education and the Year 2000!," *Woman's Own*, October 31, 1987, 8.) The phrase as I repeat it here is from Hugo Young's often-used source *One of Us: A Biography of Margaret Thatcher*, rev. ed. (London: Macmillan, 1990), 490.

80. See Neville Wakefield, "Pretty Vacant," *Brilliant: New Art from London*, exh. cat. (Minneapolis: Walker Art Center, 1995), 8–12; Lane Relyea, "What? Me Work? Richard Linklater Interviewed," *Artforum* 31, no. 8 (April 1993): 74. Frances Stark's more nuanced and self-conflicted comments about punk and the 1990s art scene can be found in her "A Little Untoward History: On Chinatown's Recent Influx of Art and Its Potential," in Welchman, *Recent Pasts*, 51. A rare instance of associating neoliberal policy and 1990s art in the North American context is Coco Fusco, "The Unbearable Weightiness of Beings: Art in Mexico after NAFTA," in *The Bodies That Were Not Ours and Other Writings* (New York: Routledge, 2001), 61–77.

81. Susan Kandel, "Exploring Power of Three among Friends," *Los Angeles Times*, July 4, 1997, F18. Bruce Hainley remarked about the same show, "Who really wants premises messing up, as they often do, the enjoyment?" ("Sharon Lockhart, Laura Owens, Frances Stark," 119).

82. Hoet quoted in Roberta Smith, "A Small Show within an Enormous One," *New York Times*, June 22, 1992, C1.

83. Daniel Birnbaum, "Practice in Theory," *Artforum* 38, no. 1 (September 1999): 154. Also Daniela Salvioni, "The Whitney Biennial: A Post 80s Event," *Flash Art* 30, no. 195 (Summer 1997): 114: "Until now hyper-thematic exhibitions have remained the dominant, albeit maligned, mode of packaging. . . . [In the current Whitney Biennial] the relation between artworks is loose and the effect is not cumulative; the exhibition is not about using art to substantiate a theory developed from without."

84. Laura Owens, "A Thousand Words: Laura Owens Talks about Her New Work," *Artforum* 37, no. 10 (Summer 1999): 131.

85. Russell Ferguson and Laura Owens, "The Exchange of Ideas among the Living," *Cakewalk* 3 (Fall 1999): 26–29. Owens praises Ferguson's show for its "distinct lack of metaphor." "O'Hara's poetry works in a metonymical, side by side way," she continues, "not a metaphoric or symbolic way. This seems hard to do, not assume the artwork as a symbol or metaphor for a larger idea."

86. Christoph Keller, introduction to "Los Angeles: Silverlake Crossings," the third installment of the exhibition "Circles," Zentrum für Kunst und Mediatechnologie, Karlsruhe, Germany, September 2000–June 2001; http://on1.zkm.de/zkm/stories/storyReader$1492. Besides Los Angeles and Glasgow, Keller's "Circles" project also examined the social networks in the Berlin, Frankfurt, and Geneva art scenes.

87. Carl Freeman, "Traffic," *Frieze* 28 (May 1996): 75.

88. Anthony Davies and Simon Ford, "Culture Clubs," *Mute* 18 (September 2000): 23–24. See also Carol Kino, "It's Time for Artists to Give till It Hurts," *New York Times*, May 28, 2006, sec. 2, 1; and Eric Wilson, "Using a White Shirt as Their Canvas," *New York Times*, May 11, 2006, G6.

89. Cloepfil quoted in William L. Hamilton, "Throwing a Bash? Surround It with Culture," *New York Times*, March 12, 2008, H42.

90. Carol Duncan and Alan Wallach, "The Museum of Modern Art as Late Capitalist Ritual: An Iconographic Analysis," *Marxist Perspectives* 4 (Winter 1978): 28–51 (this is a revised version of their essay "MOMA: Ordeal and Triumph on 53rd Street," *Studio International* 194, no. 988 [1978]: 48–57); Douglas Crimp, "On the Museum's Ruins," *October* 13 (Summer 1980): 41–57; Hans Haacke, "Museums: Managers of Consciousness," *Art in America* 72, no. 2 (February 1984): 9–17; Craig Owens, "From Work to Frame, or, Is There Life after 'The Death of the Author?'," originally published in Lars Nittve, ed., *Implosion—A Postmodern Perspective* (Stockholm: Moderna Museet, 1987), reprinted in Owens, *Beyond Representation: Representation, Power, and Culture* (Berkley: University of California Press, 1994), 122–139.

91. Claire Doherty, "The Institution Is Dead! Long Live the Institution! Contemporary Art and New Institutionalism," *Art of Encounter. engage review* 15 (Summer 2004): 6. See also Alex Farquharson, "Bureaux de Change," *Frieze* 101 (September 2006): 156–159; and Rebecca Gordon Nesbit, "Harnessing the Means of Production," in Jonas Ekeberg, ed., *Verksted 1: New Institutionalism* (Oslo: Office for Contemporary Art Norway, 2003), 59–87.

92. Gilles Deleuze, "Postscript on the Societies of Control," *October* 59 (Winter 1992): 5–6.

93. Marc Bousquet, "The Informal Economy of the Information University," *Works and Days* 41/42, vol. 21, nos. 1 and 2 (2003): 27.

94. Quoted in Stefan Römer, *Reports from the Conceptual Paradise* (Munich: Silke Schreiber, 2007), 31.

95. Jean Baudrillard, *The System of Objects*, trans. James Benedict (London: Verso, 1996), 21. According to Lisa Adkins, "Capacities and abilities cannot be unproblematically accumulated by workers in the new economy, since such qualities are no longer figured in terms of an internal relation to the person." Lisa Adkins, "The New Economy, Property and Personhood," *Theory, Culture and Society* 22, no. 1 (February 2005): 117.

96. On this aspect of contracts, see especially Michel Callon, "Introduction: The Embeddedness of Economic Markets in Economics" and "An Essay on Framing and Overflowing," in Callon, ed., *The Laws of the Markets* (Oxford: Blackwell/Sociological Review, 1998). Such analysis of contracts can be considered part of a growing literature on economic sociology and the embeddedness of market transactions, a good introduction to which is Mark S. Granovetter and Richard Swedberg, eds., *The Sociology of Economic Life* (Boulder: Westview Press, 2001).

97. In an important essay, Carrie Lambert-Beatty has detailed the crucial role trust plays within a strain of contemporary art that she calls "parafiction" (art that conjures plausible but made-up events and histories passed off as real). But what she says could easily be applied more generally to any art that conforms to a communicational rather than representational paradigm. "Parafictional strategies," she writes, "are oriented less toward the disappearance of the real than toward the pragmatics of trust. Here belief becomes the crux of the performative. . . . [T]he viewer's credence (and secondary audiences' witnessing of that credence) becomes a synapse between the imagined and the actual. . . . [P]lausibility (as opposed to accuracy) is not an attribute of a story or image, but of its encounter with viewers, whose various configurations of knowledge and 'horizons of expectation' determine whether something is plausible *to them*." Carrie Lambert-Beatty, "Make-Believe: Parafiction and Plausibility," *October* 129 (Summer 2009): 54, 65, 72–73.

98. Hou Hanru, "Initiatives, Alternatives: Notes in a Temporary and Raw State," in *How Latitudes Become Forms: Art in a Global Age*, exh. cat. (Minneapolis: Walker Art Center, 2004), 38.

99. Maria Lind, "Learning from Art and Artists," in Gavin Wade, ed., *Curating in the 21st Century* (Walsall: New Art Gallery, University of Wolverhampton, 2000), 94. Lind also deploys the label "constructive institutional critique" in "Models of Criticality," in Yilmaz Dziewior, ed., *Contextualize* (Hamburg: Kunstverein, 2002), 150–151. See also Lind, "When Water Is Gushing In," in Anton Vidokle and Tirdad Zolghadr, eds., *Printed Project 6: I Can't Work Like This* (Dublin: Visual Artists Ireland, 2006), 18–22.

100. Charles Esche, "Beyond Institutional Critique: Modest Proposals Made in the Spirit of 'Necessity Is the Mother of Invention'," in Bik van der Pol, *With Love from the Kitchen* (Rotterdam: NAi Publishers, 2005), 23.

101. David Joselit, "Institutional Responsibility: The Short Life of Orchard," *Grey Room* 35 (Spring 2009): 109.

102. Boltanski and Chiapello, *The New Spirit of Capitalism*, 84.

103. Ibid., 112. Italics in the original.

104. Nohria and Eccles, "Face-to-Face" (as in note 4), 293, 297–298.

105. Boltanski and Chiapello, *The New Spirit of Capitalism*, 390.

106. Roland Barthes, *S/Z*, trans. Richard Miller (New York: Hill and Wang, 1974), 9.

107. Charles Esche, "The Experience of Trust," *Kunst & museumjournaal* 7, no. 5 (1995): 47. See Esche's other version of this article, "Curating and Collaborating: A Scottish Account," in Mika Hannula, ed., *Stopping the Process? Contemporary Views on Art and Exhibitions* (Helsinki: Nordic Institute for Contemporary Art, 1998), 248–256.

108. Brown, "Trust" (as in note 43), 185.

109. Esche, "The Experience of Trust," 47; Esche quoted in Lowndes, *Social Sculpture*, 191–192.

110. Esche, "The Experience of Trust," 48.

111. Brown, "Trust," 185.

112. Ibid., 183–185.

113. Clare Henry, "Leaving Them at a Loss," *The Herald* (Scotland), May 15, 1995, available online at http://www.heraldscotland.com/sport/spl/aberdeen/leaving-them-at-a-loss-1.680589.

114. Esche, "Curating and Collaborating," 249–250; Esche, "The Experience of Trust," 48–49.

115. Charles Esche, "A Framework for Exercising the Mind," *The Herald* (Scotland), May 25, 1995, available online at http://www.heraldscotland.com/sport/spl/aberdeen/a-framework-for-exercising-the-mind-1.678812.

116. Esche, "The Experience of Trust," 50; Esche, "A Framework for Exercising the Mind."

117. Giovanni Intra, "Sharon Lockhart, Laura Owens, Frances Stark. Blum & Poe, Santa Monica," *Flash Art* 30, no. 197 (November/December 1997): 76; Hainley, "Sharon Lockhart, Laura Owens, Frances Stark," 120; Kandel, "Exploring Power of Three among Friends," 18.

118. Neil Mulholland, "Glasgow: Onwards and Upwards," *Art Monthly* 216 (May 1998): 26. In retrospect Brown acknowledged this problem with the show. "It foregrounded the centrality of socializing, networking, discussion, contact, which by some in the city was of course seen as something negative, something overly subjective and exclusive, in contradiction to the objectivity and inclusiveness to which public institutions ought to aspire." Brown, "Trust," 183.

119. Quoted in Lowndes, *Social Sculpture*, 192. In "Self-Conscious Stateless Nation: Neoconceptualism and the Renascence of Scottish Art," *Third Text* 22, no. 2 (March 2008): 287–294, Neil Mulholland discusses how this perception of an insider's club inflected the reference Gordon made, when accepting the Turner Prize a year later, to a "Scotia Nostra." (The GSA certainly wasn't the first art school to produce a "mafia": see, for example, Richard Hertz, *Jack Goldstein and the CalArts Mafia* [Ojai, CA: Minneola Press, 2003].) Even former Transmission director Malcolm Dickson, who had argued so forcefully for a more capacious left position within the Glasgow art scene, would write about his former collaborators from the GSA's Environmental Art department, "How an original 'radicality' soon petrifies into a new stasis is the subject of much informal discussion on the art streets of Glasgow." Malcolm Dickson, "Another Year of Alienation: On the Mythology of the Artist-Run Initiative," in Duncan McCorquodale, Naomi Siderfin, and Julian Stallabrass, eds., *Occupational Hazard: Critical Writing on Recent British Art* (London: Black Dog, 1997), 90.

120. Esche, "The Experience of Trust," 49.

121. Jens Hoffmann, "The 6th Caribbean Biennial. Castaway," in *Theanyspacewhatever*, exh. cat. (New York: Guggenheim Museum, 2008), 199.

122. *6th Caribbean Biennal—A Project by Maurizio Cattelan* (Dijon: Les presses du réel, 2001), n.p.

123. See Howard Singerman, "In Theory and Practice: A History of the Whitney Independent Study Program," *Artforum* 42, no. 6 (February 2004): 116.

124. Quoted in ibid., 170. Compared to working at the ISP, Kelly says of her other teaching job, "At UCLA interdisciplinarity or conceptualist work can only be one option among many." No doubt the ISP's complicated reputation owes to its being both a small, self-selecting community and also touted by its own members as the "most resepected, provocative and . . . demanding site of intellectual and artistic production in America today," on a par with the Bauhaus and postrevolutionary Russia's first state art school, VKhUTEMAS. (At the same time it should be kept in mind that such over-the-top testimonies from former students are likely motivated in part by repeated threats to the program's funding if not very existence.) Along with Singerman see Miwon Kwon, "Reflections on the Intellectual History of the ISP," in *Independent Study Program: 25 Years* (New York: Whitney Museum of American Art, 1993), 52–83; George Baker, "Pedagogy, Power and the Public Sphere: The Whitney Program and (Its) History," *Whitney Program Newsletter* (Spring/Summer, 2000): n.p.; and Stuart Comer, "Art Must Hang: An Interview with Andrea Fraser," in Mike Springer, ed., *Afterthought: New Writing on Conceptual Art* (London: Rachmaninoff's, 2005), 29–41.

125. Writing in general, according to the poststructuralist account, could be said to threaten the primary by standing for what Jacques Derrida calls "the possibility of extraction and of citational grafting"—that is, the possibility of becoming repeatable, "iterable . . . cited, put between quotation marks," and thus severed from one context and shuffled into others, so that "there are only contexts without any center of absolute anchoring." Derrida goes on: "I will not conclude from this . . . that there is no effect of the performative . . . no effect of presence. . . . It is simply that these effects do not exclude what is generally opposed to them term by term, but on the contrary presuppose it in dyssemtrical fashion, as the general space of their possibility." Jacques Derrida, "Signature Event Context," in *Margins of Philosophy*, trans. Alan Bass (Chicago: University of Chicago Press, 1982), 315, 317, 320, 327. See my "Talking in Place of Writing in Place of Art: A Short History," in *USC School of Fine Arts MFA 2002* (Los Angeles: University of Southern California, 2002), 8–17, where I discuss the elevation of speech over writing as it persists in US art from abstract expressionism into the 1970s, being particularly thematized in the writings of Michael Fried and Robert Morris.

126. Esche, "The Experience of Trust," 48–49; Esche, "Curating and Collaborating," 254. Maria Lind writes that "One of the most usable, and familiar, keywords for 1990s art is the 'personal,'" in "The Biography of an Exhibition," in *Manifesta 2* (Luxembourg: Forum d'art contemporain, 1998).

127. Jakobson, "Two Aspects of Language and Two Types of Aphasic Disturbances" (as in note 51), 101, 104.

128. Rosalind Krauss, "Notes on the Index: Seventies Art in America," *October* 3 (Spring 1977): 75, 81.

129. Owens, "From Work to Frame," 136.

130. Gregg Bordowitz, "Geography Notes: A Survey," originally published in *Real Life Magazine* 16 (Autumn 1986), reprinted in Bordowitz, *The AIDS Crisis Is Ridiculous and Other Writings: 1986–2003* (Cambridge: MIT Press, 2004), 5. Bordowitz's essay goes on to discuss Andrea Fraser's performance *Damaged Goods Gallery Tour Starts Here* of the same year, and in response suggests the need, in anticipation of Meyer's and Kwon's writings of the 1990s, for a more expanded and discursive conception of site specificity, concluding that "a place as defined by the limits of its area can be viewed as separate from the location it is assigned through discourse." See George Baker's discussion of this important part of Bordowitz's essay in "Fraser's Form," in Yilmaz Dziewior, ed., *Andrea Fraser: Works 1984–2003*, exh. cat. (Cologne: Dumont, 2003), 56.

131. Bordowitz quoted in Meyer, *What Happened to the Institutional Critique?* (as in note 26), 12.

132. Isabelle Graw, "Field Work," *Flash Art* 23, no. 155 (November-December 1990): 137.

133. Dion quoted in Meyer, *What Happened to the Institutional Critique?*, 14.

134. Jan Verwoert, "This Is Not an Exhibition," in Nina Möntmann, ed., *Art and Its Institutions: Current Conflicts, Critique and Collaborations* (London: Black Dog Publishing, 2006), 135.

135. Clare Pentecost and Adam Simon, "Four Walls: Ten Years," *Documents* 4/5 (Spring 1994): 4–5.

136. Josef Strau, "Friesenwall 120," *Real Life Magazine* 23 (Autumn 1994): 15.

137. Josef Strau, "The Non-Productive Attitude," in Bennett Simpson, ed., *Make Your Own Life: Artists In and Out of Cologne*, exh. cat. (Philadelphia: Institute of Contemporary Art, 2006), 29.

138. Peter Weibel, *Kontext Kunst: Kunst der 90er Jahre* (Cologne: DuMont, 1994), 57.

139. Daniela Salvioni, *Parallax View: Cologne–New York*, exh. cat. (New York: PS1, 1993), 5–6, 9.

140. Simpson, *Make Your Own Life*, 8, 18.

141. Meyer, *What Happened to the Institutional Critique?*, 13–14. Italics in the original.

142. Yilmaz Dziewior, "Fair Wars," *Artforum* 35, no. 3 (November 1996): 31.

143. Meyer, *What Happened to the Institutional Critique?*, 21–22.

144. Andrea Fraser, "An Artist's Statement," in *Museum Highlights: The Writings of Andrea Fraser*, ed. Alexander Alberro (Cambridge: MIT Press, 2005), 5; Andrea Fraser, "From the Critique of Institutions to an Institution of Critique," *Artforum* 44, no. 1 (September 2005): 282–283.

145. Jean Baudrillard, "The Ecstasy of Communication," in Hal Foster, ed., *The Anti-Aesthetic* (Port Townsend, WA: Bay Press, 1983). See also Baudrillard's discussion of the emptiness of the phrase "I did it!" as uttered by exhausted marathon runners crossing the finish line in "Astral America," *Artforum* 23, no. 1 (September 1984): 73.

146. Rosalind Krauss, "Video: The Aesthetics of Narcissism," *October* 1 (Spring 1976): 56. For a very different use of the terms *reflexive* and *reflective* see Scott Lash, "Reflexivity as Non-Linearity," *Theory, Culture and Society* 20, no. 2 (April 2003): 49–57.

147. Yilmaz Dziewior, "Interview with Andrea Fraser," in Dziewor, *Andrea Fraser: Works 1984–2003*, 94.

148. Loic J. D. Wacquant, "Towards a Reflexive Sociology: A Workshop with Pierre Bourdieu," *Sociological Theory* 7, no. 1 (Spring 1989): 33, 34, 53, 55.

149. James Meyer, "The Functional Site," *Documents* 7 (Fall 1996): 24; Meyer, *What Happened to the Institutional Critique?*, 18; Meyer, "Das Schicksal der Avantgarde" (as in note 25), 82–84. Meyer's writing comes directly on the heels of Chantal Mouffe's essay "For a Politics of Nomadic Identity," included in the catalog (ed. Peter Weibel [Cologne: Walter König]) for *Andrea Fraser/Christian Philipp Müller/Gerwald Rockenschaub*, the Austrian contribution to the 1993 Venice Biennale. Despite many similarities, Mouffe's argument differs in its reliance on a Lacanian model of subjectivity and its stated antipathy toward "liberal rationalism, which is at the root of the current lack of vision afflicting political thought" (240). For a critique of the portrayal of artists as "nomads," with particular reference to Müller's 1993 work, see T. J. Demos, "The Ends of Exile: Towards a Coming Universality?," in Nicolas Bourriaud, ed., *Altermodern* (London: Tate Publishing, 2009). For a more general discussion of the term "nomads" used in reference to a new brand of social and cultural politics emerging in the late 1980s, see Alberto Melucci, *Nomads of the Present: Social Movements and Individual Needs in Contemporary Society*, ed. John Keane and Paul Mier (Philadelphia: Temple University Press, 1989).

150. Meyer, *What Happened to the Institutional Critique?*, 11, 14.

151. See Fraser's discussion of these conflicting aspects of artistic autonomy in "What's Intangible, Transitory, Immediate, Participatory and Rendered in the Public Sphere? Part II," in *Museum Highlights*, 55–56.

152. Andrea Fraser, "What Do I, as an Artist, Provide?" (1995), in *Museum Highlights*, 166.

153. Dziewior, "Interview with Andrea Fraser," 100.

154. On the specifics of the contracts for *Untitled*, see Susan E. Cahan, "Regarding Andrea Fraser's *Untitled*," *Social Semiotics* 16, no. 1 (April 2006): 13.

155. Baker, "Fraser's Form," 72.

156. Howard Singerman, *Art Subjects: Making Artists in the American University* (Berkeley: University of California Press, 1999), 3.

157. Quoted from www.protoacademy.org, a now-defunct website created and maintained by the group's members. For more on the Protoacademy, see the essay by and interview with Charles Esche in Paul O'Neill and Mick Wilson, eds., *Curating and the Educational Turn* (London: Open Editions, 2010), 297–319.

158. Christopher Caldwell, "What a College Education Buys," *New York Times Magazine*, February 25, 2007, 15. This recalls Miwon Kwon's remark in "One Place after Another" that "the ability to deploy multiple, fluid identities in and of itself is a privilege of mobilization that has a specific relationship to power."

159. Irit Rogoff, "Academy as Potentiality," in *Academy* (Frankfurt: Revolver, 2006), 20.

160. Quoted in Andrew Hulktrans, "Surf and Turf," *Artforum* 36, no. 10 (Summer 1998): 110.

161. Anton Vidokle, "Exhibition as School in a Divided City," available online at http://byanalogy.org/pages/m6.html.

162. From a lecture delivered at the Staatliche Akademie der bildenden Künsten, Stuttgart, July 2000.

163. Daniel Birnbaum, "The Art of Education," *Artforum* 45, no. 10 (Summer 2007): 474.

164. Katy Siegel, "Lifelong Learning," in Alexander Dumbadze and Suzanne Hudson, eds., *Contemporary Art: 1989 to the Present* (New York: Wiley-Blackwell, 2013), 414.

Chapter 3 Ruins

1. Quoted in Dick Hebdige, *Subculture: The Meaning of Style* (London: Routledge, 1979), 128. Aragon discusses collage's relative "poverty" in his introduction to the catalog accompanying the "Exposition de collages" at the Galerie Goemans in Paris in 1930. See *La peinture au défi* (Paris: Librairie José Corti, 1930).

2. Brian Neville and Johanne Villeneuve, "Introduction: In Lieu of Waste," in Neville and Villeneuve, eds., *Waste-Site Stories: The Recycling of Memory* (Albany: SUNY Press, 2002), 1.

3. Hal Foster, "Archives of Modern Art," *October* 99 (Winter 2002): 81.

4. See, for example, Frank Rose, "The Father of Creative Destruction: Why Joseph Schumpeter Is Suddenly All the Rage in Washington," *Wired* 10, no. 3 (March 2002): 93; and Charles J. Whalen, "Today's Hottest Economist Died 50 Years Ago," *Business Week* (December 11, 2000): 70–72.

5. Chris Anderson, *The Long Tail: Why the Future of Business Is Selling Less of More* (New York: Hyperion, 2008), 2.

6. Rosalind Krauss, "Photography's Discursive Spaces: Landscape/View," *Art Journal* 42, no. 4 (Winter 1982): 312.

7. Ibid.

8. Rosalind Krauss, "Pictorial Space and the Question of Documentary," *Artforum* 10, no. 3 (November 1971): 69.

9. Rosalind Krauss, "A View of Modernism," *Artforum* 11, no. 1 (September 1972): 49.

10. Marcos Sanchez-Tranquilino and John Tagg, "The Pachuco's Flayed Hide: Mobility, Identity, and *Buenas Garras*," in John Tagg, *Grounds of Dispute: Art History, Cultural Politics, and the Discursive Field* (Minneapolis: University of Minnesota Press, 1992), 184.

11. Iwona Blazwick, Susan Cahan, et al., "Serving Audiences," *October* 80 (Spring 1997): 130.

12. Leslie Dick, "First Bank's Secret Videos," *Artpaper* 9, no. 7 (March 1990): 10.

13. Lev Manovich, *The Language of New Media* (Cambridge: MIT Press, 2001), 219.

14. James Roberts, "The Crisis of Critical Postmodernism," in Annette W. Balkema and Henk Slager, eds., *The Photographic Paradigm. Lier and Boog Studies 12* (Amsterdam: Rodopi, 1997), 95.

15. Fredric Jameson, "Postmodernism, or The Cultural Logic of Late Capitalism," *New Left Review* 146 (July-August 1984): 72.

16. Nicolas Bourriaud, *Postproduction* (New York: Lukas and Sternberg, 2002), 7.

17. Ibid., 12.

18. Ken Johnson, "Mary Heilmann: Unabashedly Joyful Paintings That Look Fun and Easy, but Don't Be Fooled," *New York Times*, October 24, 2008, C30.

19. Quoted in Johanna Neuman, "A Museum with a Patented History," *Los Angeles Times* July 3, 2005, E36.

20. Rosalind Krauss, "Postmodernism's Museum without Walls," in Reesa Greenberg et al., eds., *Thinking about Exhibitions* (New York: Routledge, 2005), 245.

21. Liam Gillick, *Proxemics: Selected Writings 1988–2006* (Zurich: JRP Ringier, 2006), 142.

22. Quoted in Jack Hitt, "Multiscreen Mad Men," *New York Times Magazine*, November 23, 2008, 64.

23. An exception is Laura Hoptman, "Unmonumental: Going to Pieces in the 21st Century," in Richard Flood, Laura Hoptman, and Massimiliano Gioni, eds., *Unmonumental: The Object in the 21st Century* (London: Phaidon, 2007), 128–138.

24. Anne Ellegood, *The Uncertainty of Objects and Ideas* (Washington, DC: Hirshhorn Museum and Sculpture Garden, 2006), 19.

25. Libby Lumpkin, *Deep Design: Nine Little Art Histories* (Los Angeles: Art Issues Press, 1999), 111.

26. Massimiliano Gioni, "Ask the Dust," in Flood, Hoptman, and Gioni, *Unmonumental*, 65.

27. Ellegood, *The Uncertainty of Objects and Ideas*, 19.

28. Douglas B. Holt, "Why Do Brands Cause Trouble? A Dialectical Theory of Consumer Culture and Branding," *Journal of Consumer Research* 29, no. 1 (June 2002): 88.

29. Steven Levy, *Hackers* (Sebastopol, CA: O'Reilly Media, 2010), 8.

30. Quoted in Fiachra Gibbons, "Good Art Is DIY Says Beck's Prize Host," *Guardian*, April 2, 2003, 9.

31. Mary Douglas, *Purity and Danger: An Analysis of Concepts of Pollution and Taboo* (London: Routledge and Kegan Paul, 1966).

32. See especially John Clarke, "Style," in Stuart Hall and Tony Jefferson, eds., *Resistance through Rituals* (London: Hutchinson, 1976), 175–191; and Hebdige, *Subculture*.

33. Hal Foster, *The Return of the Real* (Cambridge: MIT Press, 1996), 173.

34. John Seabrook, *Nobrow: The Culture of Marketing, the Marketing of Culture* (New York: Random House, 2000).

35. Richard Peterson, "Understanding Audience Segmentation: From Elite and Mass to Omnivore and Univore," *Poetics* 21 (1992): 243–258.

36. Benjamin H. D. Buchloh, "All Things Being Equal," *Artforum* 44, no. 3 (November 2005): 224.

37. Hoptman, "Unmonumental," 133.

38. Jean Baudrillard, "The Ecstacy of Communication," in Hal Foster, ed., *The Anti-Aesthetic: Essays on Postmodern Culture* (Port Townsend, WA: Bay Press, 1983), 128.

39. Donna Haraway, "A Manifesto for Cyborgs: Science, Technology, and Socialist Feminism in the 1980s," *Socialist Review* 80 (March-April 1985): 67–68.

Index

Note: page numbers in *italics* refer to illustrations.